Marilyn
Portrait of a Shooting Star

THE SEA HORSE IMPRINT

Paola Mieli, *Publisher & Director*
Mark Stafford, *Editor*
Martin Winn, *Editorial Support*

This book is published under the aegis and with the financial assistance of Après-Coup Psychoanalytic Association, New York

Marie-Magdeleine Lessana

Marilyn
Portrait of a Shooting Star

translated by Mimi C. Newton

Agincourt Press
New York, 2019

Originally published as:
Marilyn, portrait d'une apparition
Bayard, 3 et 5 Rue Bayard, Paris, France 2005
All rights reserved
English language rights the author
Copyright © 2019

ISBN: 978-1-946328-23-6

Copyedited
Zachary Slanger

Design and typesetting
Danilo Montanari

Agincourt Press
P.O. Box 1039
Cooper Station
New York, NY 10003
www.agincourtpress.org

The publisher welcomes enquiries from copyright-holders he has been unable to contact

To Aurélien

TABLE OF CONTENTS

Prologue — 9
Introduction — 11

I - Norma Jeane Mortensen

1 - A California Girl — 17

II - Marilyn Monroe

2 - The First Contract with Fox — 37
3 - A Unique Screen Presence — 41
4 - The Sensational Calendar Photos — 47
5 - *Niagara* and DiMaggio—Marilyn Affirms Her Uniqueness — 53
6 - Everyone's Favorite Star — 57
7 - An Exceptional Actress — 63
8 - New York—The Turning Point — 67
9 - The 'Angel' in *Bus Stop*—The Toll on Marilyn — 75
10 - The Shock of the English Experience—*The Prince and the Showgirl* — 81
11 - *Some Like It Hot*—A Masterful Performance — 89
12 - Tempestuous Affair with Yves Montand—*Let's Make Love* — 97
13 - *The Misfits*—An Ordeal — 105
14 - Arthur Miller, Forty Years After—Still Unfinished — 117
15 - *Something's Got to Give* — 125
16 - Keep Marilyn Hushed Up—She's Dead — 139

Table of Contents

III - The Actor's Studio, Psychoanalysts, and Photographers: The Pitfalls of Stardom

17 - She Was the Light, the Wind 151
18 - Method Acting—The Actor's Studio 155
19 - Psychoanalysis—The Misunderstanding 161
20 - Marilyn's Evanescence—Made for Photography 185

Conclusion 195

PROLOGUE

"It was my fascination. Here is a story from my childhood: my mother loved Marilyn, and we had a poster of her in our apartment. I asked: 'Who is that?' And she replied: 'It's Marilyn Monroe, she was a very beautiful movie star and she killed herself by taking too many sleeping pills!' I was eight or nine years old, and I found this disturbing—not right away, but gradually, over time. I must have asked my mother other questions. I wasn't a big reader like my sister was, but I started buying books about movie stars and soon focused on Marilyn. It became a tradition, a thing shared between my mother and me and no one else. To me, Marilyn was a motherly image, sweet and reassuring like the smell of a mother's bosom. That's how it was even though I knew she didn't have any children. I was a bit into mysticism and religion; I talked to her and said little prayers to her. I thought she listened to me and I kept photos of her under my mattress. If I pinned a photo to the wall, I was careful not to stick a thumbtack through her skin. I didn't tell anyone about it; it was my secret. I completely covered my little bedroom with pictures of Marilyn, I even put them on the ceiling and the windows so that there was no other light in the room, not one square inch without her image. I don't remember my parents being worried about this. My mother might even have encouraged me to do it. In any case, no one bothered me about it. Even to this day, I find it comforting to have a picture of Marilyn near me. I got hooked on collecting everything about her and I wanted to know absolutely everything. I had books and photos, I collected articles about her (it always had to be the entire article), and, if I saw Marilyn's name in print, I had to cut it out, to make it mine. I amassed Marilyn gadgets: boxes, badges, labels, stickers, posters, CDs, and, of course, movies—everything. A relative who was a psychiatrist told my parents that it was simply like playing with dolls, but it was nothing of the sort! My Marilyn was a paradox. This was before the revelations about her possible assassination. For me, she had committed suicide. Because I was a typical starry-eyed

Prologue

young girl, I dreamed of becoming a star. I wondered how this beautiful woman who was so beloved, such a perfect looking movie star, could have committed suicide. It was a mystery. I wanted to be like her: I would die at thirty-six. It seemed logical—who wants to live any longer that that! In my magical fantasy, I would become a Hollywood star. I was in elementary school and I wanted to join the Actor's Studio. Later on, thanks to a friend of my parents, I was lured with a promise of some little role and went to do some auditions. I was thirteen or fourteen years old and the friend was actually kind of coming on to me, how awful! In the typical daydream, somebody comes to you and says, 'you're the one, exactly right for the character! I'll help you become someone everyone loves.' Oh, to be beautiful and admired by everyone! I still felt passionate about Marilyn, but in a different way. My walls were still covered with her, but I didn't say prayers to her anymore. I had to be surrounded by Marilyn: it was a commitment. I simply couldn't allow myself to put anything else up on my walls; it would have meant betraying her. For the past two years, I have lived in this new apartment with my husband, and at first, I had no intention of putting Marilyn on the walls, and yet I have. When the assassination hypotheses came to light, I was stumped; I couldn't make any sense of it. I would read about it and couldn't remember a thing. It wouldn't stick in my mind, and so I am holding on to my story from before. Anyway, it wasn't the actress that mattered, but rather the image."[1]

[1] From a conversation with a young woman that took place in the 2000s.

INTRODUCTION

It is common knowledge that Marilyn Monroe's mother was considered insane, that the identity of her real father was not known, and that, as a little girl, Marilyn was shuttled from one impoverished family to the next and spent two years in an orphanage. It would seem natural, then, to expect that deciphering her past would be the key to explaining the Marilyn Monroe phenomenon. But this kind of approach would automatically produce yet another "tabloid" version of her life, replete with interpretations disguised as explanations. Like all explanations, they say too much. In the end, they are but oversimplifications, inevitably loaded with distorted judgments and accusations, with knights in shining armor and villains. Besides, American biographers have done plenty to explain the impact of Marilyn Monroe's image as being a result of her vulnerability and by the fact that she was an abandoned child, which would explain why everyone loved her so much. But for me, Marilyn Monroe is a work of art. To understand Marilyn as an artist, to paint her portrait as a creation through photographs, films, and testimonies—this is my psychoanalytic position.

Her spontaneous brilliance, admired by all, continues to generate creative inspiration. Marilyn Monroe was a monumental star and she shines still today. The Monroe phenomenon is not just the image of a glamorous woman and sex symbol, synonymous with the cultural changes of an era; it is a force, a current, a moving picture, a kinetic fantasy that has had an incredible impact and whose magic continues to hold countless people under its spell.

In many parts of the world, Marilyn Monroe remains a persistent part of daily life. In the spring of 2004, she could be seen in Paris on posters for the Cannes Film Festival. She appeared as a shadow in silhouette, leaning over to hold down her billowing skirt—a reference to the famous film *The Seven Year Itch*. Parisian bus shelters sported ads for the Morgan fashion brand featuring a girl made to look like Marilyn did in the film *Something's Got to Give*. The model is platinum blond

Introduction

and slim, again wearing that white dress that flutters up à la Marilyn. She delivers the slogan, "Je suis Morgan de toi" (I am Morgan about you), but she could have said, "Je suis Marilyn de toi"! Leafing through gay magazines, one quickly realizes that Marilyn's poses and makeup serve as models for cross-dressing, right down to the wigs—parodies of femininity. To continue window-shopping, here and there—proliferating in the most diverse, as well as the most whimsical, contexts—one can spot images that hold the promise that you too could be like Marilyn. I am told that in Berlin, Germany, as well as in Montpellier, France, there is an exhibition of never-before-seen photos of Marilyn taken by Sam Shaw. In Vienna, Austria, for a photo exhibition, Nam June Paik chose to present videos of news images concerning the death of Marilyn Monroe. I have also learned about a night club in Tokyo called the New Marilyn Club, which brings together women who have been disappointed by men and who choose to have intimate relations with *onabe* (male impersonators)—the examples go on and on.

Marilyn: a name, an image that opens a portal onto strange and erotic fantasies. It serves as an emblem, an interface upon which are projected alluring gestures that beguile, enticing us to embrace her essence. Marilyn is a source of entertainment, a springboard for freedom, for erotic titillation. Marilyn: an ever-changing image, her presence comes forth—strange, unconventional, unsettling.

Marilyn Monroe, a persistent image. Fleeting, flickering, infinitely multiplied—she evokes an intact presence that may yet vanish at any moment. This image is so difficult to capture that each biographer, each witness, has created his or her own idea of the woman Marilyn, often outrageously distorting the information in order to justify a thesis, to prove that he or she is presenting a valid interpretation. But Marilyn moves, slips away from our grasp, shattering preconceived ideas. Her image is everywhere, yet, because it is so pervasive, so ubiquitous, it becomes impossible to fathom; we are distanced from her and she from us. She always surprised those who tried to define her, because what they said was never quite right. Her presence may permeate our daily lives, but the Marilyn phenomenon insidiously renders her ever more remote.

Before I would begin writing, I always had to look through a number of photos of Marilyn or see some of her films in order to feel the effect of her presence. The attitude of an objective researcher was in no way appropriate for the task; instead, I had to submit to the

movement without trying to harness it. As a result, I have removed most quotation marks around extracts taken from more or less accurate sources or resulting from fanciful translations. I have refrained from using cumbersome expressions, such as "it is believed that," "it is said that," with respect to elements repeated by all biographers. I have retained those aspects that are incontestably present in all the biographies I have read, but I frame them in my own way. This is going to be neither a biography, nor a case study, nor an inquiry, but rather a fusion between the portrait of an artist and the portrait of her work: a legend. "Legend," from Latin *legenda*: that which must be read. My task is to render legible the uniqueness of Marilyn Monroe so that everyone may perhaps find here what that is. This is especially fitting for Marilyn because her work cannot be dissociated from who she was as a person. She not only comes to life in her movies, recordings, and photos, but she is also a movement, an active presence that defies time.

As I worked, I discovered that Marilyn Monroe extensively consulted psychoanalysts who tried to help her, each in their fashion. As we will see, these encounters give a rueful impression of missed opportunities. I have tried to obtain the psychoanalysts' own insights from their correspondence about her, but much has remained inaccessible, as if this information might contain within it a veritable ticking time bomb. Marilyn, it seems, is just as alive today as she has ever been—and dangerous as well.

I
NORMA JEANE MORTENSEN

1
A CALIFORNIA GIRL

To begin to understand Marilyn, let's start with some biographical details. She was born on June 1, 1926, in Los Angeles, under the name of Norma Jeane Mortensen, into a milieu that could be classified as California lower working class. Her grandparents and parents held irregular jobs: some worked on the construction of the railway to Mexico, others for film studios. Gladys Mortensen, Marilyn's mother, had already had two children with another man; they were declared "deceased" at the moment the third child was born even though in reality they lived with their father, Mr. Baker. Martin Edward Mortensen had been away from the marital home when Norma was born, so the child's birth certificate stated, "father's address unknown," not "father unknown" (contrary to what has been repeated so often). Marilyn's official father was thus Martin Edward Mortensen.

In that family, it was not uncommon to take some liberties when filling out official paperwork. Were they influenced by the California pioneer spirit, which allowed for such liberties, or was this a sign of a dysfunctional family unit? One can certainly cite historical and social reasons why, in this region of the Far West, one might get married and divorced at the drop of a hat. Blurring the civil registry information must also have been common practice. In this way, Marilyn's mother, Gladys, had been married to Baker at the age of fourteen, but with the support of her own mother, Della, she declared her age to be eighteen. Gladys never acknowledged being the mother of her first child, Jack Baker, whom her mother Della was forced to recognize as her own. When Gladys' second child, Berniece, was born, she was officially recorded as her first child. In 1921, Gladys divorced Baker and stopped caring for her children altogether. In her revised autobiography, Marilyn Monroe recounts how, one day, her mother discovered her husband making love to another woman and that there was a vio-

lent scene after which they separated.[2] Baker went on to quietly raise his children. According to Marilyn, Gladys made many attempts to get Jack and Berniece back.

Gladys worked as a film cutter for Consolidated Film Industries. She struck up a friendship with her superior, Grace McKee, a film librarian, and they rented a place together in Hollywood after the breakup of Gladys' first marriage. The two young women's main concerns were having fun and flirting with the men around them. They were a pair of flappers—Grace was a bleached-blond, 'good time' girl while Gladys had her hair dyed red. In the summer of 1924, Gladys met Martin Mortensen, a meter man for the gas company, and by October they were married. Only four months later, Gladys had already left her husband and returned to live with Grace. Martin tried to win his wife back several times, as well as to protect her from the more or less crude advances of other men. Gladys never said exactly who got her pregnant in 1925. Several men other than her husband had been her lovers, and the name of one of them kept coming up more insistently as the one responsible for the pregnancy: Charles Stanley Gifford, a shift foreman at Consolidated Film Industries. He is the only one whose photo was proudly displayed in Gladys' bedroom, and he was the only man whom Gladys once identified as Norma's father.

In June 1926, very soon after Norma Jeane was born, Gladys placed her daughter in the care of a foster family: Ida and Albert Bolender, who lived across the street from Gladys' mother in Hawthorne, some fifteen miles from Hollywood. Was it for reasons of respectability, but also for convenience, that Gladys gave her daughter to a stable family rather than keep her? These factors must have combined with the fact that Gladys probably didn't feel up to the responsibility of raising a child herself, nor was she disposed to living with a man. It seems that Gladys needed to live with another woman who would control her, which is exactly what her superior, Grace, did—a job that she had taken over from Della, Gladys' mother. In August 1927, Della had a psychotic episode during which she went to the Bolenders' home and broke down the screen door, screaming Norma Jeane's name.[3] Marilyn recalled that her grandmother had tried to choke her with a pillow.[4]

[2] Marilyn Monroe, *My Story* (New York: Taylor Trade, 2007), 2.
[3] Norman Mailor, *Marilyn: A Biography* (New York: Grosset & Dunlap, 1973), 29.
[4] Hans Jorgen Lembourn, *Forty Days with Marilyn* (London: Hutchinson, 1979), 74.

The foster parents called the police, who took the grandmother to an asylum in Norwalk where she died from cardiac arrest in the following days. All we know is that the child, Norma Jeane, must certainly have been a major contributing factor in the madness of the relationship between her mother and grandmother.

In August 1928, Gladys divorced Martin Mortensen. It was she who was paying for Norma's room and board, and Gladys visited her from time to time. Norma received a severe, religious, regimented education at the Bolender home, where the father was a postal worker and the mother was raising her own son along with other adopted children. They were Pentecostal evangelists. Marilyn would later say that Albert Bolender was the only man who had ever answered any of her questions.

In those days, Norma was enthralled by the sound of the organ music in church. Marilyn wrote:

> ... [T]he impulse would come to me to take off all my clothes. I wanted desperately to stand up naked for God and everyone else to see.... Sometimes I had to pray hard and beg God to stop me from taking my clothes off.... I even had dreams about it. In the dream I entered the church wearing a hoop skirt with nothing under it. The people would be lying on their backs in the church aisle, and I would step over them, and they would look up at me.... Dreaming of people looking at me made me feel less lonely.[5]

We later learned that, as an adult, Marilyn enjoyed being naked—under her clothes, under her sheets, under her bathrobe, in her home. She also liked to impress people by innocently letting them glimpse her curves—foreshadowing the playfulness of the scene with the billowing skirt.

According to her biographers, Norma once brought home a puppy that became her faithful companion, and whom she named Tippy. Shortly after her seventh birthday, a short-tempered neighbor, annoyed by the dog's barking, pulled out his gun and shot it. In her autobiography, Marilyn gives a different version of this story. She says that, as she was returning home after having her tonsils removed, the dog, who was very fond of her, started barking out of joy at her return

[5] Monroe, *op. cit.*, 13.

Chapter 1

and the neighbor, raging mad, threw a garden spade at it, nearly cutting the dog in half. Norma was so crushed with grief that the Bolenders had to summon Gladys. She came, accompanied by Grace, and took her daughter back with her. This is how Norma left the family that had taken care of her for the first seven years of her life. She would later say that it was the first happy day of her life. She was finally going to live with her mother.

Thanks to a government loan for single parents, Gladys bought a house near the Hollywood Bowl. She rented out four of the six rooms to a couple of English actors and lived with her daughter, Norma, in the other two. There were two significant objects in this new space: a white baby grand piano and a single picture on the wall—that of Charles Stanley Gifford,[6] Norma's presumed father. The little girl loved that photograph, this "father" with his fedora gently tipped to the side and a thin mustache that made him look like Clark Gable. "He was killed in a car accident," interjected Gladys whenever her daughter raised the subject. Gladys told her that they used to live in the same building and that he left without a word when Norma was born. Marilyn wrote, "[E]verything I heard about him made me feel warmer toward him."[7] The little girl would daydream about her father. In all these daydreams, "even my largest, deepest daydream," he would always wear his hat.[8]

At that time, in 1933, Gladys was still working as a film cutter and wanted to fully support her daughter. According to Marilyn (writing in 1960), life became "...pretty casual and tumultuous.... [They] worked hard when they worked, and they enjoyed life the rest of the time. They liked to dance and sing, they drank and played cards, and they had a lot of friends." She adds, "Because of that religious upbringing I'd had, I was kind of shocked—I thought they were all going to hell. I spent hours praying for them."[9] She wrote that she spent most of her time in a closet. Her mother kept telling her, "Stop making

[6] All this information can be found in several biographies. Here, I drew in particular on Donald Spoto, *Marilyn Monroe: The Biography* (New York: HarperCollins, 1993), 28.

[7] Monroe, *op. cit.*, 4.

[8] *Ibid.*, 5.

[9] Georges Belmont, interview with Marilyn Monroe for *Marie-Claire*, published in 1960. English version reprinted in Georges Belmont and Jane Russell, *Marilyn Monroe and the Camera* (Munich: Schirmer/Mosel Verlag, 1989), 14. Also quoted in Spoto, *op. cit.*, 28–29.

noise, Norma!"—even if Norma was just flipping through the pages of a book. The rustle of paper made by her daughter was enough to disturb Gladys. Norma had to make herself smaller and quieter than the noise of a page being turned!

Without any transition, the little girl would go from the church to the movies—her Sunday entertainment. She would be dropped off there in the morning and then watch the same movie over and over throughout the rest of the day. Her mother and Grace both loved Jean Harlow, Norma Jeane's namesake, except without the extra *e*. In elementary school, she was registered under the name Norma Jean, adopting the more traditional spelling, thereby compounding the confusion.

In May 1933, Gladys' grandfather, a farmer driven to despair by financial problems, hanged himself. Even though she had never known him, Gladys' mental state declined catastrophically: "In the evenings, she stalked the rooms of the house, muttering prayers and reading aloud from a family Bible."[10] She came to believe that her whole family was cursed with mental instability and started drinking and seeing doctors who would prescribe her pills. Finally, according to Marilyn, early in 1934—when the mother was barely thirty-two and her daughter still only eight—Gladys threw a fit of wailing and laughing and was committed to an insane asylum. Norma had lived with her mother for only a few months before she was taken in by the omnipresent Grace McKee. Marilyn would write that she remembered her mother as "... a pretty woman who never smiled... never kissed me or held me in her arms."[11]

Grace is said to have loved and adored Norma.[12] Grace convinced her that she would become a great actress, a movie star like Jean Harlow (the first Hollywood actress to have platinum-blond hair). And so, Harlow became Norma Jeane's idol. Sometimes, on Sundays, Gladys would come to visit her daughter and Grace and they would go out to a restaurant together and then to the movies. But, in the fall, they had to sell the Hollywood Bowl home and, as Grace had decided to become Norma Jeane's legal guardian, the girl was required to spend six months in an orphanage while the guardianship was be-

[10] Spoto, *op. cit.*, 32.
[11] Monroe, *op. cit.*, 1.
[12] Maurice Zolotow, *Marilyn Monroe* (New York: Harper Perennial, 1990), 18.

ing approved: "The State of California required proof that the living natural parent [was] incompetent. . . . Grace obtained a formal statement from doctors that Gladys was insane" and had her transferred to Norwalk State Hospital (where Della had been committed).[13] "Her illnesses," proclaimed the chief's report, "have been characterized by (1) preoccupation with religion at times, and (2) at other times deep depression and agitation. This appears to be a chronic state."[14] Before being sent to the orphanage, Norma Jeane was placed in the care of a foster family, the Giffens, then transferred to Grace's mother, Emma Atchinson. Grace then petitioned the court to be awarded exclusive control over Gladys' affairs. On Norma Jeane's ninth birthday, Grace received full possession of Gladys' property. The white piano was put up for sale. Later, Norma would try to find it and buy it back.

Shortly thereafter, Grace fell in love with a certain Erwin Goddard, nicknamed Doc (because his father was a surgeon), and they were married in Las Vegas in August 1935. The couple, along with Norma and Nona, Doc Goddard's daughter, moved into a bungalow on Odessa Avenue. Marilyn recounts that a neighbor at that time forced her to have oral sex with him—an event that Grace absolutely refused to acknowledge. Goddard quickly declared that Norma was one mouth too many to feed and, on September 13, 1935, Grace took Norma Jeane to the Los Angeles Orphanage in Hollywood, where the girl remained for two years (until June 7, 1937). A note in her file states that, in 1935, she was "a normal, healthy girl who eats and sleeps well, seems content and uncomplaining and also says she likes her classes."[15] On Saturdays, Grace would take her to the cinema and often to a beauty parlor. She would press the tip of Norma's nose and say that it could be made to look like Jean Harlow's. Later, Marilyn would remember that she felt isolated at the orphanage, and that she imagined that Clark Gable was her father. "I was never used to being happy during those years," she recalled.[16] She started stuttering and having coughing fits and occasional panic attacks.[17] Once, she addressed a

[13] Spoto, *op. cit.*, 40.
[14] The patient file of Gladys Monroe Baker, Los Angeles General Hospital, 1935. Preserved by Marilyn Monroe, kept in the Milton Greene Papers. Quoted in *ibid*.
[15] File preserved by Marilyn Monroe, kept in Milton Greene Papers. Quoted in *ibid*., 44.
[16] *Ibid*., 47.
[17] Orphanage file dated February 20, 1937.

postcard to herself signed "Daddy and Mommy" to show to the other children. She used to climb to the rooftop of the orphanage and look at the RKO Studios sign where Gladys had worked. She wrote, "I hated the sign. It reminded me of the smell of glue. My mother had taken me to the studio where she worked. The smell of wet film she cut and spliced had stuck in my nose."[18]

The final papers for guardianship were filed in the spring of 1937 and on June 7, shortly after her eleventh birthday, Norma moved back to Grace and Doc's bungalow. Once, however, after a night of heavy drinking, Goddard tried to force himself on Norma. Yet again, Grace had to send Norma away; she took her to Norma's maternal cousins, who were close to her age. This was the first time that Norma found herself among her own family, the Monroes. The cousins' father, Gladys' brother and Norma's uncle, Marion Monroe, had disappeared without a trace four years earlier. It seems that, at that time, the eleven-year-old Norma firmly stated that she would never get married, that she was going to become a school teacher and have a lot of dogs. Her cousins' mother, Olive Monroe, declared her husband dead and her children "fatherless" in order to be eligible for financial aid from the state. For her part, Norma would say at school that her parents had been killed in an accident, which earned her the status of the teacher's pet. Marilyn wrote in her autobiography, "The families with whom I lived had one thing in common—a need for five dollars."[19] Marilyn was anxious when she heard adults talk about her "background." The expression "mentally unstable," used in reference to her mother, worried her, even though she wasn't quite sure what it meant. Grace told Norma a sordid, yet comical, story. It appears that Martin Mortensen, having been declared dead by his neighbors (the rumor was that he died following a motor scooter accident in 1929), resurfaced when he phoned the Norwalk institution where Gladys was hospitalized. As he had always done before, once again he wanted to save his wife and come live with her. Gladys was said to be overjoyed at the thought that he hadn't forgotten her and tried to escape from the hospital to join her ex-husband. But, since she had declared him dead, the hospital staff took her attempted escape as a sign of delirium and she was

[18] Monroe, *op. cit.*, 45.
[19] *Ibid.*, 15.

Chapter 1

transferred to a state asylum at Agnew, near San Francisco. It was later proven that this Martin Mortensen was indeed Gladys' ex-husband.[20]

In June 1938, when Norma was twelve, she was "sexually assaulted" by her thirteen-year-old cousin, Jack Monroe. Grace wanted to take Norma away, not to her house, since the drunken advances of her own husband made it impossible, but rather to her paternal aunt, Ana Atchinson Lower. Norma and Ana were very fond of each other: "She was the first person in the world I ever really loved and she loved me. She was a wonderful human being. I once wrote a poem about her and I showed it to somebody and they cried... it was called 'I Love Her,'" wrote Marilyn.[21]

Using Gladys' nest egg, Grace showered Norma with feminine gifts like dresses, makeup, and shoes. She wanted the young woman to go to high school in Los Angeles. Because Mortensen had reappeared, Grace thought it best to register Norma under the name of her mother's first husband, Baker. The name Norma Jeane Baker was used everywhere. This accounts for the frequent error in Marilyn Monroe's biographies: she is often referred to as Norma Jeane Baker, rather than Mortensen. There is confusion regarding the spelling of both her first name, Jeane or Jean, and of her last name. This unstable identity (the juggling of names, dates, places, fathers, deaths...) might explain the multiple versions of Marilyn's life in circulation and shows that one version is as valid as the next. These details are not of great importance.

In Emerson Junior High School, students were of diverse ethnic and economic backgrounds (Japanese, Hispanic, Indian, farmers, Okies, middle class). As for Norma, she came from Sawtelle, a poor, disreputable neighborhood in LA. "She was very much an average student... but she looked as though she wasn't well cared for.... [She] was a nice child, but not at all outgoing, not vibrant," commented one of her schoolteachers.[22] Around that time, Marilyn also began to menstruate; her periods were painful and would remain so throughout her life.

On one of the rare occasions when Norma accompanied her guardian, Grace, on her visit to see Gladys, her mother was calm, well

[20] Martin Mortensen died in 1981 in Riverside County, CA. Quoted in Spoto, *op. cit.*, 57.
[21] Quoted in *ibid*.
[22] *Ibid.*, 61.

cared for, and wasn't sedated, but wouldn't say a word. When Norma was about to leave, her mother looked at her with sadness and said quietly, "You used to have such tiny little feet."[23] Was Gladys stuck in a moment of the past when her baby had cute little feet kicking in her crib? As if she were facing the abyss, she could feel that that moment had gone. Had the passage of time left no other trace?

In 1939, when Norma was thirteen, her figure was fully developed and the often-stitched and hemmed blue orphanage-issue skirt finally grew too tight. Having no money to buy new clothes, she got the idea to put on bargain men's trousers, complemented by a buttoned cardigan she wore backwards. The outfit was quite "alluring... and in one week that autumn [it] caused such a sensation that... twice she was sent home."[24] Marilyn would remember later that it was precisely from that moment on that she started being seen: "Suddenly, everything seemed to open up.... Even the girls paid a little attention to me.... I had to walk to school and it was just sheer pleasure. Every fellow honked his horn—you know, workers driving to work, waving, and I'd wave back. The world became friendly."[25] She started wearing makeup to school and had no undershirt or brassiere under her sweater. "Suddenly she just seemed to stand out in a crowd," recalled one of her classmates.[26] Norma would spend a lot of time in the ladies' room fixing herself up. She invented her own look—unusual and unexpected.

The same classmate also said, "Norma Jeane was really awfully nice and sweet, but she also seemed a little pathetic, because she was constantly ashamed of her background."[27] These remarks contradict the story that Marilyn would tell about this period in her life. She was not in the least ashamed of being poor, she claimed. She did not spend time in wealthy neighborhoods with her friends, and preferred to bike to the ocean, along Los Angeles boulevards, and go to small bars or

[23] Unrevised notes by Ben Hecht, who would go on to ghost-write Marilyn Monroe's autobiography in 1954, but was unable to publish it at the time because DiMaggio was opposed to the project. When these notes appeared in *British Empire News*, Marilyn threatened to sue, alleging misquotation. After the actress' death, the notes were revised by M. Greene: see Monroe, *op. cit.*

[24] Spoto, *op. cit.*, 63.
[25] Quoted in *ibid.*
[26] Quoted in *ibid.*
[27] Quoted in *ibid.*, 65.

dance clubs. The other girls resented her more and more, while young men would follow her in the street. Once, on a walk along the ocean front, a group of young men were tailing Norma, whistling at her. She was the "Mmmm girl." Norma loved joking, laughing, and dancing, but if a boy wanted more, she was able to fight him like a man. She became the star at her high school. Nevertheless, she would write later that she had felt "increasingly confused."

In late 1940, Norma Jeane moved back in with Grace and befriended one of Doc Goddard's daughters, Eleanor, known as Bebe. The two girls grew very close, like sisters. In June 1941, Norma passed her final exams and graduated from Emerson Junior High School. Her final grades were quite mediocre and her "fear of seeming verbally inept and socially unacceptable paralyzed her throat and silenced her."[28] Only in her journalism class did she show a quick mind and a good sense of humor. She contributed to the high school paper *The Emersonian*. In the "Features" column, one of her articles read:

> ...After tabulating some 500-odd questionnaires, we have found that fifty-three percent of the *gentlemen prefer blondes* as their dream girl. Forty percent like brunettes with blue eyes, and a weak seven percent say they would like to be marooned on a desert island with a redhead... According to the general consensus of opinion, the perfect girl would be a honey blonde with deep blue eyes, well molded figure, classic features, a swell personality, intelligence, athletic ability (but still feminine), and she would be a loyal friend. Well, we can still dream about it.[29]

Norma's interests are clearly coming to the surface. At the age of fifteen, her words foreshadow her future choices.

At the start of the new school year in 1941, she enrolled at Van Nuys High School, where her grades would be hardly better than at Emerson Junior High. Grace was friends with one of her neighbors whose son, Jim, older than Norma and Bebe, often drove the girls home from school. In Norma Jeane's eyes, he was a "dreamboat"; he sported a moustache that, it seems, fascinated Norma. Grace actively encouraged Norma's infatuation with the young neighbor who thought of her as a "little girl." Grace arranged for them to attend a

[28] *Ibid.*, 68.
[29] Quoted in *ibid.*, 68–69.

Christmas ball together, where adolescent Norma danced cheek to cheek with Jim under the approving gaze of her guardian. They went out together on walks and picnics, often along Mulholland Drive.

In early 1942, Doc Goddard was promoted and transferred to a position on the East Coast. Grace and Doc decided to take Bebe with them, but not Norma Jeane. Once again, a suitable home needed to be found for Norma. She went back to live with Ana, who was ill. That's when Grace suggested to Jim's mother that the young couple should get married. Norma was about to turn sixteen—the legal age for marriage. Jim agreed to his mother's suggestion. Because he knew he would soon be going into the service and because he was fond of Norma, he wanted her to come live under his mother's protection. In March, just as the Goddards had left Los Angeles, Norma Jeane abruptly quit her studies and announced at her school that she was going to get married in June. She confessed later that she was too afraid of going back to the orphanage and so chose marriage instead.

Norma asked Grace, with some apprehension, whether she could get married but not have sex. Grace replied that she would soon learn.[30] Ana gave her a puritanical book about what young girls should know about marriage. Marilyn commented later that her misgivings about marriage must surely have come from the fact that, until then, she had never seen a successful one. Norma turned sixteen on June 1, 1942, and the wedding took place on June 19, with a party thrown together by the kind-hearted Ana Lower and Jim's parents. The invitations were made in the name of Ana Lower, for the wedding of her niece, Norma Jeane Baker, whereas the name on the marriage certificate was the one used at birth: "Norma Jeane Mortensen, daughter of E. Mortensen (birthplace unknown) and Gladys Monroe (born in Oregon)."[31] Neither Gladys nor the Goddards and their daughter Bebe attended, but the Bolenders, the first foster parents of the bride, came from Hawthorne, although "they disapproved of the hasty marriage." The ceremony took place at the house of Grace's friends. Norma wore a white dress and a veil; there were twenty-five guests and there was dancing. Jim recalled later: "... she never let go of my arm all after-

[30] This information, present in all the biographies, comes from Jim's—James E. Dougherty's—recollections and frequently edited interviews he gave.

[31] Quoted in Spoto, *op. cit.*, 75.

Chapter 1

noon, and even then she looked at me as though she was afraid that I might disappear while she was out of the room."[32]

The newlyweds moved into a brand new studio on Vista del Monte, which Norma adored—the first place she could call her own. According to her husband, she loved making love and did it with joy, regardless of the location (in the car, at the market); if the desire was intense, she would give Jim a sign and they would immediately jump into action. Sometimes it was uncomfortable, but Jim said that he couldn't resist. He said that the sight of their naked bodies would be enough to arouse them and send them into each other's arms.

Her husband worked the night shift and Norma had the habit of slipping little love notes into his lunch box, such as: "Dear Daddy—When you read this, I will be asleep and dreaming of you. Love and kisses. Your Baby."[33] Marilyn would call all her husbands "Daddy." Jim recounts in his memoir that Norma was very sensitive and even easily hurt: he had to kiss her before going out and she would be offended if he stayed out too long with his friends. He said that, on the whole, she was adorable, but that they weren't sure how to behave towards each other. They were at first awkward at living together and Norma tried hard to please Jim and be a good wife. She also enjoyed taking care of her nephews. Eventually, the young couple started to make friends and would invite them over for dinner and dancing. It was on those occasions that Norma would abandon her shyness and reveal her charming side. She spent a lot of time taking care of her body and her looks, as well as selecting clothes that best suited her figure. She was very likeable, cheerful, delightful, entertaining. Neither men nor women were immune to her spirited allure. Marilyn later said that she had loved Jim and wanted to please him, but that the marriage could not last because they had nothing to say to each other.

Jim dreamed of enlisting in the army. He could have avoided going, but in 1943 he was sent to Santa Catalina Island for training with the Merchant Marines, where Norma joined him at the end of the year, bringing their dog along.

Jim experienced fits of jealousy when Norma enjoyed herself dancing with other men. In the spring of 1944, Jim was sent to the

[32] James E. Dougherty, *The Secret Happiness of Marilyn Monroe* (Chicago: Playboy Press, 1976), 30.

[33] Quoted in Spoto, *op. cit.*, 79.

Southeast Asian war zone; Norma begged him not to go, but he refused. She then asked him to make her pregnant: "... she wanted something, *someone* she could hold on to all the time," Jim Dougherty would say later.[34] His wife's tears and anxiety when they parted remained engraved in his memory. Norma went to live with her mother-in-law, who found her a job spraying varnish on fuselage fabric—a task that workers called "working in the dope room."[35] She worked eight-hour shifts, always on her feet. Norma asked to be assigned a job in the Civil Service, but had to give up on it because, in her words, there were just too many "wolves."[36]

Very grateful to her legal guardian, Grace, Norma wrote her often and sent her money, adding words of love for Doc Goddard. Norma was then given a more bearable job at Radioplane: folding parachutes.

When Jim returned home for Christmas, Norma was trying to reach her presumed father on the phone. Jim recalled that, when she introduced herself as Gladys' daughter, the prodigal progenitor hung up on her. For hours afterwards, Jim had to hold her tightly in his arms. Similar scenes of attempted phone calls to her father would be repeated several times in her life.

That same year (1944–1945), Norma Jeane, barely eighteen, was photographed by a crew documenting the contribution to the war effort of young women around the country. It was a man named Conover who first discovered Norma Jeane. He later asked her to pose for some color shots in his studio and gave her some tips on clothes and makeup. "Something fresh and lively came from her.... There was a luminous quality to her face, a fragility combined with astonishing vibrancy," Conover recalled years later.[37] She was already an extreme perfectionist and she scrupulously examined the prints and negatives. Conover suggested that she become a model. Throughout the summer of 1945, he went on to photograph Norma Jeane in different locations all around California. He submitted some of the photos to magazines, prompting Norma's mother-in-law to take a stand and declare that the career of a model was incompatible with being a wife. Jim was notified and tried to downplay the issue. Nevertheless, Norma left her

[34] Quoted in *ibid.*, 86.
[35] *Ibid.*
[36] Letter quoted in *ibid.*, 88.
[37] Quoted in *ibid.*, 92.

Chapter 1

in-laws' home and moved back in with her good-natured aunt, Ana. Jim wrote her that she could model while he was away, but that, once he had returned, they would start a real family and she would have to give it up. From that moment on, Norma Jeane considered her marriage to be over. Their correspondence became sparse. She accepted offers from magazines: she liked modeling, why would she give it up? Norma recalled later on, "... I wanted to know who I was... and Jim certainly thought he knew but he was wrong."

Norma Jeane was signed by the Blue Book Modeling Agency. Her file indicated her measurements, her "blue-green eyes, [her hair] too curly to manage, recommend bleach and permanent, perfect, pleasantly white teeth." It was also noted that she knew how to "dance a little and sing."[38] Norma started attending posing, makeup, and fashion classes. To pay for her training, she took on a job as a hostess and sometimes posed for advertisements. All those who knew her at the time agree that it was Norma Jeane herself, and not the clothes she modeled, that made an impression.

During Jim's end-of-year leave, Norma left to pose for the photographer André de Dienes in different parts of California.[39] It was he who immortalized Norma Jeane suntanned, barefoot on the asphalt, her hair tied in little pigtails—like a sassy hitchhiker. He photographed her with a newborn lamb in her arms or wearing jeans and a red blouse knotted under her breasts, straddling a fence. When she returned home, she showed these photos to her husband, enthusiastically recounting her adventures. When she was away from home, Norma always felt the urge to call Jim so that he wouldn't worry. In the motels where she stayed with de Dienes, she would ask for a separate room and she needed to eat and sleep well before plunging into work. De Dienes photographed her in Yosemite National Park, in the Nevada desert, and on the snowy slopes of Mount Hood. She bought her clothes at department store sales and put together her own wardrobe. De Dienes was in love with her and wanted to make her his mistress, but she resisted until the day when, on their way through Oregon,

[38] Quoted in *ibid.*, 94.
[39] De Dienes' collected photographs have been published by Taschen in a wonderful book that contains all the shots of Norma he took at that time, as well as a facsimile of his journal. Unlike many others, this document has the advantage of never having been revised in light of Marilyn Monroe's success.

they stopped to see Gladys, who lived in a seedy hotel in Portland. Norma gave her some gifts and money. As de Dienes recalled:

> We found her mother in a small room on the top floor. She greeted Norma Jeane with a sad expression, then she set in a chair near the window, and they carried on a slow-paced conversation, in a very low, monotonous tone. The lady was... thin, expressionless, void of any emotional ups-and-downs... her mother put her head into her hands, bent down, and there were rather painful silent moments like that. It was a dark, cloudy afternoon, the room seemed very gloomy to me. Norma Jeane looked at me with painful embarrassment. Then, since there was little else to do, we departed.[40]

That same night, the young photographer and Norma became lovers. It was a happy moment, but Norma cried. Nevertheless, their trip continued with a feeling of euphoria. It seems that what was essential for Norma was the joy that she derived from the photo sessions with him, in staging the scenes and choosing the locations, clothes, and poses.

Upon her return to Hollywood, Norma was glad to accept offers from other photographers. De Dienes wanted her to get a divorce so that they could get married and wasn't very pleased that she made herself available for other modeling assignments.

In the spring of 1946, Norma Jeane was featured on no less than thirty-three magazine covers. Her employers would say that one of her main attributes was the fact that she gave the impression that she was amused—she giggled with satisfaction, even while taking her work seriously. Marilyn commented years later:

> ...[Y]ou act as if you're having a good time—but it's a day when you're really having terrible cramps.... [S]ometimes modeling seemed so phoney and fake I had to laugh. They thought that was great, they had a great smile from you, and they just snapped away, thinking that, well, I was having a good time. Sure, sometimes it was fun. But modeling can also be a little crazy. I once asked why I had to wear a bathing suit for a toothpaste ad. He looked at me as if I was some kind of crazy![41]

[40] Steve Crist, *André de Dienes, Marilyn* (Köln: Taschen, 2002), 201.
[41] Quoted in Spoto, *op. cit.*, 96.

Her naïveté and sincerity, which Marilyn never lost, as well as her genuine way of enjoying herself during photo shoots, indicate a strong character trait: she never played along with anything less than a straightforward proposition. Mrs. Snively, the head of the Blue Book Agency, asked that Norma lighten her hair for a shampoo ad.

The Goddards returned shortly thereafter and were overjoyed at the transformation of their protégée. Jim also came back, but wasn't as happy with what he found and quickly understood that his wife was becoming a big success. She had plenty of work and she was aiming high.

Norma worked for many photographers, including William Burnside, Earl Moran, and Lazlo Willinger. They all agreed that Norma was shy, that she hated being touched, and that she would not be conquered by force. "She loved posing. For her, it was like play acting and, instinctively, she always did it right" (Earl Moran); "She made love to the camera, and then to the man who stood behind it" (William Burnside); "She would fade as soon as the shoot was over... [E]ven people who had been around and knew models fell for this 'Help me' pose" (Laszlo Willinger).[42]

Norma never yielded to material temptations, as many models did in that milieu, nor was she tempted by romance, by trading love for a job, by a useful address, by a contract, by financial support, or by connections. She loved walking along the ocean and going out to nightclubs. "She never lost her natural sweetness and discretion" (Ray Bourbon).

At the same time, Gladys pressured her daughter to let her come live with her. In April 1946, Norma sent her mother money to cover the trip, and Gladys soon moved into her studio apartment. When Jim came home on leave, he had to stay at his mother's house. He didn't welcome this "intrusion" and interpreted it as a premeditated maneuver to exclude him. The experience was short-lived and decisive. In late April, Gladys was admitted to a Northern California clinic. It was impossible for mother and daughter to live under one roof; as soon as they would find themselves together, Gladys would have a breakdown and require hospitalization.

[42] Quoted in *ibid.*, 105.

Grace quickly understood that there was only one way to resolve the conflict between Norma's ambitions and the demands of her marriage to Jim. She shipped Norma off to another aunt in Las Vegas, where she could obtain a quick divorce, as was customary at the time. Norma had to swear that she was settled in Nevada on a permanent basis and that her husband's "extreme... cruelty" and angry outbursts, as well as his failure to provide for her, "impaired [her] health."[43] Any reconciliation was impossible. Jim first learned about the proceedings while stationed in Asia. In September 1946, he countersigned the divorce decree. In short, by the time she was twenty, Norma's marriage, as well as her divorce, had been arranged by Grace.

Around that time, Norma landed her first role in a Technicolor production by Leon Shamroy at Twentieth Century Fox. "Her natural beauty plus her inferiority complex gave her a look of mystery," said Shamroy. "I got a cold chill. This girl had something I hadn't seen since silent pictures.... Every frame of the test radiated sex. She didn't need a sound track—she was creating effects visually. She was showing us one could sell emotions in pictures."[44]

From the time she was twenty, this radiating quality that Norma possessed would be captured in photos, even before she began her acting career.

In July, despite Zanuck's reservations, the studio offered Norma a standard six-month contract, "without... emendations," set at seventy-five dollars a week, whether she worked or not.[45] It was Grace who signed the contract, since she was still Norma's legal guardian—as well as the puppet master pulling the strings in her life.

When de Dienes announced he would come to Las Vegas to arrange the details of their marriage, Norma replied, "Please don't come, I can't marry you. I'm going to be an actress!"[46] He was stunned and came anyway. They did not get married.

The studio, in the person of Ben Lyon, let Norma Jeane know that the name Dougherty was too much of a mouthful, impossible for an actress. She chose Monroe, her mother Gladys' maiden name. Marilyn said that it was Grace who had suggested this name, claim-

[43] Quoted in *ibid.*, 108.
[44] *Ibid.*, 111.
[45] *Ibid.*, 112.
[46] De Dienes quoted in Crist, *op. cit.*, 97.

ing that her family was descended in a straight line from President Monroe. Grace was capable of making up any story. Norma also wanted to change her first name. Lyon was happy with Jean Monroe, but, having listened to Norma's story, suggested "Marilyn." He himself was engaged to the actress Marilyn Miller, who had been abandoned by her father.

It should be pointed out that the name Marilyn Monroe sounds very much like Marion Monroe, the name of Norma's cousins' father, her uncle who had disappeared without a trace when she came to stay with his family at the age of eleven. This familial resonance with Marion Monroe certainly contributed to the choice of Marilyn Monroe's stage name. It is likely that Marion had committed suicide after having been wrongfully declared dead by his wife. Marilyn, therefore, is a name of survival. Her family had played too much at making people disappear, even to the point of declaring an absent husband dead when he was still alive.

II
MARILYN MONROE

2
THE FIRST CONTRACT WITH FOX

At the end of August 1946, her stage name chosen, Marilyn Monroe was quick to inform her dear friend André de Dienes and they set out together for a photo shoot in southern California. In these photos, one can already see the emergence of a newfound maturity and ease. In their first series of photos, done the previous year, Norma looked like an extremely fresh-faced young girl, but in naïve, sometimes silly, poses showing the same charming yet predictable smile with her head slightly lowered. In the new shots, Marilyn seemed more natural and showed more presence. The poses de Dienes demanded were varied, including her looking sleepy, pouting, regretful, joyful, enthusiastic, and, like "the end of everything," death itself.

De Dienes wrote, "...I began taking pictures of her, one by one, depicting the different moods she interpreted for me. An entire spectrum of life, depicting happiness, pensiveness, introspection, serenity, sadness, torment, distress—I even asked her to show me what she imagined 'death' looked like in her imagination. She threw a blanket over her head."[47] Marilyn said, "André, do not publish those photos now, wait until I die." This request seems to have stayed in the photographer's memory.

A contract with Twentieth Century Fox in hand, Marilyn started her acting career in Hollywood. 1947 and 1948 were strange years, filled with trial and error, confusion, and romantic turmoil. Marilyn had appeared in bit parts as a waitress in *Dangerous Years* and as a student in *Scudda-Hoo! Scudda-Hay!*, most of which was cut from the final version. But, at the end of 1947, her contract with Fox was not renewed.

She had already been taking classes at the Actor's Laboratory since January 1947. "It was my first taste of what real acting in real

[47] De Dienes quoted in Crist, *op. cit.*, 110.

Chapter 2

drama could be, and I was hooked," she later said.[48] At the Actor's Laboratory, they were developing socially committed theater, taking into account societal questions and the condition of the excluded and downtrodden.[49]

According to her biographers, during this period Marilyn went hungry and traded favors with unknown men in exchange for meals or in exchange for necessities (Spoto) or slept with those who could help her in the profession (Summers). In her autobiography, she describes how repulsive it was for her to exchange sexual favors in order to get introductions to influential people in Hollywood. However, later she told certain people that she had worked as a call girl to survive.

It's hard to distinguish what was true and what was not in the successive and differing accounts Marilyn herself gave of this period. Between what she said and what numerous other witnesses have said, nothing matches up. Each person sees things through the prism of their own interpretation of Marilyn's tragic destiny, more or less formulated in the aftermath of her death. If it was suicide, then it's psychopathology that wins out—but if it was murder, then it's political conspiracy. What is certain is that Marilyn answered questions differently depending on the person asking, the period, and the circumstances, without necessarily desiring to confuse the issue or muddy the waters. While aiming to avoid traps reporters set for her, she tried to convey a certain truth, one not reduced to the simple tabloid story standards. She wanted to open the discussion to a dimension more exact than the one in which those asking questions were always trying to corner her. Marilyn was very witty and had memorable comebacks when faced by aggressive and rapacious journalists who were always trying to reduce her to a simple and more degrading cliché.

When the English writer W. J. Weatherby asked her if the rumors about her call-girl past were true, she answered, "They can be. You can't sleep your way into being a star, though. It takes much, much more. But it helps. A lot of actresses get their first chance that way.

[48] Spoto, *op. cit.*, 122.
[49] The list of sponsors of the Laboratory was a real *Who's Who* of suspected Hollywood communists!

Most of the men are such horrors, they deserve all they can get out of them!"[50]

Why wasn't Marilyn's contract with Fox renewed in 1947? She was told that she wasn't photogenic enough: "Your type of looks is definitely against you."[51] She wrote about this, "I went to my room and lay down in bed and cried. I cried for a week. I didn't eat or talk or comb my hair. I kept crying as if I were at a funeral burying Marilyn Monroe.... That's the way you feel when you're beaten inside. You don't feel angry at those who've beaten you. You just feel ashamed. I had tasted this shame early—when a family would kick me out and send me back to the orphanage."[52] The shame involved when one feels rejected is a driving force in the invention of oneself.

Joseph Schenck, a prominent Hollywood figure and the former president of Fox, liked Marilyn's 'offbeat' personality and advised her not to give up. Two days later, according to Marilyn, Columbia was ready to hire her.

The biographer Don Wolfe highlights another element to consider.[53] According to his research, there are no remaining photos of Marilyn between June 1947 and March 1948. He suggests that this can be explained by her obscure dismissal from Fox and by the fact that she kept a low profile during this period. She was allegedly fired by the studio because she was pregnant. A crazy rumor was going around at that time, one that was later confirmed by Marilyn herself. She confidentially told several people close to her that, in her late adolescence and/or after her first marriage, she had given birth to a child. Her guardian, Grace, along with a doctor and a nurse, allegedly took the child for adoption, although Marilyn begged them to let her keep her baby.[54]

[50] Anthony Summers, *Goddess: The Secret Lives of Marilyn Monroe* (London: Phoenix, 1985), 51.

[51] Monroe, *op. cit.*, 74.

[52] *Ibid.*, 74, 75.

[53] Donald H. Wolfe, *The Assassination of Marilyn Monroe* (London: Little, Brown, and Company, 1998).

[54] *Ibid.*, 251–252. A girl named Nancy Maniscalco Greene, born in November 1947, was placed with a family of Sicilian origin in Brooklyn. This girl testified to *Hard Copy* in 1991 that her grandmother told her that the 'pretty lady' who often came to visit her was really her mother, Marilyn Monroe. The baby was placed with this family by the boss of the New York Mafia. The same Nancy is currently involved in legal arguments and battles that broke out over papers held by Cuzack, the Kennedys' lawyer. Three hundred pages, mostly handwritten, dealing with legal affairs between John Kennedy and Marilyn Monroe

Chapter 2

It is not possible to check the exactitude of any statements by biographers and, in any case, I do not wish to. However, such an event, real or imagined, could have crystallized as something possible, conceivable. It shows to what extent Marilyn told her own story, all the while preserving secrets that she could not keep entirely hidden.

It has been affirmed that, depending on her interviewer, Marilyn made up stories to reveal things, but also to hide things. Lying about an event such as the secret birth of a child obviously carries more weight than certain other stories about her unhappy childhood or about any of her lovers, stories all told with varying details. However, in her autobiography, she writes about this rather tumultuous period: "I was the kind of girl they found dead in a hall bedroom with an empty bottle of sleeping pills in her hand."[55] Is this a prophetic image of an anonymous young girl who is suffering, a girl whose illegitimate baby has been taken away because it was conceived during a secret affair with a powerful and influential man, a girl who is dismissed because she might be compromising?

Is this already a sign from a person desperately calling for help, trying to hang on, but hang on to what? One thinks of the empty pill bottle in her autobiography or the telephone off the hook at the scene of her death. At the most difficult moments, Marilyn was always trying to grasp something or someone for help—a hand, but one that was never there.

contain documents some of which concern a financial settlement in favor of Gladys, Marilyn's mother, and Berneice, her half-sister, for compensation for "unkept, fallacious promises from JFK to Marilyn." In a document handwritten by JFK, dated 1960, he evokes Nancy Greene and writes "MM wants to go public with it." Wolfe concludes that this astonishing statement means that "If this is so, John Kennedy was the father of the child!"

[55] Monroe, *op. cit.*, 79.

3
A UNIQUE SCREEN PRESENCE

In March 1948, Marilyn's contract with Columbia was signed and the studio suggested that she take some acting classes with Natasha Lytess. Marilyn's career took a new turn.

She fell in love with the musical director at Columbia, Fred Karger. He had her get a tooth straightened and insisted she move out of her little studio apartment to come live closer to him. He helped her with voice training to give more volume to her breathy timbre and also to help her with her terrible stage fright. Everybody loved Marilyn's joy and gaiety, her affectionate, intelligent, generous, and uncomplicated personality. Marilyn always knew how to make herself loved by a family, parents as well as children, and she knew how to make herself at home with ease wherever she was welcomed. It seems she gave much of her presence, which was witty and never conventional. She wanted so much for Karger to marry her, but he was already married and did not want to seek a divorce.

At that time, she was involved with Johnny Hyde, a rich and influential man in Hollywood—older than she—who really loved her and believed in her. He wanted to help her and, in exchange, he wanted her to marry him so she would be more comfortable financially. Marilyn accepted his help and his love, but refused the marriage-for-money arrangement. Hyde sent her to get plastic surgery, which gave a smoother line to her cheeks and nose. Marilyn apparently submissively agreed to these procedures, but they have never been proven. It is true that, at that time, her face changed significantly and her smile was forever changed. The signature feature of this metamorphosis was the appearance of a beauty mark on her left cheek, which dates from after 1949.

The young Norma Jeane's full-cheeked, charming, candid, and frozen smile disappeared from photos and gave way to a more mature smile, one that inevitably excites and sparks emotion. Marilyn's new contrived expression—blond hair, soft complexion, half-closed eyes,

and erotic smile—evokes pleasure, pleasure to come or pleasure already experienced. Marilyn's expression waits there, in suspension, at the point of enigmatic ambivalence where pleasure calls for pleasure. The Monroe smile, already visible in *Asphalt Jungle*, was forever immortalized by Andy Warhol in 1962 (just after her death).

From then on, Marilyn's fan base attained proportions beyond what movie star specialists ever deemed possible. It was this incredibly strong impact that provoked the rage and disdain of many of those who employed her, as well as the unbridled excitement of so many others.

Thanks to Hyde, Marilyn appeared along with Groucho Marx in a David Miller film, *Love Happy*, a madcap comedy. Her appearance lasts only a minute, a sexy blonde with a swaying walk. "Men are following me," she whispers, to which Groucho replies, "I can't understand why!" His answer makes his thick wiggling eyebrows seem even more hilarious.

And after that, her career stalled. Marilyn was out of work, but had to pay the bills. This is when she agreed to pose nude for an advertising photographer named Tom Kelly. He paid her fifty dollars so she could make her car payment. These magnificent photos appeared on calendars for the year 1953. Marilyn had accepted to do what no film actress should do at the risk of ruining her future career. She had asked that her identity not be made known and that the pictures be taken with the photographer's wife present. These calendar shots would become legendary and scandalous three years later.

In autumn 1949, Marilyn met the already famous photographer Milton Greene, with whom she immediately had a ten-day passionate love affair. Then, Johnny Hyde got her the role of Angela in John Huston's film *Asphalt Jungle*. It was a small role; the character was described in the script as someone "voluptuously made; and there was something about her walk—something lazy, careless and insolently assured—that was impossible to ignore."[56] Although Huston was not very enthusiastic about the choice of Marilyn Monroe, later, when the film turned out to be a huge box-office hit, he admitted that she had gotten the best out of the role.

[56] Spoto, *op. cit.*, 160.

Thanks to Hyde again, Marilyn played in *The Fireball*, directed by Tay Garnett, and then in *All About Eve*, directed by Joseph Mankiewicz.

In December 1950, her lover and fervent supporter, Johnny Hyde, died of a heart attack. All her friends and other eyewitnesses said she had a complete breakdown. His family did not want to include her to mourn along with Hyde's loved ones. Kazan, who met her at that time, said she was crying all the time. Shortly after, she was found unconscious as a result of a suicide attempt. Under the pillow, there was a little note in place of a will: "I leave my car and my fur stole to Natasha." Her pathetic fortune went to her acting coach. Even though she had always refused to marry Johnny, it seems she had remained faithful to him and had enthusiastically accepted his love and help. The Hyde family demanded that Marilyn leave her companion's home at once. Marilyn wrote that she had no money and was hungry, but she knew that:

> ...there was something wouldn't let me go back to the world of Norma Jean. It wasn't ambition or a wish to be rich and famous. I didn't feel any pent up talent in me. I didn't even feel that I had looks or any sort of attractiveness. But there was a thing in me like a craziness that wouldn't let up. It kept speaking to me, not in words but in colors—scarlet and gold and shining white, greens and blues. They were the colors that I used to dream about in my childhood when I had tried to hide from the dull, unloving world in which the orphanage slave, Norma Jeane, existed.[57]

Beyond any skill she might have had, this madness made up of colors held her in its grip and wouldn't let her go.

Thanks to Hyde, a photograph of Marilyn made the cover of the New Year's 1951 edition of *Life* magazine. She was presented as the new rising star. Before his death, Hyde had also negotiated an appearance for her in the film *As Young as You Feel*. Marilyn was to play a beautiful secretary, Harriett. It was an insipid film by Harmon Jones and Marilyn was despondent about the mediocrity of the role.

The photographer Sam Shaw, who knew Marilyn at that time, said of her, "Everybody knows about her insecurities, but not everybody knows what fun she was, that she never complained about the

[57] Monroe, *op. cit.*, 88.

Chapter 3

ordinary things of life, that she never had a bad word to say about anyone, and that she had a wonderful, spontaneous sense of humor."[58] Joe Schenck, a rich and famous Hollywood figure, also believed in her. He became close to her and, just as his predecessor had done, tried to marry her, but she refused. He campaigned for several roles for her, against the judgment of Darryl Zanuck, the president of Twentieth Century Fox, who did not give Marilyn much consideration, deeming her a mere second-class sexy starlet. However, thanks to Schenck, Marilyn signed a seven-year contract with Fox. What is extraordinary is that the studio also hired Marilyn's acting coach, Natasha Lytess, paying her more than they did Marilyn.

Marilyn had met Elia Kazan on the set of *As Young as You Feel* and they began a love affair that lasted throughout the time that Kazan shot *Viva Zapata* in Hollywood. He was married, but that seemed to pose no obstacle to their romance. In his memoirs, he wrote:

> When I met her she was a simple, eager young woman who rode a bike to the classes she was taking, a decent-hearted kid whom Hollywood brought down, legs parted. She had a thin skin and a soul that hungered for acceptance by people she might look up to. Like many girls out of that kind of experience, she sought her self-respect through the men she was able to attract.[59]

She was usually dressed in white and kept a white concert piano at home, like the one she'd had in her youth. However, Kazan noticed a contradiction, which he deemed 'fatal': "She deeply wanted reassurance of her worth, yet she respected the men who scorned her, because their estimate of her was her own."[60] Kazan and Marilyn had much fun together; her lover was her savior. At a party in honor of the Pulitzer Prize winner Arthur Miller, Kazan introduced her to his friend Arthur, who was immediately smitten. Marilyn beamed with joy over meeting a man who treated her gently and, even more, who spoke to her about his own personal troubles. Miller and Marilyn seemed to be in love. Kazan, seeing Miller tortured by an unhappy marriage and by his attraction to Marilyn, decided that "...If Miller came back, I'd

[58] Spoto, *op. cit.*, 180, 181.
[59] Elia Kazan, *A Life* (New York: Knopf, 1988), 404.
[60] *Ibid.*, 407.

yield...."⁶¹ He did think, however, that "Marilyn simply wasn't a wife. Anyone could see that.... Marilyn was what she was, a delightful companion. A delightful companion is a delightful companion, not a wife."⁶²

In the spring of 1951, Marilyn played the role of a provocative blonde in *Love Nest* by Joseph Newman. According to Spoto's biography, she had once again been cast to liven up an uninteresting scenario. When Marilyn appeared on the set in a polka-dot bikini, "...the whole crew gasped, gaped and almost turned to stone... she grabbed the entire picture." The journalist Ezra Goodman didn't even bother to talk about the flop *Love Nest*, but he raved about Marilyn: "...one of the brightest up-and-coming [actresses]."⁶³ *The New York Times* reported about her performance in *As Young as You Feel*: "Marilyn Monroe is superb as the secretary." The public clamored for her, but Zanuck continued to ignore her and the studio did not give her any serious backing.

It was all because of her natural, personal star quality that her success on screen was so phenomenal. She wrote, "I knew I belonged to the Public and to the world, not because I was talented, or even beautiful, but because I had never belonged to anything or anyone else. The Public was the only family, the only Prince Charming, and the only home I had ever dreamed of."⁶⁴

"Never really belonged to anyone" added another dimension to her undeniable aesthetic ideal and the acting skill she had honed. The public was moved by the fact that she was an unknown, that she came from nowhere with no ties, with a certain frailty where there might rather have been the affirmation of an iconic beauty. The public imagined they detected a presence underneath the painted-on-features—a demonstrative, moving, instructive, comical, dramatic presence. With Marilyn, it wasn't the success of her made-up image that had such an impact, but rather what was revealed by that image. It was something other, something shifting, something that she produced through her existence, her work, in real life, in the presence of the public. It was a sort of 'madness' set in motion by something not seen. Marilyn was

⁶¹ *Ibid.*, 416.
⁶² *Ibid.*, 415.
⁶³ Quoted in Spoto, *op. cit.*, 187.
⁶⁴ Monroe, *op. cit.*, 159.

the consummate artist of this new original performance, one that surpassed any conventional styles of staging, poses, or predictable cosmetics. She knew how to be true to this transformation and how to unfailingly bring it to life.

At the heart of her performances, Marilyn appeared larger than life and gave generously of herself. She invented her own understanding of the situation for her roles in movies as well as for photographs, those taken for advertising, for interviews, or from her private life. She was sometimes too provocative, her curves shown so explicitly, her dress so low-cut and tight around her bottom, her breasts perched so high, her smile so fresh-faced, her heels so high, her voice so soft and low, her laugh so scintillating, her look so sad, her walk so swaying, her expression so distant, herself so naked beneath her bathrobe. Marilyn gave off such spontaneity and life—there was something so natural and dynamic in the style of her overacting that those who were affected by it became completely hooked. Something familiar broke through the screen, pierced through the illusion of her perfect image, and changed the fictional image into something fleetingly erotic. Marilyn made people fall in love with her. She realized it fairly early on, without understanding exactly how she managed to produce such an effect. She knew it had nothing to do with her beauty or her acting, yet she was careful to manage it, to control it. She slowly built her image, carefully constructing all the details, and, by transforming artifice into extreme mastery, she revealed herself as something completely different, never before seen. She said she wanted to be "just wonderful." She was certain that she had a different kind of power and needed to constantly master its impact and control its force. Even with such power, she remained extremely modest—she saw in it a form of generosity, something that might bring about an existential brotherhood among people, across cultures and races, particularly among the downtrodden and the poor or disenfranchised.

Marilyn was already aware of her uniqueness, even though she had only played small parts—sexy dumb blondes—and she definitely was not dumb. She lit up the screen; you simply couldn't take your eyes off her. The way she constructed the spellbinding image—visible everywhere—also conjured something beyond what could be seen.

But Marilyn was quite determined to be more than just the effect she produced. She wanted to take advantage of her impact on people to become a true movie actress, respected and accomplished.

4
THE SENSATIONAL CALENDAR PHOTOS

Throughout 1951, Marilyn was becoming more and more popular without ever having played a major role in any movies and without the help of Fox. She wanted to become a great professional actress and so took more acting classes and attended more readings. Natasha Lytess was her main acting coach, but she also took classes with Michael Chekhov, the Russian nephew of Anton Chekhov. He found her reserved and shy and helped her develop her acting potential through work on diction, body movement, and breathing. At the same time, Marilyn seemed to be gripped more and more by extreme fear whenever she had to act or to appear in public. She took hours to get ready, to get her make-up just right, to dress, to work on her role. She simply could not manage without Natasha, even though Natasha herself knew she was not indispensable and that Marilyn was a marvelous actress, sometimes with exceptional instincts. Yet Marilyn needed her coach beside her whenever she went out. She needed confirmation from Natasha that her acting was good or advice from Natasha if it was deemed not good enough. The more Marilyn worked at constructing her roles, the less self-confident she was and the more dependent on her teachers she became.

In several important press articles accompanied by photos, she was compared first to Lana Turner and then to Joan Crawford. She had a small role in *Let's Make It Legal*. The critics all agreed that the story was without interest, but that Marilyn was 'amusing.' She was imposed on Fritz Lang for a supporting role in his film *Clash by Night*. The film was austere and gloomy, but many people flocked to see it just to see Marilyn, whose presence livened up the dismal story. She was physically ill before the filming of every scene and she fought with Lang to be allowed to keep her acting coach with her. She was constantly late, couldn't remember her lines, and was very demanding for every detail. Barbara Stanwyck, a respected actress, said of her, "She wasn't disciplined and she was always late, but there was a sort of mag-

ic about her which we all recognized at once."[65] Journalists rushed to the set to interview Marilyn. She feared them and wanted to speak only of her career. When the film was released, *The World Telegram and Sun* reported, "a forceful actress [and] a new gifted star.... Her role is not very big, but she makes it dominant."[66] From New York, Fox shareholders complained that the studio wasn't giving any real roles to Marilyn. Zanuck could no longer hold her back.

Zanuck finally offered Marilyn a major role in the film *Don't Bother to Knock*. She was directed by the English director, Roy Baker, who disdained her even more than Lang had. Yet he kept the first takes of every scene in spite of Marilyn's protests. She was terrified, but she was doing a terrific job of improvising a very difficult dramatic role. She plays Nell, a young girl who is released from a psychiatric ward and who takes a job one evening in a hotel babysitting for a little girl. In the hotel, Nell is approached by a man, played by Richard Widmark. She mistakes him for her fiancé, a pilot whom she had loved and who is now dead. Marilyn plays Nell with restraint and talent. She wears little make-up and she shows, in turn, expressions of joy, fear, expectation, desire, terror, madness, and love. In black and white, Marilyn conveys the range of Nell's tormented emotions with delicacy and great precision. Finally, Nell, overcome by madness, ties up the little girl so she can leave the hotel and find her lost love. In the end, she must return to the psychiatric hospital. Marilyn is excellent in the film. Richard Widmark said, "We had a hell of a time getting her out of the dressing room and onto the set. At first we thought she'd never get anything right and we'd mutter, 'Oh, this is impossible—you can't print this!' But something happened between the lens and the film and when we looked at the rushes she had the rest of us knocked off the screen!"[67] Here, she was the complete opposite of a sex symbol.

She said, "I wasn't sexy... I've been made to be... but deep down inside it's not me."[68] In her appearances, she assumed a role—the popular conception of a sexy woman. But the presence she projected actually derived from some other, loftier realm. She was misunderstood by her detractors, who labeled her as cheap, even whorish.

[65] Quoted in Spoto, *op. cit.*, 195.
[66] Quoted in *ibid.*, 195.
[67] Quoted in *ibid.*, 198.
[68] Lembourn, *op. cit.*, 92.

Journalists were starting to dig deep into her private life to find tidbits that would fuel her celebrity. The studio was impressed by the fact that she received thousands of letters from fans and admirers. Marilyn took on a business manager, Inez Melson, and entrusted her to be the legal guardian of her mother Gladys. Gladys no longer wished to take care of her own affairs and Marilyn wanted to provide for her mother without necessarily wanting to see her.

Zanuck gave Marilyn two new supporting roles, eternally the sexy dumb blonde. The first was the role of a secretary in *Monkey Business*, directed by Howard Hawks and starring Cary Grant. The second, in *We're Not Married*, was the role of a wife and mother who, having won the Miss Mississippi beauty contest, learns that her marriage is, in fact, not legal. This role was written with the sole purpose of showing Marilyn in a bathing suit. Hawks remarked, "The more important she became, the more frightened she became..."[69]

She appeared for one minute as a well-dressed prostitute in *O. Henry's Full House*. In the film, a tramp leaves her his sole possession as payment: an umbrella. A policeman happens by and questions her and she breaks out in tears as she answers: "He called me a lady!" It is a touching and tender scene.

On April 18, 1952, her contract with Fox was renewed with a raise: she was paid $750 per week for a year, one of the lowest salaries at the time for a leading actress. It is remarkable to note that Marilyn was always very badly paid by the studios. She was becoming a major star, adored by the public and generating enormous income for the studios. And yet, they continued to disdain her by giving her pathetic roles, which frustrated her greatly, but which she played brilliantly. What is more, her work was not recognized for its true worth and she was always short of money. Besides taxes, she paid dearly for her teachers (for acting, voice, and dance), her hairdressers, housing, her agent, and upkeep for her mother. To add to this, she was so generous that she was always giving extravagant gifts to all her friends. For example, she gave a Cadillac to Natasha Lytess. Money slipped through her fingers.

During the course of 1952, Marilyn was charmed by the advances of the great baseball champion, Joe DiMaggio. The undisputed sports

[69] Quoted in Spoto, *op. cit.*, 200.

Chapter 4

star of Sicilian origin had just retired from baseball. Marilyn was moved by the attention he paid to her, by his serious intentions and his wish to start a family, but she was still seeing other men. Biographers evoke Robert Slatzer, a journalist, with whom she allegedly had a romantic escapade culminating in a quickie marriage in Mexico. The marriage was annulled as soon as the effect of the champagne wore off.[70]

At this time, the journalists, so hungry for details about Marilyn's past, dug up the calendar for which she had posed naked for Tom Kelly in 1949. Two of the photos are very famous: one shows Marilyn totally nude, posed erotically with her legs curled up beneath her and her face half hidden behind her arm. Her hair falls in long, loose curls and there is a smile of joyous pleasure on her face. The other photo shows Marilyn from the side, stretched out on a red velvet sheet. Her body is slender and graceful, her head turned toward the lens as if in a moment of ecstasy. Fox was panicked by the rumors about these photos and advised her to categorically deny their existence. It was the period of McCarthyism; the censors could bring her down and, with her, the considerable financial capital she represented for Fox. She refused to be intimidated and quite cleverly and trustingly told the true story about the photos. Pretending to ask for advice, Marilyn confided in reporter Aline Mobsby, who quickly published the news in the *Los Angeles Herald Examiner* under the heading, "Marilyn Monroe Admits She's Nude Blonde of Calendar."

The story related that Marilyn had done it because she needed the money. She had accepted to pose anonymously in exchange for fifty dollars under the condition that the photographer's wife be present for the shoot. Marilyn explained that she thought no one would recognize her and that she simply did not know how to lie. She begged to be understood and forgiven. Interviewed often about this, she would answer differently depending on the interviewer. She said, "I've been on a calendar. I don't want to be just for the few, I want to be for the many, the kind of people I come from. I want a man to come home after a hard day's work, look at this picture, and feel inspired to say,

[70] This story, while disputed, may well be true. It was alleged to have happened at the end of 1952 and is told by Robert Slatzer himself in his book *The Life and Curious Death of Marilyn Monroe* (London: W.H. Allen, 1975).

'Wow!'"[71] Marilyn was truly a girl of the people, far removed from the false puritan furor of the time.

To other journalists who aggressively asked what she had put on for the famous calendar shoot, she answered, "the radio." It was so like Marilyn to answer cleverly in a spontaneous way rather than to carefully work out her answer beforehand.

Aline Mobsby's article was reprinted in all the papers, both in the US and in Europe. What Fox feared would be a disaster was transformed into a victory for Marilyn alone. It might not be decent to show your naked body for money, but it certainly is honest to do anything you can to be able to pay the bills, even if it means accepting to pose for nude photographs while insisting that the photographer's wife be present. Then it becomes a question of self-sacrifice. And it certainly took courage to tell the truth to all the public and not be ashamed for what she had done. She was nude for all the world to see, but without having sinned. Marilyn beat the puritans at their own game and she was adored for having done so.

DiMaggio was unhappy about this calendar incident and acted irritated each time Marilyn pulled off another triumph when speaking about it. It must also be remembered that she knew nothing about sports or baseball and that he disliked both Hollywood and the movies. The calendar photos were published everywhere—Joe remained distant.

In the spring of that year, the filming of *Monkey Business* was interrupted because Marilyn came down with appendicitis. She wanted to postpone an operation, but finally had to have an appendectomy on April 28, 1952, at the Cedars of Lebanon Hospital. The surgeon was astounded to find a note taped to Marilyn's lower abdomen. It read, "Dear Dr. Rabwin, *Cut as little* as possible. I know it seems vain but that doesn't really enter in to it. The fact that I'm a *woman* is important and means much to me.... For Gods sake Dear Doctor No ovaries removed.... Thanking you with all my *heart, Marilyn Monroe*."[72] Was she really afraid that, since the appendix was so close to the ovaries, the doctor might end her chance to become a mother? Rabwin worked along with a gynecologist during the operation in order to reassure his

[71] Quoted in Spoto, *op. cit.*, 213.
[72] Quoted in *ibid.*, 218, 219.

Chapter 4

surprising patient. This episode shows how much Marilyn feared that she might be wrongly deprived of the possibility of having children. This was a naïve and working-class fear of the almighty power of doctors, to think that while the patient was under anesthesia the doctor might go too far. One could surmise that Marilyn had a worried desire to have children.

It was right about that time that DiMaggio began talking with Marilyn about starting a family. He sent masses of flowers to the hospital before she even got there. She left the hospital on the arm of her faithful friend, Allan Snyder, whom she had called to come do her hair and make-up. At that time, she asked Snyder to promise her that he would do her make-up the day of her funeral, which he did.

The reporters had sniffed out her mother, Gladys, who had remarried and whose husband had just died. Marilyn had previously led reporters to understand that she was an orphan. Faced with these sensational new reports about her mother, Marilyn did not back down. She explained that she had hardly lived with her mother at all. When she was little, Marilyn had been told that her mother had died in an accident and she had allowed this version of her story to be told. Then she explained that she wanted to respect her mother's desire to "remain anonymous." She declared to one journalist, "We have never known each other intimately and have never enjoyed the normal relationship of mother and daughter. If I have erred in concealing these facts, please accept my deepest apologies and please believe that my motive was one of consideration for a person for whom I feel a great obligation."[73] She did not want it known that her mother had been "mentally ill," so, by keeping her mother unknown, both she and her mother were protected from attack by reporters who were always looking for lurid and simplistic stories on the theme of abandonment and madness.

This "respect for anonymity," formulated under the guise of maternal protection, was more elegant than just a wish to hide the facts. Yet again, Marilyn had found a way to publicly deal with details about her life. She was named Monroe, like her mother, and she was free to write her story the way she wanted.

[73] Quoted in *ibid.*, 217.

5
NIAGARA AND DIMAGGIO—MARILYN AFFIRMS HER UNIQUENESS

At a concert for soldiers at Camp Pendleton, Marilyn brought the house down with the sensual song "Do It Again." She excelled with her unique, whispered voice, almost as if she were near fainting or completely exhausted. Her voice evoked intimacy, privacy, secrecy. The soft voice was sometimes accompanied by a slight whimper, which added a little touch of irony, all her own. There was a veritable uprising of delight for her. The press couldn't stop talking about her: articles, photos, magazine covers, films, reporting about her love affair with the great champion DiMaggio. At twenty-six years old, she was the talk of the town, featured non-stop in the press.

Philip Halsman photographed Marilyn at that time in a very low-cut white dress. She is in the corner of a room, trembling, innocent, surprised, with an air of fleeting sexual availability. These famous photos reveal an incorrupt sensuality, expressed as limitless self-sacrifice. It is a sweet mastery over the terror of sex. She allegedly told Hans Jorgen Lembourn, "I would like to make sex into love, to make sex into something that's not corporeal...."[74]

Fox offered her a role in the Technicolor film *Niagara*, directed by Henry Hathaway. It is an oppressive film of muggy eroticism filmed with Niagara Falls as the backdrop. She plays Rose, a voluptuous wayward wife who plans to kill her husband (Joseph Cotton) with the help of her lover. It was during this film that Marilyn took advantage of a broken heel on her shoe to develop her swaying walk. She has such a suggestive walk that it becomes comic, shifting eroticism into a parody of the feminine gender, a man-trap. This exaggeration becomes fun and attractive. It makes the viewer reflect back to the ever-present clichés of eroticism and thus renders these clichés rather ridiculous.

[74] Lembourn, *op. cit.*, 178.

Chapter 5

In an atmosphere of danger, dampness, and the roaring waterfall, Rose indulges in her clandestine passion for her lover and becomes determined to do away with her husband. But just as her lover is trying to kill him, her husband discovers the scheme, kills her lover, and then kills his wife. Once again, when Marilyn is given a real leading role, not just that of a seductive birdbrain, she proves she can play it perfectly. She embodies the erotic energy in her destructive power. Hathaway remarked, "She never had any confidence, never sure she was a good actress. The tragedy is that she was never *allowed* to be."[75] This film established her reputation. She hums the song "Kiss," which she had especially requested for the film. The scene where her husband breaks the record was added at the last minute because a representative of the Woman's Club of America had visited the film set. This person had been outraged by the character of Rose, but without realizing it, in pointing out the scene, she brought to everyone's attention just how talented Marilyn was as she sang the suggestive, sensual song. That side of Marilyn had to be offset by a violent fight scene. Hathaway said of Marilyn, "She was the best natural actress I ever directed... *bright*, just naturally bright. But always being trampled on by bums. I don't think anyone ever treated her on her own level. To most men she was something they were a little bit ashamed of—even for Joe DiMaggio."[76]

It seems that what Hathaway said was true. The exceptionally strong point in Marilyn's art is that she displayed clearly and openly the extravagance of the simple fact of being a woman. In the US of the 1950s, there was a move to free women from the guilt of sex, but eroticism had to be shown as comical, light, in keeping with married life, a kind of amusement. The studios saw that Marilyn sparked an unprecedented vibration, but they feared what she embodied to be low-class, the dark side of eroticism, its lewd force for destruction. In fact, this is exactly where Marilyn excelled as a "natural" actress. She was exploited as a glamorous plaything, both happy and damaged, but she was not recognized for her ability. What she could do in her "natural" acting was to combine eroticism, love, and the dimension of the terror of sex that she knew how to convey so pertinently.

[75] Quoted in Spoto, *op. cit.*, 220.
[76] Quoted in *ibid.*, 221, 222.

Marilyn wanted to marry and have children. When she realized the cultural demands of Joe DiMaggio's Sicilian family, she officially declared that she wanted to become a housewife and that she would be truly fulfilled once she had started a family. The simple fact of announcing it publicly gave her plan an unconventional, satirical dimension. Joe asked her seriously if she would consider giving up her career. However, Marilyn did not want to have to choose between her career and a family life; she wanted them both. It was this refusal to choose one or the other that had made her end her first marriage, even if, in the beginning of her career as a single girl in Hollywood, she had to pay a high price because of the sometimes sordid and misleading aspects of the unforgiving movie industry. Now she was famous and this would be the marriage of two great stars. She wanted to build on her great celebrity through public appearances, photos, and films, while at the same time experiencing a great love affair as a wife and mother. She wanted to live the great feminine American dream *par excellence*.

While going through this dilemma privately with Joe, she continued to surprise and to defy expectations. She read a play live on the radio. In an interview, she declared that she never wore underwear: no bra, no underpants. "I like to feel unhampered,"[77] she said. Hathaway had suggested she wear her own clothes for *Niagara*, but she said she had hardly any clothes of her own, only a sweater and two pairs of trousers. She borrowed from the studio all her clothes for her roles as well as her outfits for appearances. Marilyn must never have learned how to buy clothes for herself, a sort of habit carried over from her childhood, a holdover of the one blue dress supplied by the orphanage. The studio, a new version of the orphanage, supplied her clothes. When, as Hathaway had suggested, Marilyn went to buy clothes, she shocked the salesgirls by being totally naked in the dressing room. Many people repeated this amusing anecdote that highlights a singular, original aspect of Marilyn. She might seem dirty or provocative by trying on clothes in a virtually public place with no underwear on!

Marilyn maintained that having nothing, belonging to nobody, being naked and free to be what she wanted to be was her form of freedom.

[77] Quoted in *ibid.*, 224.

6
EVERYONE'S FAVORITE STAR

It was decided that Marilyn would act along with Jane Russell in *Gentlemen Prefer Blondes*. Although her salary was raised for the film ($15,000), she was still earning ten times less than Russell ($150,000). Whereas she was the number-one box-office star, her earnings were still kept shamefully low, as if she were not considered someone to be respected. A girl from the lower working class shouldn't be paid much, and Marilyn was nothing other than that.

Lorelei is a lovely singer, crazy about diamonds and hypnotized by precious gems. She is engaged to a very rich young man whose father does not approve. Her friend Dorothy must play the chaperone on a test trip to Europe. Marilyn, as Lorelei, added a few personal touches to the script. For example, when her fiancé's rich father says to her, "I thought you were dumb!," she came up with the answer, "I can be smart when it's important, but most men don't like it!"[78] Both actresses are excellent in this light musical comedy, which makes a mockery of love for money as well as clichés of macho seduction. In the film, Marilyn does her legendary performance of "Diamonds Are a Girl's Best Friend." She knew how to play up the offbeat irony of male/female issues and she conveyed this well in the song. She maintained that it was she, the blonde, whom men preferred, and yet she was paid much less for the film than the brunette Jane Russell!

By the end of 1952, Marilyn had succeeded very well in establishing the image of a spirited woman of her time, an image she had carefully crafted. She was the calendar star who could rouse crowds with her 'Lolita' voice and her vibrant beauty. She excelled at parodying her own image, and yet she was unhappy and admitted that she wanted more.

[78] Quoted in *ibid.*, 229.

Chapter 6

At the beginning of 1953, DiMaggio made a deal with her. He demanded that she no longer wear low-cut dresses in public. He hated her acting coach, as did most of the people who had worked with Natasha Lytess. He started a campaign to wean Marilyn of her dependence on this woman whom he felt to be totally unnecessary and costly.

Next, Marilyn played in *How to Marry a Millionaire*, directed by Jean Negulesco. The film was designed solely to showcase the most famous stars of the moment—Betty Grable, Lauren Bacall—in a comedy that would be a box-office hit. The scene where Marilyn sleeps in the nude under a simple sheet caused a sensation. Her boldness won her unimaginable success; she was inundated by thousands of fan letters, countless articles in the press, photographs, and interviews.

Fox offered her a role in *River of No Return*, directed by Otto Preminger. Once again, the film was designed solely to make money and the scenario was simply a string of clichés. Marilyn acts with Robert Mitchum in a setting of magnificent scenery. She is on a raft, courageously and uncomplainingly enduring surges of whirling rapids, all the while heavily made-up and sexily clad in tight blue jeans. The shooting was extremely physically demanding and called for a considerable amount of stamina. She sang with great style the songs "One Silver Dollar," "I'm Gonna File My Claim," and "Down in the Meadow." Preminger could not tolerate Natasha, who, he said, only pushed Marilyn to do multiple, and more or less unnecessary, takes and who contributed to making the atmosphere on set unbearable. Everyone agreed that Natasha reinforced Marilyn's yearning to be perfect and therefore contributed to her incurable anxiety about her worth as an actress. However, Marilyn must certainly have needed Natasha. Perhaps she embodied the gateway to this other exaction, this 'sort of madness' that Marilyn never stopped seeking.

During filming, Marilyn injured her leg and had to be flown to L.A. at once, where the film was later finished in the studio. When the plane touched down, the crew and Mitchum had to fend off a crowd of waiting reporters. Somewhat peeved, Mitchum remarked, "... she thought they were cheering for someone else!"[79]

At that time, Kinsey's famous study, *Sexual Behavior in the Human Female*, came out, the second volume after *Sexual Behavior in*

[79] Quoted in *ibid.*, 246.

the Human Male. The press tied Marilyn's success to the results of the Kinsey study. The study reported that "more than half of the country's women were not virgins at the time of marriage; fully a quarter of married women had extramarital affairs; and, most astonishing of all, women were indeed enjoying sex."[80] The book sparked controversy in the press and was threatened with censorship, but it did not cause as much reaction in Europe. What it meant in America was: it had to be admitted openly that women had sexual desires, that they aspired to certain freedoms, and that Marilyn's success embodied these 'revolutionary' discoveries—she was the emblematic image of all of this.

At the same time, Zanuck offered Marilyn the role of a teacher who becomes a music hall singer in the film *Pink Tights*. She did not want to do the film and hoped to shake things up at Fox. Joe encouraged her in this because he realized how hugely successful she was and how much money she was making for her employers. He came up with a strategy, which involved waiting to negotiate until the exact time when the results of her latest hit films were published. The first of her demands was to be able to read the script before she agreed to do a film. Apparently, she was very nervous at the idea of refusing anything to Zanuck. She worried about not having any money if he suspended her, but her new agent, Charles Feldman, and DiMaggio both urged her to stand firm.

Marilyn wanted to earn more money, make fewer films, and have final choice of director as well as director of photography. Joe was solid as a rock and determined to back her up. She was terrified at the idea of a confrontation. At Christmas, Joe gave her a 'black mist' mink coat in a show of his moral support.

She received notice to report to begin filming *Pink Tights* on January 4, 1954, but Joe advised her not to go. As a result, she heard about her suspension from the studio from a reporter. Feldman asked Marilyn to sit tight as he wanted to wait and negotiate when the box-office figures from her latest films were made public. Joe once again asked her to marry him and this time she agreed. She made sure to sneak the information to a few members of the press. They wed very soon after, on January 14, 1954. She wore a dark dress with a white ermine collar, simple and absolutely charming. When asked how many

[80] *Ibid.*, 248.

Chapter 6

children she hoped for, she replied, "six." Joe said he wanted to start with one. The two stars were surrounded by several members of Joe's family and were hounded by the press when they left San Francisco City Hall.

When Zanuck heard about Marilyn's marriage to Joe DiMaggio, he lifted her suspension, but demanded she come to the studio no later than January 24. The two newlyweds had to sneak out of San Francisco and find refuge in a nondescript hotel room so they could lose the pack of paparazzi on their trail. After a ten-day escapade in the snow, they came home. Zanuck knew Marilyn had complained about not seeing the scripts before filming, so he had the one for *Pink Tights* delivered to her home. After she read it, she refused to show up for filming and had her lawyer announce, "She has read the script and does not wish to make the film." She was suspended once again.

Thus began a period of very complicated negotiations with Fox. Zanuck agreed to accord her some 'symbolic' favors, but he was determined to be the sole judge when it came to deciding on her partners and which script would be chosen for each film. Feldman feared Marilyn's moods, especially since he knew he would be paid only after her film contracts were signed.

Joe invited his young wife to accompany him for baseball training in Japan. This was the perfect excuse to make Marilyn unavailable to begin filming, as she was being constantly hounded to do so. Feldman wanted to hold out for more time. When the couple took off for Japan via Honolulu, the press noticed that Marilyn had a broken thumb. She elegantly declined to answer any questions, but it was suspected that her 'bruiser' husband might have pushed her a little too hard during a domestic spat. When they arrived in Tokyo, the crowd hardly noticed DiMaggio, but Marilyn was so swarmed that they had to exit the plane through the baggage hold, surrounded by policemen. The beautiful lady's great success overshadowed her husband, even though he too was quite a star.

While Joe had sports commitments to fulfill, Marilyn was asked by the Far East Command to visit American troops stationed in Korea for an improvised concert. Marlene Dietrich was also invited. Joe was opposed to the idea, but military authorities were insistent and Marilyn was enthusiastic, so he gave in. On February 8, dressed as a sailor, she flew to Korea in a military helicopter. She asked the pilot to fly low so she could show her luminous features and wave to the enthusiastic

soldiers below. Marilyn was greeted with thundering accolades and endless ovations. She sang at least twelve times and stood on makeshift scaffolding to perform her famous "Diamonds Are a Girl's Best Friend," "Do It Again," and other songs. These performances drove the troops into a frenzy. It is said that she was beautiful, happy, sexy, generous, and that she was enjoying herself immensely. She was afraid of nothing. She was simply "very happy," she said. Sixty-thousand men were carried away by her charm, her talent, her magical simplicity, her exuberant vitality, her bloom. When she got back home and the press asked her about her trip to Korea and how she had felt there, she replied with her usual wit, "Safe!" And when they asked her if her way of walking was natural, she replied, "I've been walking since I was six months old!" What fur are you wearing, they asked. She replied, "Fox—and not the Twentieth Century kind!"[81]

Marilyn always remembered her experience in Korea as an extraordinary one, where, she said, "I felt I belonged," in front of an audience who was "accepting me and liking me."[82] She had actually found her stride in these improvised performances. She showed herself to be a brilliant show-woman, without her acting coach or her husband, who was busy elsewhere. In Korea, she suffered no stage fright, didn't fluff her lines, felt perfectly at ease. Alone with her public and her sponsors, Marilyn knew how to perform and to show how talented she was. It was her own self-imposed insistence to be a great dramatic actress that suffocated her with anxiety and inhibition.

On February 24, Marilyn came alone to collect the Oscars for *Gentlemen Prefer Blondes* and *How to Marry a Millionaire*. She was dressed in white satin and her honey-blond hair had turned to platinum.

On March 31, Marilyn signed with Famous Artists and left the William Morris agency. Fox officially gave up on demanding she appear in *Pink Tights*, but insisted she take a supporting role in *There's No Business Like Show Business*. They also offered her the leading role in *The Seven Year Itch*, directed by Billy Wilder and co-produced by Wilder and Feldman. A new contract would start in August 1954 and she would receive a bonus of $100,000 for *The Seven Year Itch*. Marilyn realized once again that she would make much more money for

[81] Quoted in *ibid.*, 263.
[82] *Ibid.*, 266.

Chapter 6

others than she would for herself. Also, she did not have entire artistic freedom, even if she had obtained payment for her acting coach and for her professors of voice and dance.

In May, the suspension was lifted and she diligently came to work on *There's No Business Like Show Business*. Marilyn appears as the coat-check girl who is given the opportunity to sing and dance—yet another film where she appears as the poor girl from nowhere who ends up in mundane, insipid music hall scenes, dressed in over-the-top outfits. That summer, she endured chronic bronchitis, which she had picked up in Japan, and she also suffered from the effects of the many sleeping pills she was taking. She sometimes showed up on set shaky and unsteady, in a mental fog. She was unhappy both in her marriage (Joe was extremely suspicious of everyone she met on set and probably beat her) and in her life as an actress (she disliked her roles and was underpaid). Joe sensed that she was having an affair with Hal Schaefer, who rehearsed her songs with her, because she had been so constantly at his bedside when he had tried to commit suicide. Joe had her followed. And during the filming of *There's No Business Like Show Business*, he was on set when Marilyn performed her erotic dance as the flirty, teasing girl trying to convince the producers of the film within the film. In her inimitable voice, she performed with brio the songs "After You Get What You Want, You Don't Want It" and "Heat Wave." It is said that, after the take, she rushed into Joe's arms, but he pushed her away violently, insulted everyone on the set, and then left. When Marilyn had to be on camera again, she had completely lost her composure.

7
AN EXCEPTIONAL ACTRESS

We should recall that Marilyn had accepted to do *There's No Business Like Show Business* only because that allowed her to do *The Seven Year Itch* in New York in September 1954.

Marilyn arrived in New York alone, wearing a tight-fitting wool dress. She was awaited once again by a mob of reporters and she gave interviews and a press conference in the offices of the *Daily News*. In spite of some charming and funny moments in the film, it rather boringly recounts a story of temptation between a man who has been married for seven years and a young anonymous woman who is quite naïvely mischievous. It takes place during a sweltering hot New York summer, where the characters make cool commentary on subjects from air conditioning to psychoanalysis. The main interest of the film lies essentially in the scenes where Marilyn appears. The one that was heavily publicized is where Marilyn stands over a subway grate and her pleated white skirt billows up in the air. The scene was shot between 1 a.m. and 4 a.m. on the corner of Lexington Avenue and 52nd Street. In fact, special effects were used to blow her skirt up and reveal her demure white panties. Marilyn is charming in the scene, where she is supposed to react as a modest young woman who laughs about this surprising mishap. A crowd gathered around to see the incredible spectacle, which had been dreamed up by the photographer Sam Shaw. But someone had the great (unfortunate) idea to casually invite Joe DiMaggio, who was passing through New York at the time, to come watch his wife on location without warning him about the scene. This initiative must surely have come from a well-meaning friend who wanted to fan the flames of Joe and Marilyn's romance. Joe showed up and discovered his laughing wife surrounded by a crowd of frenzied gawkers with her skirt blown up around her, her bare legs showing. In a rage, he beat her that very night and, two weeks later, she asked for a divorce, which he wanted to avoid at all costs. In fact, the final scene that was used was actually shot in the

Chapter 7

studio and one can barely see her legs and can see nothing of the white panties.

Hundreds of photos of the scene show Marilyn laughingly surprised, modestly trying to hold down her skirt. These photos were seen around the world and they are still today fixed in our living memory, even though the pose does not even appear in the film. In fact, Marilyn's role in the film had much less of an impact than the photos did. This incident is significant to the Marilyn Monroe phenomenon. Here, once again, her carefully orchestrated image bursts out of these photographs, even more intense than what she conveyed through her films. The viewer feels her exceptional vitality, the 'my panties are showing' smile every girl in the world knows about. It's a big joke!

The horrible night Marilyn endured after filming the scene was followed by a bout of pneumonia and filming had to be delayed. Everyone was very upset and Billy Wilder knew that the success of the film depended entirely on Marilyn's presence.

Wilder spoke of Marilyn's "flesh impact":

> [S]he looks on the screen as if you could reach out and touch her, she's a kind of real image, beyond mere photography. But there's something else too, she had a natural instinct for how to read a comic line and how to give it something extra, something special. She was never vulgar in a role that could have become vulgar, and somehow you felt good when you saw her on the screen. To put it briefly, she had a quality that no one else ever had on the screen except Garbo. No one.[83]

She had a natural talent for fiction.

At the beginning of October, Marilyn announced that she was filing for divorce. She wanted to make an announcement worthy of her public image. To the hordes of reporters camped outside her house, she appeared looking sad and solemn on the arm of her agent. The photos of her are touching and sincere; she could do nothing more than repeat that she was "so sorry."

From then on, DiMaggio kept close tabs on Marilyn by hiring a private detective to follow her. He even went so far as to stage a raid on a place where Marilyn's lover, Hal Schaefer, was reported to be. He

[83] Quoted in *ibid.*, 287, 288.

showed up with Frank Sinatra, but his detective had given him incorrect information and they broke down the wrong door!

In spite of all her personal turmoil, Marilyn had been cooperative and professional for the filming of *The Seven Year Itch*. And, unlike Zanuck and his constant recriminations about Marilyn, Wilder couldn't say enough about this "sensational" actress and how great she was. Feldman, Marilyn's agent and the co-producer of the film, celebrated by throwing a big party in her honor at Romanoff's. All the top Hollywood stars were there for her: Lauren Bacall, Humphrey Bogart, Gary Cooper, Samuel Goldwyn, Billy Wilder, Clark Gable, Darryl Zanuck, of course, and many others. They all praised Marilyn—she had finally been accepted as one of acting's elite. Even Zanuck complimented her and said he found her "magnificent" in the film.

Behind the scenes, she was hatching a plan to leave Hollywood. Her lawyers were looking for a way to prove that her contracts were void so she could set up a production company of her own with her friend Milton Greene, the brilliant photographer who had reappeared in her life.

If we look at the two last films that led to her divorce, we can note that Marilyn was used as the classic object of sex appeal. She's beautiful and radiant and she knows it and plays it up. The producers always wanted to exploit what they saw as the cheap and trashy caricature of her personal life story. Given her incredible popularity, we can understand that she wanted to play more consequential roles—ones that were more psychologically complex. She had now been genuinely recognized by the Hollywood acting milieu as an excellent actress, but not yet by the studio management. She wrote, "When I remember this desperate, lie-telling, dime-hunting Hollywood I knew only a few years ago I get a little homesick. It was a more human place than the paradise I dreamed of and found. The people in it, the phonies and failures, were more colorful than the great men and successful artists I was to know soon."[84]

Marilyn wanted to leave behind the studio system, where even successful actors couldn't choose their roles and were bound by their contracts to do what they were told. She was both very hesitant and yet extremely determined to take the big step.

[84] Monroe, *op. cit.*, 48.

Chapter 7

As with every turning point in her life, this one had a huge effect on Marilyn's health. In November 1954, she was hospitalized for gynecological problems. DiMaggio, her ex-husband, was watching her every move.

Just after her recovery, she learned that the top nightclubs would not hire black artists. So, she decided to take up the cause of her idol, Ella Fitzgerald, who had been excluded from The Mocambo Club on Sunset Strip. Marilyn made a deal with the owner—if he agreed to let Ella perform at his club, Marilyn would agree to be there every night at the front table. As a result, the club was packed night after night and Ella was a huge success. This was Marilyn's typical style—her way of fighting for civil rights, which were so flouted in the US. This was her way of showing her political freedom.

In December, Marilyn fired her agent and her lawyer and informed Fox that, from then on, they would have to deal directly with her or her new lawyer in New York, Frank Delaney.

8
NEW YORK—THE TURNING POINT

With the help of Milton and Amy Greene, Marilyn was able to break away from Fox. Milton was a great photographer ("the best photographer of women," said Avedon) and a very close friend of Marilyn's, her accomplice. He had been her lover some years before and probably was again for a short time when they worked on a story for a fashion magazine in August 1953. That was when they came up with the plans for their project.

Very soon after, Marilyn and Greene announced the creation of their new production company, Marilyn Monroe Productions (MMP). She was the president and the major shareholder. From then on, the 'new Marilyn' was born. She proclaimed that she was fed up with just playing sex symbols and wanted to choose her own roles. The press found that the announcement seemed a bit improvised and the new undertaking quite precarious, so they tried to make a joke out of it: "The New Marilyn seems just like the old one!" But Marilyn needed the support of the New York art milieu. At the same time, conflict and negotiations were ongoing with Fox. The studio representatives were furious to hear her lawyers claim that her contract had ended after *The Seven Year Itch*. They wanted her to act in a film written by Nunnally Johnson, "created especially for her": *How to Be Very, Very Popular*. Marilyn had to proceed carefully between finishing the last takes and doing post-production for *The Seven Year Itch* while, nevertheless, refusing to do a new film. She returned to Los Angeles to work on *The Seven Year Itch* with the moral support of Joe DiMaggio, always ready to help. As soon as she finished, she disappeared again and was suspended once more by Fox.

It was a difficult period—Milton Greene was not a businessman and he had to build trust in their new company in order to find financing to bankroll Marilyn's lifestyle. Marilyn herself pitched her project to influential and doubting investors. She managed to convince Cheryl Crawford (an important Broadway producer), who had been openly

wary about Marilyn after her separation from Feldman. Crawford offered to introduce Marilyn at the Actor's Studio, a laboratory-school for actors, which had been founded by Crawford, Elia Kazan, and Robert Lewis in 1947.

On February 4, 1955, for the first time, Marilyn attended an actor's work session there along with Cheryl Crawford. The artistic director, Lee Strasberg, watched his students' performance and "analyzed, criticized, clowned, pontificated, and attacked.... His speech was swift and argumentative."[85] Some called him the Rabbi. It was said that he could be frankly uncouth and he "tended to look right through people as if they did not exist."[86] Unlike professors of stage acting who relied on text, he conducted his workshops by relying on psychology, like in sessions of group therapy. Students could come transitorily and participate if they liked, as if it were a short-lived, one-time workshop for experimentation. Once accepted, students had no set curriculum, no requirement for continued attendance; weekly open sessions as well as private classes with Lee Strasberg were offered. Strasberg "challenged them to probe their own psyches."[87] He encouraged them to "take a minute" to retrieve within themselves "a powerful, emotional experience related to the scene they were about to perform."[88] This did not mean calling forth the memory of an emotional experience, but living here and now the kinetic "perception" left by an emotional experience from one's own life, with all the taste, the sight, the sound, the touch of it, even if there was no connection with the scene to be played. Often, this reliving of feelings was very upsetting and students left work sessions in tears. Strasberg quoted Goethe: "The actor's career develops in public, but his art develops in private."[89] He talked of "talent in flux." This was an import of the method used by Stanislavski and the Russian Chekhov School of acting, reworked American-style. Strasberg promoted what he called The Method, considered by all as the only way to achieve excellence in acting, whether for stage or screen. He advised that actors should disregard the commercial demands of Hollywood so that they would be the elite among actors and

[85] Barbara Leaming, *Marilyn Monroe* (New York: Three Rivers Press, 1998), 157.
[86] *Ibid.*
[87] *Ibid.*
[88] *Ibid.*
[89] Quoted in *ibid.*, 158.

proud of it. Kazan had already told Marilyn much about Lee Strasberg and the Actor's Studio. This time she was there to see for herself. She had remained friends with Kazan even though he had testified before the House Un-American Activities Committee (HUAC).

Strasberg seems to have welcomed Marilyn with real interest and understanding. He explained to her that being a star in Hollywood would never bring her the dignity she sought. He was struck by her sensitivity and declared that he wanted to help her study her "problem" to uncover her "underlying personality." He promised to work with her, even to give her private lessons, under the condition that she begin psychoanalysis, which was not one of his usual demands. Usually, he did not advise psychoanalysis for those studying his Method, believing that the two experiences were not compatible.

Milton Greene immediately sent her to see his own analyst, Margaret Hohenberg. Marilyn's schedule was soon filled: twice a week she had sessions at the Actor's Studio, three nights a week private lessons with Lee Strasberg followed by dinner with his family, and four hours a week were devoted to the study of sensory memory. In addition to this, she had five one-hour sessions of psychoanalysis per week. One can imagine the time she spent on thinking, analyzing, trying to find within herself her own feelings, and learning all the psychological terms needed to express all these emotions. Marilyn had begun an immersive period of introspection.

Milton Greene is said to have used many drugs, sedatives as well as stimulants, and he supplied them to Marilyn. The use of pharmaceuticals was widespread in New York at the time; everything was there to help find within oneself the way to make acting match up with real feelings.

In photos of this period, Marilyn appears in the casual, simple attire of a student. She looks serious and attentive, as if absorbing conscientiously all she is being taught. The photos show a face of intense luminosity, far from that of the heavily made-up star. Constance Collier said of her:

> Oh, yes, there is something there. She is a beautiful child.... I don't think she's an actress at all. What she has—this presence, this luminosity, this flickering intelligence—could never surface on the stage. It is so fragile and subtle, it can only be caught by the camera. It's like a hummingbird in flight: only a camera can freeze the poetry of it. Somehow I don't think

she'll make old bones. Absurd of me to say, but somehow I feel she'll go young. I hope, I really pray, that she survives long enough to free the strange lovely talent that's wandering through her like a jailed spirit.[90]

A professional opinion given by someone so respected is a valuable thing—this diagnosis that Marilyn was exceptional on film, but was certainly not a theater actress, is an important observation. Marilyn's amazing and fleeting luminosity was all the more dazzling because it was ephemeral. Many people noticed this phenomenon: Marilyn would seem bland, invisible, and then she would light up, come to life, and become something more than just visible—she would become radiant. There must surely be some connection between this tremulous sparkle she possessed that foretold an early death and the horrible fright that plagued her each time she had to appear on camera.

In New York, she encountered Arthur Miller, whom she had not seen since January 1951. It seems she may have dreamed up ways to cross his path. Through her friend Sam Shaw, the photographer, she was able to engineer a meeting with the Rostens, good friends and neighbors of Arthur Miller in Brooklyn Heights. They became close friends with Marilyn, which is all the more surprising as they were not at all involved in show business.

Rosten observed that Marilyn would speak of herself in the third person when she was talking about a possible film role: "Marilyn Monroe would not do this role or that role." Her presence on screen had an existence all its own.

Marilyn began a secret affair with Arthur Miller, who did not want to break up his marriage. He was writing the play *A View from the Bridge*, the theme of which dealt with the public disgrace of a traitorous member of a family of immigrant Italian dockworkers. Here, the main character denounces clandestine workers, whereas in Kazan's *On the Waterfront*, the story deals with a boxer who testifies against the mob. Marlon Brandon exuded magic and ambiguity in his portrayal of the boxer. "The informant knows that he is doing the right thing," said Kazan, whose film won eight Oscars. Miller's play showed a different angle, "Naming names inevitably destroys the person who does it." This remark appeared within the larger context of a general obser-

[90] Quoted in Wolfe, *op. cit.*, 312.

vation about America. Miller felt Americans wanted to intentionally forget their past mistakes, cruelties, and injustices. He claimed to aspire to a world where "actions would once again have consequences."

Marilyn found herself in the middle of a complex network of three men: Elia Kazan, Lee Strasberg, and Arthur Miller. The three of them were linked by complicated circumstances. Lee Strasberg was said to be at a crisis point with the Actor's Studio, and the arrival of Marilyn Monroe represented a lifeline for him. Kazan, when he was still an unknown, had been humiliated by Strasberg. But now Kazan had successfully directed some very important films (including *A Streetcar Named Desire*). Strasberg was the "born teacher,"[91] but was not an artist and was a poor director. In addition, Kazan had not been forgiven for naming names to the HUAC. He was called "looselips" or "the informer." Miller avoided him and certain students at The Studio disdained him. It is true that Strasberg had certainly become the king of The Studio, but he had done so by going against Kazan, which only served to underline the fact that Strasberg did not have the artistic creativity he would have liked. At the same time, Kazan made no bones about taking the most gifted actors from The Studio. The resounding success of *On the Waterfront* and Marlon Brando's performance, as well as that of James Dean in *East of Eden*, had made Kazan a hero again. In addition, Marilyn's arrival at The Studio seemed to contribute to Strasberg's dominance in his struggle for control there. Strasberg insisted that Marilyn begin all over again, start from zero—as if her phenomenal Hollywood success meant nothing compared to what she would have to accomplish with him.

As a result, she seemed to become dull and unexciting at interviews. Zanuck was worried about the effect that would have on *The Seven Year Itch* and decided to advance the release of the film to coincide with Marilyn's twenty-ninth birthday. We must remember that "Marilyn was the most idolized, the most photographed, the most well known person in the entire country."[92] *The Seven Year Itch* was a huge success.

In 1955, because McCarthy had been condemned by his peers, the witch-hunt against communists was less aggressive than in pre-

[91] The term used by Kazan.
[92] She was making millions of dollars for Fox Studios. See Spoto, *op. cit.*, 331.

vious years. Miller needed a passport; he had been refused one in 1954 and had been asked to appear before the HUAC. He did not support communists or the USSR, but he refused to give in to a form of blackmail disguised as patriotism or to give the names of friends with whom he had attended political meetings—meetings which were not necessarily very subversive. Outside of the unions, there was no clear structure for left-wing American politics. The HUAC was trying to revive its own image and hoped to take advantage of the rumor of an affair between Arthur Miller and Marilyn. Plans were made to stage a reason to whip up growing public frenzy about communism. The HUAC hearings were public rites of humiliation and allegiance to the American myth.

In a critique of both *On the Waterfront* and *A View from the Bridge*, journalist Eric Bentley establishes a parallel between the two works: "It will surprise no one that, in Mr. Kazan's movie, the act of informing is virtuous, whereas, in Mr. Miller's new play, it is evil.... [I]t is easy enough to end by winning the game if you begin by stacking the cards, only you then have to concede that the game then loses all its interest as a game."[93] Bentley highlights the morality of each of the writers and pits them against each other.

It was Tennessee Williams himself who thought of Marilyn Monroe for his own *Baby Doll*, to be directed by Kazan. But Kazan couldn't envision Marilyn in the role of a nineteen-year old girl who plays the spoiled brat. Williams insisted on Marilyn and she also fought for the role, but, finally, Kazan opposed choosing her. It is easy to bet that, if she had been given the chance to play this part, something would have changed for Marilyn, as this was just the right time for her to play a major role, written and directed by two great artists. It was a painful disappointment for her.

However, she managed to obtain the rights for *The Sleeping Prince* for her company MMP. She was able to get Laurence Olivier interested in directing and starring in the film. At the time, he was one of the most respected actors in the world.

Meanwhile, she had succeeded in getting the contract with Fox for which she had been fighting for over a year; she was given final say on the choice of director, script, and director of photography. In addi-

[93] Quoted in Leaming, *op. cit.*, 182, 183.

tion, she obtained a raise that was more commensurate with her popularity as well as a contractual agreement for possible co-productions between Fox and MMP. Zanuck had been defeated and he resigned from his position as Director of Production. She signed her contract on December 31, 1955—it was an astounding victory for her.

Two projects were now in the works: *Bus Stop* with Joshua Logan (Fox had bought the rights for Marilyn) and *The Sleeping Prince*, which Laurence Olivier was to direct and star in.

The time had come for Marilyn to prove herself by acting in a scene during a workshop at the Actor's Studio. She chose the role of Anna in the bar scene from *Anna Christie* by Eugene O'Neill. This scene was already very well known, as it had been played by Greta Garbo. Marilyn overcame her crippling fear and did the scene. Her performance was cheered and applauded, which was not the habit at the Actor's Studio. But Marilyn wasn't satisfied with herself; she was convinced that she hadn't done it well. As with many artists, by the time they play a role in public, they can no longer determine whether or not they have done a good job. Something disappoints them at the very moment the public views the performance. The artist can no longer be a judge of her work; she is shut off from it, no longer in control. It is only after the public has taken possession of the performance that the actor can re-appropriate her role, her creation, through the work, which has become independent.

Strasberg was definitely showing special interest in Marilyn, spending more time and attention on her than on anyone else—whether his actors or his children. Concurrently, to hold up under the strain of all this, Marilyn was overdoing it on sleeping pills and champagne.

9
THE 'ANGEL' IN *BUS STOP*—THE TOLL ON MARILYN

The first contact with Joshua Logan to prepare the filming of *Bus Stop* took place with apprehension from all concerned, and yet the first meeting went very well, with Milton Greene playing the go-between. Logan was known for being temperamental and tough on actors and Marilyn was known for being fragile, easy to crush if not treated with kid gloves or if rebuked for her stage fright and delays. The day of the first meeting, when Marilyn had still not shown up after dinner, Logan became impatient, asking if there was any chance of seeing her. Marilyn was in her room, feeling unready, yet Greene forced her to come out. She had the ingenuity to say that, just as Chérie, the singer she was to play in the film, she couldn't manage to come out of her dressing room because of stage fright. Logan liked the 'artistic' aptness of Marilyn's comment. She was then shown the costumes she was to wear for the film: as always, flashy and tacky, covered with sequins. Chérie was supposed to be an unassuming singer from a small town in Arizona. Marilyn supposedly pretended to consent to the costumes she detested in order to test Logan. Once alone with her, he asked what she really thought. When Marilyn answered that she thought they were all wrong for Chérie's character, Logan understood that she knew what she was talking about. Together, they dug around in the studio wardrobe to come up with costumes pathetic enough to fit the characters in *Bus Stop*. For Marilyn's first film under Strasberg's training, her master had to be present, all the more so as Logan had also come from the Actor's Studio. Since Lee Strasberg could not be in Arizona or Nevada in person, he managed to impose that his wife, Paula, should go. Logan in no way wanted this woman to intervene on the set, so he negotiated with Marilyn that her consulting with Paula Strasberg would be done strictly in private (in her dressing room or at her home), never on set. This contract was upheld to the letter.

Chérie, a singer in a shabby music hall, the Blue Dragon Café, hopes to get to Hollywood one day. On a map, she has drawn a straight

Chapter 9

line to the Pacific, representing the course of her fate. She has made her way west from her birthplace, step by step. Her one goal in life is to act in roles she has chosen herself. A young cowboy, played by Don Murray, leaves his ranch for the first time to attend the annual rodeo in Phoenix. The fact that he has never had a girlfriend is eating away at him. He says he wants not just any girl, but an "angel," and, when he finds her, he'll lasso her just like he does with cows; she'll have no choice but to give in. In the bar, he spots the luminous Chérie. He's found the one, his angel! Instead of the French pronunciation of Chérie, he calls her Cherry, which annoys her. She insists on the correct pronunciation and asserts that, one day, she'll be a real actress. His name is Beauregard, a flattering French name from his mother's side of the family. This endears him to her, even though he goes by the simple name Bo. But he wants to grapple her as he does his cows; he tries to grab her and she runs.

Milton Greene had the excellent idea to have Marilyn made up almost clownishly, in very pale white make-up which gave her an unreal aspect. It was said that Murray was too gentle with Marilyn on the set. She countered violently, as if to show him that his approach was wrong, that he should be more brutal and humiliating so as to trigger in her a reactionary attitude of indignation. Murray complained that Marilyn had socked him in the eye and this led to a lengthy back-and-forth. Logan took Murray's side and asked Marilyn to apologize. She agreed, then refused, maintaining that Bo should be more brutal, that the story called for it. In the script, her character is supposed to react strongly to physical manhandling. Logan finally realized that Marilyn had truly grasped the character. This episode is certainly indicative of the deep underlying issues unfolding during the shooting of the film. Marilyn agreed to go along with the pathetic aspect of Chérie's character, but she was afraid to lose any of her resplendence in the eyes of her fans. Apparently, Murray was not especially attracted to Marilyn, and perhaps that offended her. While his character was supposed to be madly in love with her, she was afraid the public would see there was really no chemistry between them. What's more, Murray was in no way macho; he was inherently elegant and refined and it was not easy for him to play a brute. In her clashes with Murray, Marilyn felt isolated and misunderstood.

At the same time, in order to establish residency and thus divorce quickly, Arthur Miller had moved in to a cottage in Nevada not

far from Reno. His wife, Mary, had heard about his affair with Marilyn and had thrown him out. Thus, during the filming of *Bus Stop*, the two lovers were able to meet in various locales on the weekends. In order to reach Miller by phone, Marilyn had sent word that he was to wait for her call at a pay phone near his cottage. The night of her fight with Murray, she rushed to call Arthur to tell him all about it and find some moral support from him. She was in despair about feeling so isolated and about the difficulty of being an actor. Miller recounted their phone conversation: "...I don't want this, I want to live quietly, I hate it, I don't want it anymore, I want to live quietly in the country and just be there when you need me. I can't fight for myself anymore...," Marilyn said.[94] Miller was dismayed and later wrote:

> ...a new terror that I was hearing, an abandoned voice crying out to a deaf sky, and the dead miles between us choked me with frustration.... I kept trying to reach her but she seemed to be sinking where I could not reach her.... "Oh, Papa, I can't make it, I can't make it!" she cried. And suddenly I realized I was out of breath, a dizziness screwing in to my head, my knees unlocking, and I felt myself sliding to the floor of the booth, the receiver slipping out of my hands. I came to in what was probably a few seconds, her voice still whispering out of the receiver over my head. After a moment I got up and talked her down to earth, and it was over.[95]

One can imagine the lone telephone booth, its light the only one rising out of the desert night, and this tall, slight man, falling into a barely discernable faint, seized by the desperate voice of his soon-to-be wife. She has not even realized what is happening to him. He has slipped, as if tumbling into his love for her, and she is sinking, wasting away from the sheer effort of existence that her appearance demands. Each time she must be reborn from the abyss, the vortex, the desert. And, on that particular day, the effort it took Marilyn to conjure her presence was not understood. It was knocked down by trivial questions between actors. She had been left alone to deal with her chasm. And, obviously, it was Arthur Miller to whom she looked for rebirth. The sound of her voice alone was enough to bring her lover along with her into the thrall of her blackout.

[94] Arthur Miller, *Timebends* (London: Bloomsbury, 1987), 379.
[95] *Ibid.*, 380.

Chapter 9

During his period of forced exile in Nevada, Miller met all kinds of unusual characters, real cowboys, more authentic than the cowboys in films. Many were guilty of having left wife and children and, through their common bond of drinking, had found a semblance of energy and brotherly community among fellow outsiders. Two of them had found an abandoned cabin where they could hole up and they used it as a base to go out and catch wild horses, mustangs, which they sold to be turned into dog food. Miller had found the material he needed to write the script for the film *The Misfits*.

Back on the filming of *Bus Stop*, Marilyn was known to fluff her lines if the text was too long. Logan had noticed that she would stop immediately whenever he said, "Cut!" And, each time she stopped, it would take enormous effort for her to start again. In short, once Marilyn had started, she couldn't be interrupted because, once she was off the set, it would take much time and effort to get her back on again. Logan had understood this, and so he filmed in one take the long scene where she is on the bus speaking to another girl about her dreams for love. Logan declared that she had been excellent in that scene. Chérie wants to be freed from the hell she is living after Bo has "captured" her. He has made her get on a bus bound for Sun Valley that stops at Grace's Diner, a necessary stopover for the desert crossing. When they arrive there, Chérie demands an apology from Bo. He refuses and the bus driver challenges him to a fight. Bo is beaten and promises to free his captive and apologize, but he does not apologize. As he's leaving to go back to the ranch where he was born, the other passengers on the bus demand that he ask forgiveness from the beautiful Chérie, as he had promised to do. When he finally talks to her, he does so in such a humble way that Chérie falls in love with him just when he is leaving her, but with respect for her this time. In the end, as they are saying *adieu* in the doorway of the bus, he throws his leather jacket around her shoulders and, in a dramatic turn of events, takes her off to marry her. Happy ending!

In Sun Valley, Marilyn caught a chill and had to be hospitalized for double bronchitis and exhaustion. This shows just how much of a toll acting took on her physically. She had to work hard to find deep within herself the luminosity of her unique spark. It was as if she worked on a tightrope just on the edge of the abyss. It was probably Strasberg and psychoanalysis that had led her to that precipice.

It is certain that Marilyn appears very pure and unsophisticated in *Bus Stop* and plays the character of Chérie with finesse. She had defended her position as an actress to play the part the way she had understood it. Even more, she is a virtuoso at what made her such a unique actress. As Chérie, she asks herself questions about love and even what is sincerely at stake in love—even more, what is at stake in *true* love. She plays the part with all the luminosity and sweetness, with all the vaporous, downy, *angelic* aspects of what she herself really possessed.

10
THE SHOCK OF THE ENGLISH EXPERIENCE—*THE PRINCE AND THE SHOWGIRL*

Now that *Bus Stop* promised to be a great success and the rights to *Sleeping Prince* had been given to Marilyn Monroe Productions, Marilyn and Milton Greene were finally going to make the independent film that they had so hoped to make. Laurence Olivier would direct and star as the Prince, and Marilyn would play the American dancer on tour in London who charms the Prince. Co-produced in part by Warner, the film was to be shot in London from the beginning of summer. Laurence Olivier was quite taken with Marilyn and seemed to be a confirmed admirer. He was enthusiastic about the filming, which would certainly be lucrative for him, given Marilyn's immense fame at that time.

While Arthur Miller was completing his mandatory residence in Nevada in view of getting a divorce, his lawyer informed him that the HUAC had sent someone to Reno to subpoena him to appear. The news about his divorce and the publicity it generated made it the perfect time for him to be summonsed. Miller needed a passport to travel to England to be with Marilyn, so he knew he would have to answer questions about his political opinions. But there was one point on which he was not prepared to budge: he would not name names of writers who had been with him to Communist Party meetings in 1947.

This period in 1956 was complex and turbulent; Arthur Miller risked a prison sentence if he was found guilty. This also meant more lawyer fees for him just on the heels of a very costly divorce (alimony for his wife and children). He planned to marry Marilyn and gossip had it that Miller was interested in the marriage not only for obvious financial reasons, but also because it would help his declining reputation.

When the studio heads at Fox got wind of the upcoming union between their number-one star and the playwright accused of contempt of court (refusing to cooperate with the HUAC), they feared that Marilyn's reputation would suffer and her films might be boycotted. *Bus Stop* had barely finished production and now it might not be

Chapter 10

the huge success predicted for the first film of the "new Marilyn Monroe," after the success of *The Seven Year Itch*. Skouras, the president of Fox, wanted to meet with the couple to try to talk them out of getting married, unless his "dear" Marilyn would officially distance herself from her future husband's political leanings. For Skouras to make the trip to meet them in person was quite exceptional. He tried, but failed, to convince Marilyn that she had too much to lose by marrying Miller. He also tried to convince Miller that he would be wrecking Marilyn's film career after she had fought so hard to get the contract she wanted with the studio. Actually, his visit simply confirmed to the couple that the studio was in dire straits.

Miller went alone to Washington and appeared with his lawyers. A horde of reporters was waiting for him, hoping only to catch a glimpse of Marilyn. He did not do well before the committee and was unconvincing, getting mired in details. He tried to show them that his affinities with the Communist Party had merely been a folly of his youth and that now he had little interest in politics. He almost apologized for not standing up for the victims of communist tyranny. Even though he did not name names, he had belittled himself. As he left the hearing, the reporters assailed him and managed to get out of him that he and Marilyn would marry "in a day or two." The news went public immediately. Back in New York, Marilyn heard on the news that they would be married and she was overjoyed. She, in turn, was hounded by the most anti-communist populist press, hoping to bring down Miller or at least get the scoop. Marilyn hedged and then got the idea to say that Skouras, the president of Twentieth Century Fox, had offered his home for their wedding. That way, she made everyone think that the studio was endorsing the marriage and thus indirectly endorsing Miller. She was certain Skouras would not refute her statement.

The following day, the newspapers were unkind to Miller, whom they said to be "...long-winded, pompous, egocentric, a Commie sympathizer." The only favorable comments about him had to do with his upcoming wedding to the beautiful star.

The happy couple had to give an impromptu press conference on the sidewalk outside Marilyn's apartment. Adorable and discreet, Marilyn hugged Miller tightly and declared, "...I've never been so happy in my entire life." Miller could hardly bear the scene, but realized he had to give the same image. Marilyn closed her eyes and Miller buried his nose in her blond curls. Marilyn knew that she would win the peo-

ple's trust, and even their hearts, if she demonstrated the truest, most intense, most visibly sincere expression of love. That was her great art.

By refusing to name names, Miller was in danger of being found in contempt and of being denied a passport. The marriage card had to be played with caution. Reporters were camped out night and day outside Marilyn's Manhattan apartment, so the couple had to sneak out to Lichtfield County in the countryside to visit the Miller family. Of course, the reporters got wind of it and swarmed the area. In the mad rush, there was a serious car accident and a reporter was killed. Marilyn was distraught. To end the media frenzy, Miller decided that the wedding should take place that very day. On June 30, 1956, at 7:21 p.m., they were married by the county judge. The religious ceremony took place on Sunday, July 1. Marilyn had converted to Judaism, but had a moment of hesitation before repeating the sacred oath. She was wearing a beige silk chiffon dress with a white tulle veil and Strasberg gave the bride away. The champagne flowed and Marilyn stayed tightly wrapped in her husband's arms.

No sooner was the wedding over than negotiations began for the film *Sleeping Prince*. Strasberg demanded that Milton Greene hire Paula for a large sum of money. Almost threateningly, he maintained that Marilyn would never be able to make the film without Paula and also took the opportunity to disparage Laurence Olivier.

Miller's lawyer had managed to get the Committee to allow Miller a passport for England under the condition that he swear to return to the States if he were found guilty of contempt of Congress. It was of utmost importance to leave before the vote was held. They left on July 10; the vote was scheduled for July 13. The lawyers believed that, if Skouras endorsed Miller, then Miller might not be found guilty, but Skouras remained silent. Was he betraying Marilyn or just trying to determine if the public would continue to defend her even if Miller were found guilty?

As with all of her film shoots, the making of *Sleeping Prince* was a terrible psychodrama. You would have to see the finished film in order to forget the mess behind the making of it. For one, it was discovered that Laurence Olivier's wife, Vivien Leigh, had a lover. Leigh had just found out she was pregnant when Marilyn and Miller arrived in London and, seeing how excited her husband was about meeting Marilyn, she wanted to announce her pregnancy to the press that very day—the day Marilyn touched down on British soil. This new pregnan-

cy development changed the dynamics for both couples and deeply affected the first meeting between them. Marilyn was welcomed as importantly as a head of state, and the Oliviers were surrounded by two hundred frenzied reporters and photographers when they went to meet her at the airport. In England, each time Marilyn appeared, she was mobbed by crowds of fans and the police had to be called in to cordon off the area.

The writer Terence Rattigan threw a ball in Marilyn's honor at Little Court on July 24. The press covered the event and, shortly after, the verdict was announced that Miller had been found guilty of contempt of Congress, so the investigation would continue.

On set, extreme tension between Laurence Olivier and Marilyn quickly became obvious. Olivier could stand neither Marilyn's delays nor the presence of Paula Strasberg. He made the unfortunate blunder of telling Marilyn, "...all you have to do is be sexy, dear Marilyn."[96] She was so furious about this comment that she phoned Lee Strasberg in New York to vent her rage and despondency. Arthur's regular visits on set buoyed her, but Olivier's arrogance unsettled her so much that she resorted to both sleeping pills and stimulants supplied by Milton Greene.

Vivian Leigh also wanted to capitalize on the publicity by throwing a big party. But, after the celebration, at five months into her pregnancy, she suffered a miscarriage. This must surely have had repercussions for the Olivier couple.

Another event also rattled this unpleasant situation. Marilyn discovered a diary entry written by Miller expressing disappointment about her as a wife. Miller, supposedly so in love, wondered about their marriage, stating in so many words that Marilyn was eating him alive. (In the play he wrote after their separation, *After the Fall*, the heroine Maggie accidentally discovers a line written by her husband: "The only one I will ever love is my daughter," the beginning of the couple's downfall; "That's what killed me...," says Maggie.)[97] Marilyn was devastated and her nervous condition worsened, all the more so as, at the same time, Miller was apparently complaining about her to Olivier, who had never stopped criticizing her. She was relying heavily

[96] Quoted in Spoto, *op. cit.*, 370.
[97] Arthur Miller, *After the Fall* (London: Penguin, 1964), 108.

on barbiturates to drug herself into a profound sleep. On August 24, Miller announced he was returning to the US to see his children. Marilyn took this very badly, but Miller left anyway. The next day, Marilyn announced that she was pregnant. Six days later, Miller was back in England, but Marilyn had had a miscarriage! She was extremely upset, but, nevertheless, found the strength to publicly stand by her husband in the face of the censors threatening his play *A View from the Bridge* (a kiss between two men was deemed to be homosexual). True to herself, in the midst of all this turmoil, when she needed to appear, she was able to find the inspiration required for each specific circumstance. She was always remarkable and always warmly represented in the press. She generated great positive publicity for her husband's play. Laurence Olivier wondered why she had such trouble acting whereas she seemed so easily inventive when it came to defending her husband to the public. He was unaware that Marilyn always excelled at staging her public appearances. In a red satin, strapless sheath, slowly descending a staircase, she carried the day and quieted all the negativity about Miller's play and about the rumors of what was going wrong on the film set. Hand in hand, the Millers greeted the rounding applause. As usual, the gossips said the applause was for Marilyn's low-cut dress more than for Miller's play. The dress was Marilyn's choice, and the applause was for her performance, this time playing the role of the wife.

In October, Lee Strasberg came to London and insisted on being on set. Laurence Olivier demanded that Greene get rid of him, so Strasberg was forced to go back to the US with his wife, Paula. Next, Marilyn's psychoanalyst came to London to visit her patient and declared that she "...did not know how long the two partners (Marilyn and Milton Greene) could work together in an atmosphere of such emotional strain."[98] She advised Marilyn to consult Anna Freud and, apparently, Marilyn's meetings with Freud's daughter helped improve the situation between Marilyn and Olivier and allowed for the return of Paula Strasberg.

On October 29, in a very low-cut dress, Marilyn was presented to the Queen along with twenty other movie stars. Her Majesty spent longer talking to Marilyn than to the others. The press couldn't print

[98] Quoted in Spoto, *op. cit.*, 374.

enough compliments about Marilyn and marveled at her "diplomacy, mischief and bubbling sense of fun" and how she was "as intelligent as she was pleasant as she was pretty."[99]

Filming was finally over. Despite all the hardships, Marilyn had insisted on seeing the rushes every evening and had made pertinent remarks. No one could understand or tolerate her interminable lack of punctuality, which seemed so contradictory to the fact that she was so professional on the set, easy to work with, and excellent on screen. The cost of filming came out lower than expected and shooting went over schedule by only two days. A box-office failure was feared and the film title was changed to *The Prince and the Showgirl*. Milton Greene made one of his signature posters with a very glamorous photo of the prince and showgirl couple.

The plot is quite simple: the Prince Regent of Carpathia comes to witness the crowning of George V, the future king of England, and falls in love with a showgirl. By way of various gags, the showgirl discovers that the son is plotting against his father. She is funny and generous and gradually brings the stuffy father together with his wary, unloved son. Without realizing it, the prince falls for the showgirl, but we are left not knowing if they will ever see each other again.

Marilyn is excellent in a role that she had overestimated before filming began. She manages to convey a whole range of attitudes: mischief, comic intelligence, and sincere emotion. It is not a great film, but neither is it a bad one, and Marilyn clearly demonstrates her acting talent.

This English experience showed all of the protagonists that they had held out false hope for what they had expected would be a perfect time in their lives. The movie was completed; the filming had ended, as had numerous illusions. The masks were off; four months had been spent under the cloud of miscarriage—hopes for fertility were dashed and the end result was disappointed defeat. One must note that this painful episode was, in one way, much like many of the ordeals Marilyn traversed in her life. Even if she found the situation torturous and carried her entourage down with her in her spiral of private interior suffering, inherent to her invention of herself as a star, she managed to complete the project and keep the public on her side.

[99] *Ibid.*, 378.

Marilyn never denigrated anyone, unlike her partners, who took a long time forgiving her for the frenzy and disruption she caused, always making mountains out of molehills. In the end, they would realize after the fact that working with her had been a valuable, productive, and positive experience, not to mention a very lucrative one.

To take a rest after all this anxiety, Marilyn suggested to Miller that they spend the New Year's holiday in the sun. They left for the northern coast of Jamaica.

11
SOME LIKE IT HOT—A MASTERFUL PERFORMANCE

The year 1957 promised to be a calm one, away from movie sets and other upheavals. Marilyn hoped for discreet married life, far from the public eye—she had dreamed of it for so long! They rented an apartment at 444 East 57th Street, which Marilyn decorated all in white—white sofa, white baby-grand piano, everything white. Arthur was very busy writing and awaiting the findings of the Committee. After the disastrous mood in London, relations between Marilyn and her business associate, Milton Greene, had rapidly deteriorated. Miller convinced Marilyn that Greene did not have her best interests at heart and that he had been spending the company money on himself. In this atmosphere of mistrust, Marilyn began to have doubts and decided to change analysts—we will never know all of the reasons why nor the contributing factors in her decision.

A new analyst was chosen: Marianne Kris, allegedly recommended by Anna Freud herself. Her office was located in the same building where the Strasbergs lived, so Marilyn spent each day on one floor or the other of 135 Central Park West. Eternally needy, Marilyn continually forced herself to look inward, to improve and change. Miller hated the considerable hold Strasberg had over Marilyn. He did not trust Strasberg and believed he was probably nowhere near as competent as he claimed to be—an opinion that many others shared. For Marilyn, Lee was the indisputable Master. Miller had had a positive experience of psychoanalysis with Rudolf Loewenstein and did not deride Marilyn's sessions. Friends of hers said that Marilyn was very emotional, that she could readily go from calmness to anger, from happiness to tears. Strasberg thought it was a good sign that she was improving, but Marilyn was drinking more and more and gaining weight.

When she viewed a copy of *The Prince and the Showgirl*, she found the editing to be slow and asked that the rhythm and the music be stepped up. Did she indirectly want to put the blame on her busi-

ness associate?[100] Marilyn wasn't content with simply being an actress; she also managed her production company. Finally, on April 11, 1957, Milton Greene was fired from the MMP company, along with the company lawyer and accountant, who were immediately replaced by men of Miller's choosing.

Greene was obviously very upset about this, however, he never spoke ill of Marilyn; he always stood up for her. He made it known that he found his dismissal unjustified given the amount of time and effort he had put in to advance Marilyn's company. Marilyn allegedly told Greene's wife, "Arthur was taking away the only person I ever trusted, Milton."[101] Obviously, Miller knew that Marilyn and Milton had been very close. Between them, they had always kept a certain secret, erotic space. Other, closer sources said that Marilyn had complained bitterly about the fact that Milton had found her a psychoanalyst who worked for him and not for her.[102] Marilyn and Greene never saw each other again; their lawyers worked out the legal details.

In May, Marilyn accompanied her husband to Washington for his appearance before the Committee—her sole purpose on the trip was to show her support for her husband. She willingly answered reporters' questions. However, Arthur was declared guilty of contempt of Congress for not having given any names and he decided to appeal.

In July, Marilyn was pregnant again and was absolutely delighted. Miller wrote that "...there were moments of a new kind of confidence, a quietness of spirit that I had never seen in her."[103] They had previously arranged for a sumptuous renovation of their house by Frank Lloyd Wright, a house Miller had bought with Marilyn's earnings. This project never saw the light because it was too expensive. The following month, Marilyn had terrible pains and had to be admitted to the hospital emergency room. It turned out that she had had an ectopic pregnancy and she lost the baby.

The short story, "The Misfits," appeared in *Esquire* magazine. The photographer Sam Shaw liked it immensely and suggested to Miller that it be made into a film.

[100] *Ibid.*, 388.
[101] *Ibid.*, 390.
[102] *Ibid.*, 391.
[103] Miller, *Timebends, op. cit.*, 457.

Christmas 1957, Marilyn was especially generous with her Christmas gifts: her pearl necklace from the Japanese Emperor for Paula Strasberg; a Chagall drawing and a car for Susan Strasberg; and, for John Strasberg, only eighteen years old, a black Thunderbird convertible. It was as if she were giving away all her belongings.

Marilyn did all she could to be a good wife and take a backseat to Arthur's work. The ectopic pregnancy had undoubtedly taken its toll on her and she was drinking heavily. She might come out with, "I'm going to have sleep trouble again tonight!"[104] She was gaining weight and seemed to be off somewhere else; on one occasion, she fell coming down the stairs and twisted her ankle. The Millers were getting short on cash.

Her agents informed her that she should start looking seriously at propositions from Hollywood. In the summer, Fox Studios had offered her a part opposite Spencer Tracy in a remake of *Blue Angel*, which had made Marlene Dietrich famous in her day. Marilyn didn't exactly say no, but she stalled for time. Tracy had stated that he would do it if his name were placed above Marilyn's on the titles and the movie posters. Just before signing the contract, in a dramatic turn of events, his New York lawyers declared that Fox owed him more than $100,000, as they had not allowed him to make a film in 1957. Marilyn owed Fox only two films, according to her contract signed in 1955. Meanwhile, Fox Studios was interested in buying the rights to Miller's film script for "The Misfits," but was not ready to sign any contract with him as long as his situation with the HUAC had not been cleared up. Marilyn was holding out, hoping to play in *The Misfits*, when Billy Wilder sent her a two-page summary of an old German film that had already been made in 1932, *Fanfare of Love*. Wilder offered her the role of Sugar Kane, a pretty singer who plays ukulele in an all-female orchestra. Two male musicians disguised as women had sneaked into the orchestra, had eyes for her, and were competing with one another to win her over, playing on their ambiguity as transvestites. Marilyn found the role to be ridiculous, another tremulous dumb blonde. Arthur needed money and encouraged her to take the role, so she agreed to do *Some Like it Hot*. Wilder wanted to shoot it in black and white so that the

[104] Spoto, *op. cit.*, 395.

men's make-up wouldn't stand out too much, but Marilyn was skeptical about the idea.

The story takes place in the middle of the Prohibition era on the date of the mob's Saint Valentine's Day Massacre. A sheriff sneaks, undetected, into a coffee bar, which is decorated for a fictitious funeral, and tastes what is supposed to be coffee, but the drink is cold—it's whiskey! So, the shootout starts and our two hapless musicians (played by Tony Curtis and Jack Lemmon) dress up as women in order to escape from the henchmen, who are looking for the witnesses. The two "men" leave for Florida on tour with an all-female jazz orchestra.

Marilyn couldn't figure out how her character would not see that these two were men dressed up as women. Strasberg reminded her that she had often complained that women had been wary of her because she was too attractive and that she had so wanted to have women friends. Pretty Sugar should be happy to make friends with the two newcomers to the orchestra, he argued. Meanwhile, the two boys are thrilled by the charms of adorable Sugar, but have to be content to fawn over her merely as women friends. The actors had to invent this "calm" feminine complicity, yet, in the film, it's easy to see that it is all contrived.

At the beginning of 1958, Marilyn landed in Los Angeles, accompanied by her secretary and Paula Strasberg. The producer put on a gala dinner party to announce Marilyn's return to Hollywood. Everyone was enthusiastically waiting for her arrival. She appeared at the end of the evening, in a dazzling white dress, and the reporters were in a frenzy. Shortly before filming began, the appeals court struck down Miller's sentence. He was free.

Unlike other actors who could joke around on the set and quickly get ready for takes, Marilyn needed silence, time, discretion, and Paula to be ready to start filming. Nothing about what went on in her dressing room leaked out to the press. Wilder understood that she couldn't manage without her acting coach. He disapproved of the Actor's Studio method and thought that Marilyn had found the character herself and would do better to stick to her instincts. But, because she had been indoctrinated into the Strasberg way of improving her character by way of introspection, Wilder went along with it. To counter the isolating effect that Paula had on Marilyn, he would ask Paula her advice on takes, in that way defusing the eternal conflict between himself and the coach. From then on, he had no more problems with

Paula Strasberg, but there was still disagreement concerning Sugar's character. Marilyn didn't want to exaggerate the obvious, but Wilder asked her to emphasize Sugar's character traits—astonishment, fear, surprise, guilt—as if she were a little girl who had done something wrong. Marilyn wanted to tone it down. She often demanded to do retakes and did it her way. She fought to play Sugar the way she understood the character. Her actions were very uneven: sometimes she was there right on time and got it right on the first take; other times, she could be extremely late, forget her lines, and falter, which required numerous takes. Totally unpredictable, she was perfect more often than not, but, when she couldn't do it, she absolutely couldn't do it. It was her idea to include the blast of steam so she could make a spectacular sidestep as she's sauntering sensually along the train platform, an idea that Wilder adored. Sometimes, she never showed up at all and Miller played the mediator. It was like an expensive prizefight. In September, she wrote a letter asking for help from her friends, the Rostens: "...I have a feeling this ship is never going to dock. We are going through the Straits of Dire, [and] it's rough and choppy." As a postscript, she added, "Love me for my yellow hair alone!"[105] Her hands shook when she wrote.

One day, Paula found Marilyn unresponsive after she had been vomiting—she had taken too many sleeping pills. She had to be hospitalized and her stomach had to be pumped. Marilyn wanted to stop filming, but Miller talked her out of it. Her gynecologist came to the set to watch over her. She was hardly sleeping and was always extremely late. When she became pregnant, she stopped taking sleeping pills. It took her at least two hours to get ready and even more to be ready to start acting; her pace was infernal, her entourage was at the breaking point. Wilder continued filming under extreme tension and Marilyn kept on with her own schedule. Miller insisted that they slow things down.

Thus, despite all the difficulties, filming ended on November 6, 1958—twenty-nine days over schedule. Marilyn was not invited to the wrap party that Wilder gave. She was admitted to Cedars of Lebanon Hospital, either for exhaustion or for fear of a miscarriage or overdose.

[105] *Ibid.*, 402.

Chapter 11

Marilyn went to the airport by ambulance so as not to "shake up the baby."

The bitterness and stress of filming were quickly forgotten when the film came out. At the first showing, in December 1958, the spectators laughed from the first minute until the very last. At the same time, Marilyn suffered a miscarriage in New York. *Some Like It Hot* was a resounding success and brought in a huge amount of money for the studio. Once again, the great star was left alone, having lost her baby, while everyone else was amused by her performance.

She blamed the miscarriage on Arthur Miller, who had pushed her to make the film, and on Billy Wilder, who, she felt, had mistreated her. She was suffering greatly while Wilder laughingly recounted to the press that working with Marilyn Monroe was so difficult, physically, that it made him want to beat his wife, just because she was a woman! These remarks illustrate just how exasperating certain men found it to give in to her demands and her style, demands and style involving more the creative side of film-making than the business side of it. Marilyn reacted violently to these public remarks and asked Arthur not to let such insults go unchallenged.

When one views this film—such a masterpiece of comedy and subtlety, full of ambiguity and parody on masculinity/femininity, with its overall impression of levity—it is hard to imagine the terrible suffering that went into its making. Marilyn plays so delightfully and mischievously all the subtleties of the male/female divide. She resonates and allows her partners to be excellent, with her mimicry, her voice, her paleness, her undulations, and her false naïvety.

In the train, when Daphne (Lemmon) has to convince himself, he repeats, "I'm a girl! I'm a girl!" (She) He can't give in to his male desire for lovable Sugar but (she) he has to turn his (sexual) desire into affectionate friendship between women. What torture! It's hilarious. You can't help laughing throughout the film at the ambiguities that are so aptly handled, right down to the famous last line: the millionaire's fiancée dares to admit that she's not a real blonde.

No problem!
She can't have children!
Who cares, we'll adopt!

Pulling off her wig, she finally admits that she's not a girl: "I'm a man!" Her future husband exclaims: "Nobody's perfect!" Even if his wife is not a girl, but rather a boy, he'll take her/him anyway, because

"nobody's perfect!" Something got to him and, boy or girl, it will be fine. Neither the one nor the other is totally a boy or totally a girl. So what?! You don't have to be a woman to be a wife. Does perfection mean that sex and gender coincide? Yes, but only in outward appearance, because this coincidence doesn't exist. Marilyn's secret was in understanding this. She seemed to know, more than anyone, the degree to which femininity (or masculinity) was made up, a false front, mimicry, a lure, a performance. All alone, she kept up this performance throughout the film and was then disowned from it as being a mere troublemaker; it is, in fact, she who, in never giving in and thus keeping up the tension with everyone else on set, made the film into a masterpiece.

On tour to promote the film, Marilyn was unfailingly charming and cheerful and the film was immediately a box-office smash. Yet, within herself, despite the accolades, as always, she was discontent with her performance and with the role she had been made to play. What's more, the film won Oscars, but she did not, which affected her greatly. However, she was nominated for a Golden Globe for Best Actress in *Some Like It Hot*.

12
TEMPESTUOUS AFFAIR WITH YVES MONTAND–*LET'S MAKE LOVE*

In order to meet the studio demands, Marilyn's lawyers officially declared to Fox that she was "ready, willing and able" to shoot the next film.

At the time, she was living partly in Manhattan, where she could make frequent visits to her psychoanalyst, and partly in her country home in Connecticut, which she adored. It is not known why she stopped taking classes with Strasberg. Perhaps it was due to Arthur Miller, who wished to get Marilyn out from under the influence of the director of the Actor's Studio.

Fox tried to arrange for Marilyn to star in *Time and Tide*, directed by Kazan, but, yet again, Kazan did not choose her for the expected role. At the same time, Marilyn's lawyers were busy at work: they were demanding payment for the two films for which she had been called in but not chosen (**Blue Angel** and *Time and Tide*). In this way, she would be freed from one of the three films she owed Fox.

In June 1959, Marilyn underwent surgery at Lenox Hill Hospital for endometriosis, which had probably caused her successive miscarriages as well as the considerable pain she suffered during menstruation.

Meanwhile, John Huston had agreed to direct *The Misfits*, written by Miller, under the condition that Miller rewrite and condense it. Miller cared deeply about this script, which he wanted to offer to Marilyn. She would finally have a role worthy of her talents and with an ethical message. At the country house, he set out to rewrite and finish the script.

Alone in Manhattan, Marilyn once again accidentally took an overdose of barbiturates. Panicked, she called their friends the Rostens, who took her to the hospital where she had to have her stomach pumped. If Lena Pepitone, her cleaning lady at the time, is to be believed, she was already secretly seeing John Fitzgerald Kennedy.

Fox got wind that Marilyn had undergone surgery during the same period when she had been declared "ready, willing and able" and threatened to sue her. The studio was in a tough fight with her law-

Chapter 12

yers, but, finally, in August 1959, Fox gave in to Marilyn's conditions. She would owe them only two more films.

Another project was in the making—a film entitled *Let's Make Love*. George Cukor would direct and Gregory Peck would star alongside Marilyn. She flew out to Los Angeles alone to meet the producers and attend a luncheon in honor of Nikita Khrushchev. The Master of Ceremonies of the luncheon was Frank Sinatra.

By the end of the summer, Miller had finished writing his script and Fox was in a position to make Marilyn a serious offer. Huston confirmed that Miller's script was superb, so all that was left to do was to schedule the project. At the same time, Marilyn was also trying to get the starring role in *Breakfast at Tiffany's*, inspired by Truman Capote's novel. The author had written the script with Marilyn in mind. She was clearly using various strategies for her future projects.

Strasberg had been denied the job as Director of Lincoln Center, predetermined for Elia Kazan. After some hesitation, as well as a secret reconciliation with Miller, Kazan accepted the position.

Marilyn had asked the great choreographer Jack Cole to direct her for the song and dance sequence in *Let's Make Love*. She was enthusiastic about the project, but could not completely make up her mind about doing it. When Cukor arrived in New York to meet her, she complained about the script she had just read, whereas, at the outset, she had agreed to appear in the film. She demanded that her husband be allowed to work on the plot and rewrite it. Miller got to work on it in exchange for the tidy sum of $15,000, under the condition that his working on it would remain a secret. Did they need the money? Were they trying to stall for time until they got absolute confirmation from the studios to start work on *The Misfits*?

When Miller finished his rewrite of the script for *Let's Make Love*, with Marilyn's role much enhanced, Gregory Peck then backed out as the role of his character had been considerably whittled down. Many actors were approached, but none agreed to do the film. Miller had the idea of Yves Montand, whom he had met in New York and Paris, but Montand's English was poor. Simone Signoret, whose command of English was better, managed to land him the role by promising to help him with his lines.[106]

[106] Simone Signoret, *La nostalgie n'est plus ce qu'elle était* (Paris: Seuil, 1976).

As for *The Misfits*, Robert Mitchum was approached, but declined after reading the script, which he found to be muddled and quite uninteresting. Clark Gable was asked, but also declined. Huston gave Miller the task of convincing Gable to do the film and Miller came up with an idea. When he pitched it as not a true Western, but as an "Eastern Western," Gable accepted.

For the auditions for *Let's Make Love*, Marilyn was often absent. She was taking too many pills (Demerol, Amytal) and not only had she gained weight, but also her speech was often slurred and she looked bad on screen.

On the other hand, she once again did a terrific job with the press. She declared publicly that Yves Montand was the sexiest man she knew, apart from her husband and Marlon Brando.

A genuine friendship developed between Marilyn and Yves Montand, who both suffered greatly from crippling fear of appearing in front of the camera. They gave each other mutual moral support and the atmosphere on set was, for the most part, much more benevolent. This time, Marilyn was not blaming everyone else and Signoret realized that Marilyn had been ill-treated and denigrated; others had always been trying to trip her up. The affection and intelligence of both Montand and Signoret helped create a more understanding and generous setting for Marilyn's work. Montand felt that Miller didn't fully grasp the extent to which Marilyn could be seized with panic. Signoret helped her husband a great deal and practiced his lines with him. Marilyn woke up each morning at 5 a.m. because it took her three hours to complete the transformation into Marilyn Monroe. She never went out other than to work. Signoret noted that in the space of four months they only went out three times; otherwise, they were either working or they stayed home.

A strike interrupted filming and Miller went back to New York. When the film shoot started up again, Marilyn could only work for half a day at a time. Cukor was on a diet and bided his time by actually eating paper! It was clear that Marilyn was troubled, but everyone thought it was because of tension between her and Miller. They suspected that perhaps she wasn't on the same wavelength with him regarding *The Misfits*, the project he cared about so much. Had she already embarked on a complex and dangerous affair with John Kennedy? Was she having trouble with Paula Strasberg since the estrangement from Lee? Mari-

lyn seemed to be in a more serious state of suffering now and those around her were worried about her.

Marianne Kris knew that Marilyn was anxious about filming and was taking too many pills, so she sent a psychoanalyst friend to offer his help. Ralph Greenson went to meet her at the Millers' bungalow in the Beverly Hills Hotel and, starting in January 1960, Marilyn met with him every day when she was in Los Angeles.

Greenson, a close friend to Anna Freud, was one of the founders of the Center for Psychoanalysis in Los Angeles. He held the title of Department Head at the Psychiatric Center of the Cedars of Lebanon Hospital and taught psychology at UCLA, where he was well known for his teaching style and very much appreciated by his students. He was the analyst to the stars. He had been a member of the Freudo-Marxist group of Jewish doctors who had emigrated to California.

Arthur Miller left for Ireland to work with John Huston. One day, Marilyn did not come out of her room and had not contacted any of her friends, not even Yves Montand and Simone Signoret. Montand slipped a note under Marilyn's door saying that he was not her enemy, but rather her friend. He said that she could have told him she wouldn't be on set because that would have spared him from showing up for no reason. He added that he simply didn't care that she had grievances with the bosses and that "capricious little girls have never amused me."[107] Signoret recounted that, as the note was pulled under the door, inch by inch, they felt relieved, but Marilyn still would not answer the door. On the phone from Ireland, Miller asked Montand to please try again and, finally, Marilyn opened the door. She fell into Signoret's arms, crying, "I'm bad, I'm bad, I'm bad, I won't do it again, I promise!"[108] Marilyn had been upset about the lighting on set, fearing she would be mistaken for a redheaded dancer. She was sulking alone in her room because she felt that no one was taking her seriously about this detail.

Simone Signoret and Marilyn became very close friends and Signoret also got along well with Miller. In her autobiography, Signoret highlights Marilyn's solitude, professionally speaking:

[107] Quoted in Leaming, *op. cit.*, 345.
[108] Simone Signoret, "Marilyn Without Makeup," *The New York Times*, May 7, 1978.

...But listening to her, you'd believe the only satisfaction as an actress she ever felt was during those disguises [posing for Avedon], when she suddenly turned into Marlene, Garbo and Harlow... none of those moments of uproarious giggles among pals... none of the noisy hugs and kisses after a scene when everyone knows all have acted well together. All these things were unknown to her [...I couldn't fathom it...].... She made me tell her my own stories... stories of marvelous complicity.... Possibly she encountered that complicity for the first time in her life when she filmed with Montand.[109]

This is interesting, coming from Simone Signoret, who had also known the anxiety of filming and who had shared professional complicity with her husband. She could easily see just how different Marilyn was and how she remained alone in her creative space, precisely without any bonds with fellow actors.

Signoret tells about how Marilyn hired her own personal hair colorist and had her flown in from San Diego, an elderly woman who had done Jean Harlow's hair thirty years before. The limousine would deliver her to Marilyn's kitchen, where she would work on bleaching both Marilyn's and Signoret's hair with hydrogen peroxide, all the while telling both sad and happy stories about Harlow and her downfall: "The old lady was reliving it all as she spoke about the past. We were eating up these stories about the past and we would trade glances when the old lady became too emotional and had to stop." Marilyn chose platinum blond and Simone a more auburn-blond tone. The old lady would stop to tame an unruly hair on Marilyn's head and then go on, her voice lulling them: "She [Marilyn] believed in her. She liked and respected her. She was perfectly willing to pay for her round trips from the Mexican border, her limousine rides and her caviar."[110]

At the time, there were much more perfected ways to dye hair than using hydrogen peroxide, but Marilyn must have found it to be a sort of magic link to Jean Harlow, whose first name she shared and whom Marilyn had idolized in her youth. The nice old witch with all her little bottles certainly played a role in creating this dazzling alchemy.

[109] *Ibid.*
[110] *Ibid.*

Chapter 12

When Miller was away, a friendly kiss between Montand and Marilyn crossed the line into the realm of passion. They began a love affair that lasted just as long as the two other spouses were away. The hotel cleaning staff quickly spread the rumor and the news got out all over Hollywood. Marilyn really seemed to want to make her marriage work, and it was rumored that she was doing it just to try to make Montand divorce, thereby giving her more sway over Miller. Filming was consequently delayed. At the time, Montand allegedly said that, if Signoret had thrown him out, he would certainly have started a solid relationship with Marilyn. But Simone seemed to accept the situation. Even though she knew about it, she reacted in a dignified, high-minded way and their marriage survived. However, the affair made the tabloid headlines as much in France as in the US and Signoret was unhappy about all the foolish, indecorous hype. Miller, on his side, acted as if nothing had happened and he was not at all concerned. The only thing that concerned him was to get started on filming *The Misfits*. Marilyn wanted to get a reaction out of Miller; she swore that Montand was ready to divorce for her, but Miller replied that it wasn't true. Marilyn allegedly ran into Montand at the airport in New York and tried once more to convince him to leave Signoret, but he wouldn't give in. The paradox is that, later, Cukor had a nearly impossible time trying to get Marilyn to come do a day of post-synchronization work in July because she refused to see Montand.

The storyline of *Let's Make Love* is quite mediocre, somewhat macho, and full of leftist clichés: the rich Frenchman is supposed to be stupid and mean because he's a millionaire. The dancer is a modern, courageous young woman who is attending night school. Scene after scene, a theater troupe satirizes the period by mimicking star singers such as Maria Callas and Elvis Presley, but they also make fun of the French millionaire Jean-Marie Clément.

The film makes a transition from one type of film that was popular at the time to a more pared-down style of acting with more choreography, closer to the musical comedies that would become more common in the 1960s.

Yet *Let's Make Love* is worth seeing to appreciate Marilyn's astonishing performance, especially powerful in the scene where she sings "My Heart Belongs to Daddy." Daddy (the name she used for her husbands) is the owner of her heart. This dear, sweet old Daddy is the reason why she can't go with boys who ask her out. *My name is*

Lolita... And er...I'm not supposed to play !...with boys! Moi? Mon Coeur est à papa. You know, le propriétaire. No! I know that you're perfectly swell, but I simply couldn't be bad. *Cause my heart belongs to Daddy, Da, Da, Da, Da, Da, Da, Da, Daaaaaad.* She gets down on all fours and crawls through the boys' legs. *My little old Daddy, My heart belongs to my Daddy, Da, Da, Da.* She throws her sweater up into the air and, as it lands on Montand's fascinated and speechless face, she continues: *That little old man treats it so....good!* She plants a kiss right on a boy's lips and the director of the comedy within the film shouts "Perfect!"[111]

Marilyn's psychoanalysts must have been overwhelmed by this crazy ride she had embarked on. They had learned that the incestuous desire between daughter and father must be repressed and can only come out disguised as a symptom. Here, Marilyn uses her genius to dance, sing, and act out a warm, beguiling love for Dad. Here is a father who is not at all repressed, but rather is the owner of her Lolita heart. This allows her to tease the boys and show them that she desires them, but she can't do anything because her heart belongs to her Daddy. Post-feminists used Marilyn's performance here to underline just how blind psychoanalytical doctrine was to the fact that, between father and daughter, there can be real explicit and intense desire, sometimes acted upon. By overplaying it as Marilyn did, something comic emerges and brings levity to the very idea. By thus making the cherished father comical, something shifts and is set in motion. This parody has much to say about the relationship between men and such a girl who suffered from a complete absence of love from Daddy.

[111] *Let's Make Love*, directed by George Cukor, performed by Marilyn Monroe and Yves Montand (Los Angeles: Twentieth Century Fox, 1960).

13
THE MISFITS—AN ORDEAL

Miller took care of everything: he kept watch over Marilyn and dealt with her agents, her director, and her producers, never letting her down. Then he went to wait for her in Nevada to begin filming *The Misfits*.

Several years earlier, Miller had written his first script for the film, inspired by the people he had met in Nevada. At the time, Marilyn was working on *Bus Stop* in the same region. Inspired by the rather 'lost' cowboys he met, he wrote a story based on what he described as the emptiness of existence. Later, he strived to construct a woman's role that would fit Marilyn best, precisely different from the eternally naïve, somewhat feebleminded, glamorous macho tease. Her character, Roslyn, finds herself in Reno, somewhat reluctantly seeking a divorce. She finds solidarity with her landlord, an older 'professional divorce witness,' a sturdy female character, used to dealing with the turmoil of women on the verge of divorce. She advises Roslyn not to dwell on it: "Drink up!"[112] Roslyn is irresolute; she is so beautiful and so pure that she lets herself and her landlord get involved with Guido, a young man who acts as a driver for the various characters in the story. He is hired to take an old cowboy friend of his, Gay, to a shack in the middle of the desert. Guido's wife has died; thus, the shack is deserted and it becomes the setting for the vacuity of their lives. There ensues a love story between Roslyn and the old cowboy Gay, who find themselves there as if by chance. Gay, the cowboy, played by Clark Gable, is alone, having left wife and children. This band of misfits picks up another character along the road: Perce, a rodeo rider. They all set up house together and Roslyn "enchants the deserted house"; she's energetic, pragmatic, emotional, sentimental, and joyful. It is clear how much Arthur Miller loves Marilyn, as shown through the eyes of Gay—the film

[112] Arthur Miller, *The Misfits* (London: Methuen, 2002).

Chapter 13

is in fact a love story. Gay says to her, "You're a real beautiful woman. It's almost kind of an honor sittin' next to you. You just shine in my eyes.... What makes you so sad? I think you're the saddest girl I ever met!" These were the exact words Arthur had spoken to Marilyn. In the film, Roslyn answers, "You're the first man that ever said that. I'm usually told how happy I am." Gay: "That's because you make a man feel happy." She answers, "I don't feel that way about you, Gay." One can justifiably imagine that Miller simply transcribed a conversation between himself and Marilyn. She was a beautiful image projected onto an abyss of sadness. And when the young cowboy, Perce, falls during the rodeo, she suffers for him and along with him. Guido says to her, "You care. Whatever happens to anybody, it happens to you. You're really hooked into the whole thing, Roslyn." She answers, "People say I'm just nervous." Guido continues, "If it weren't for the nervous people in the world, we'd all still be eating each other." Then she realizes they are going to hunt down the wild horses and sell them to be killed. And the drama begins there, because Roslyn suffers for these persecuted animals; she finds the hunt to be cruel and gratuitous, a completely male manifestation. The men remark upon a bright star shining in the sky: its light is so intense because it is in fact already dead—a metaphor for this woman, Roslyn/Marilyn.

She asks Gay:

- You kill them?
- No.... I just round 'em up.
- But you know what you're doing isn't right, don't you?
- If I didn't do it, somebody else would.... Nothin' can live unless somethin' dies.... All I know is everything else is wages. I hunt these horses to keep myself free. So I'm a free man. That's why you liked me, isn't it?
- I liked you because you were kind.
- Honey, a kind man can kill.
- No. He can't.
- I could have looked down my nose at you, too. Showin' yourself off in a nightclub for so much a night. But I took my hat off to you, 'cos I know the difference.

Reality suddenly dawns on her and she is filled with tenderness for him:

- You took your hat off to me? You mean that, don't you, Gay?[113]

Respect, such a piercing word for Marilyn as she was persuaded that she had never been respected and never would be. She had come to New York to be a respected actress. She knows in the most heartfelt way that no one respects a sexy girl from nowhere who demands the right to appear desirable. For the others, for the 'respectable' kind of people, she'll always be a tramp.

In the film, everyone can see that Roslyn is totally upset and cannot bear to watch this cruel capture of the horses. One by one, the horses are lassoed and pulled down to lie on the dusty ground. With her rage and pain, Roslyn exposes the absurdity of this mustang hunt, its completely outdated character. She humanizes the event and reveals to each of the characters the side of themselves that no longer wants anything to do with pleasure in destroying life. They all begin to love Roslyn even more and each of the men wants to win her over and steal her from old Gay. Guido (Eli Wallach) is ready to betray his old pal, while Perce (Montgomery Clift) wants to give up horses all together for the love of Roslyn. She doesn't fall for any of it and remains faithful to her man, even though he causes her pain. She shows her confusion and anger. The scene is at its climax when Gay sees Roslyn becoming frenzied, shouting insults and demanding to buy the horses herself so they won't suffer. Deep down inside, Gay is also ready to give up the hunt, but he can't bring himself to give in to a woman's demands; he can't allow himself to defer to her. She insults the three men and yells, "Killers! Murderers!... You're only happy when you see something die!... You're three dead men!" She has rejected Guido's clumsy advances and he reacts by speaking ill of her, "...She's crazy, they're all crazy.... You struggle, you build, you try, you turn yourself inside out for 'em.... I been thinkin'.... the world is full of mountains, there's horses. Probably we could clean 'em all out..." Gay doesn't go along with this misogynistic ranting and tells Guido to shut up. At the peak of the tension, Perce silently goes to set the stallion loose. The horse bolts off in a gallop, magnificent and free. But Gay hurries out to recapture the stallion and lassoes him back again. In a prodigious face-to-face power play, he forces the horse to the ground. He goes on to do it with each horse, one by one, to the point of exhaustion. And

[113] *Ibid.*

Chapter 13

then, in one sudden and firm gesture, he sets all of the horses free again. He has shown that he could do it, he has proven to himself that he would not give in—neither to the demands of a woman in distress nor to those of a traitor. Because he loves Roslyn and because, deep down, he is not a bad person, he frees not only the stallion but all the horses—a decision all his own. In short, he shows that there is a difference between the cruelty of wanting to kill or alienate the weakest and the pure pleasure of hunting, detached from the pleasure of hurting. Gay does not aim to hurt and he has demonstrated this to Roslyn. She pulls herself together, shows her love for him, and speaks about having a baby: "Gay, if there could be one person in the world... a child who could be brave from the beginning... I was scared to when you asked me. But I'm not so much now. Are you?"[114]

They are together again, in love, exhausted, but going towards what new direction? The highway is empty and wide; the desert stretches out under the starry sky.

Roslyn: "How do you find your way back in the dark?"

Gay: "Just head for that big star, straight on. The highway's underneath, it'll take us right home."

Because she loves him, Roslyn brings the old cowboy into the modern world. She has shown to him that his pride in hunting mustangs, his joy of being a free man in the desert, no longer means anything in today's world; that's all over. To give up this egotistic pretension also means to accept life, to accept a new child, to no longer feel afraid. But is this really true? Home: is it where the unending earth meets the sky? What is this infinite, desert vision if not one of death? Miller ends his scenario with a mystic fusion of love on the threshold of the beyond.

As for the psychological turmoil on the set of the film, different biographers have different interpretations, based on the same unchanging available documents.

Since the filming of *Let's Make Love* had gone overtime, *The Misfits* was necessarily delayed. Marilyn finished work on post-production sound (and her break up with Montand) on the first movie and immediately starting filming again on the next.

[114] *Ibid.*

On July 20, 1960, a crowd waited at the airport for Marilyn to arrive: Miller, the reporters, the governor of Nevada and his family. The heat was crushing—between 100 and 104 degrees. She must have been exhausted already. Spoto notes that the producer of the film, Frank E. Taylor (Miller's close friend and editor), John Huston, and Miller himself had decided to neutralize Paula Strasberg by refusing to speak to her. When Marilyn understood their strategy, she became enraged and called Lee Strasberg, who flew in at once, dressed head to toe in cowboy regalia. He threatened to take his wife back to New York if Miller continued to mistreat her. Finally, Paula stayed. Miller remembered it differently and wrote that Paula treated Marilyn as a child and isolated her from everyone, especially from him. He found that the Strasbergs took advantage of Marilyn's fear of not being a good enough actress and kept her more and more dependent on them. He wrote that they spoke a special language between them and that Paula Strasberg was slightly crazy, an opportunist calculating to isolate Marilyn from Huston and from Miller: "Between takes, she would retire with Marilyn to her trailer, where, when I entered, they would usually fall silent, just as they would before Huston."[115] Paula was always there, dressed completely in black, counseling Marilyn. They all hated her and called her Black Bart.

Marilyn seemed to be consuming too many barbiturates because she was in such pain. Huston was gambling and losing money every day. Clift was drinking too much. Gable was drinking and smoking too much. Miller was writing furiously. Huston had hired him to re-write a large part of the script and Miller worked night after night rewriting as filming went on. Each morning, he gave the new script to the actors. The situation was unbearable to them all, but especially to Marilyn, who was a perfectionist and worked slowly. It was also unacceptable to Clark Gable, who declared one day that he would not accept any more changes in the script.

The filming was "total chaos." Gable was paid highly, but had the habit of taking great risks. At one point, he had himself pulled in the sand behind a car at 25 MPH and came out of it completely drained. A stand-in for Clift was severely hurt by a horse.

[115] Serge Toubiana, "Black Desert, White Desert," in *The Misfits: Story of a Shoot*, by Arthur Miller and Serge Toubiana (London: Phaidon, 2000), 79.

Chapter 13

The heat, Marilyn's physical and mental pain, the heated atmosphere between Miller and Paula Strasberg, the conniving between Huston and Miller, Huston's heavy losses at gambling—all served to aggravate tensions between Marilyn and Miller. Greenson, Marilyn's psychoanalyst, was not far away from the set and was prescribing drugs for her. She even had injections and had difficulty waking up in the morning. She was said to have a faraway look in her eyes and had to wear a wig to conceal her hair, which had been heavily damaged on the previous film set. A certain disagreement about Roslyn's character persisted between her and Miller, as Marilyn apparently thought that Roslyn was too passive and too naïvely emotional. She resented Arthur for having written a supporting role for her in a script that was essentially about men, whereas he had continuously promised to write her a dramatic role, his gift to her. In this script, her character is still an unknown who just happens to find herself there and is only necessary because she is beautiful and moving, therefore playing the mediator between the men. The theme of the film is an intellect's reflection on the state of the US. All in all, Marilyn, as a well-loved person, herself as a "state of the world," as an enigma, as a unique personality, was not really the subject of the film. The script—written, rewritten, and rewritten again every night of the filming—was like daily torture between them. Marilyn couldn't sleep. She could no longer complain about the others and find solace with Arthur. Instead, she complained to Paula about him—this was a major turnaround for the couple.

Many believe that Marilyn was not only the recipient of, but also the inspiration for, the character of Roslyn. Marilyn loved animals to the point of throwing small fish back in the ocean when the fishermen rejected them. Miller had come to Nevada to get a divorce to be free to marry Marilyn, and there he had discovered this strange desert place of "misfits." Here were people who had come to get a quickie divorce and had never left, individuals who roamed about in this place of lost, isolated, odd souls who could not easily communicate with others. Miller had noted that, when in Nevada, you have to give up all that you hold dear and all that defines you, any worry about time or accent, everything that identifies you. He tapped into these immense desert spaces—his state of distress, his chance encounters that spoke to him of his own condition, of the condition of late 1950s America, of people left out of the new advances in technology, but also of cowboys who knew that they were just a pale comparison to the real cowboys, the

ones in the movies. Americans' lives were no longer their own, but rather seemed to resemble those in a Hollywood script. In fact, the only communication between individuals had to be somewhat based on a script, had to resemble a commonplace story, already written. Here, in the film, Miller put into the action the exchange he had witnessed between these lost souls and this infinitely empty space. The close-ups that Huston shot bothered Miller and gave the text more power over the image, he thought. He would have preferred "...a grey salty lake miles long, surrounded by a Paiute Indian reservation, a forbidding but beautiful place."[116] Something funereal should come out of this lunar image and give the feeling of the presence of death. Miller felt that Huston did not manage to convey the feeling of death alongside the love that bound these misfits together.

The goal was to show isolated people who could not manage to communicate. During filming, Marilyn and Arthur became more and more isolated from one another and communicated less and less.

According to Miller, things started to go wrong when Marilyn became ill. He says he went from feeling happy to feeling sad, but he does not say what illness Marilyn had. In many still photos from the set published by Magnum, one can see scenes of happiness among the cast and crew. They look like they are having lots of fun, whether it is Miller showing Eli Wallach how to dance with Marilyn or whether it is the staging of the group shot for the film.

Sinatra invited Marilyn to the Cal-Neva Lodge on Lake Tahoe. They all went to spend the weekend there with him. A scene was shot there with Roslyn coming out of the lake. Some sources attest that JKF and Sam Giancana (one of the Chicago Mafia bosses) were on the guest list that weekend. Was Kennedy there? The upcoming elections and the eventuality of his win probably changed his involvement with Marilyn. The people who went regularly to Cal-Neva Lodge were important for the Democrats' campaign. JFK's father, Joe Kennedy, allegedly went there and negotiated Mafia support for his son's election. The crisis between Miller and Marilyn on the set of *The Misfits* was no doubt aggravated by the visit to Lake Tahoe. Three weeks later, Marilyn was hospitalized.

[116] *Ibid.*, 50.

Chapter 13

Marilyn was still thinking about Montand; the two of them were slated to go to the premiere of *Let's Make Love* in Reno on August 21, 1960. The press was eager for gossip and ready to pounce on them, but a fire destroyed the Crest Theater in Reno and the premiere did not take place there after all. Meanwhile, Montand had accepted to give an interview to a popular magazine. However, he managed to avoid doing it and let it be known that his was but a minor role and all that was really required of him was to do a good job in the love scenes for which he had been hired. Maybe this was his way of publicly saving his marriage. To do this, he needed to make a mockery of his affair with Marilyn. **The schoolgirl crush on me** was what the notoriously malicious gossip columnist Hedda Hopper reported he'd said. Signoret wrote, "...it can't be true, if for no other reason than that its grammatical form and its difficulty of pronunciation would have cost Montand a week's hard work."[117] Signoret wrote that Hedda Hopper had two weapons: "words that wound or silence that kills." Simone Signoret thought that Hedda Hopper had chosen to remain silent about her, which probably saved Signoret from the usual infighting among Hollywood stars and probably allowed her to win the Academy Award for best actress for her role as Alice in *Room at the Top*. For Marilyn, Hopper had chosen to use hateful words, maliciously attributed to Montand. Some think that it was Hopper's reporting that made Marilyn break down to the point of requiring hospitalization. To the indiscreet questions that reporters asked Montand, he and Signoret often replied that the film itself had provoked the situation. After all, the title was *Let's Make Love*, and Marilyn and Montand's supposed affair had simply been a misguided embodiment of the movie, nothing more. There was no need to make a big fuss about it. This clearly seems to be a French point of view! Signoret was not angry with Marilyn and she disapproved of the meanness and razzing by the press. After Marilyn's death, Signoret wrote, "...She never knew how thoroughly I had understood the story that was no one's business but ours, the four of us."[118] Signoret criticized Arthur Miller for having written *After the Fall* after Marilyn's death. A play that made a mockery of Marilyn was obviously regrettable.

[117] Signoret, "Marilyn Without Makeup," *op. cit.*
[118] *Ibid.*

Simone Signoret had understood that Marilyn and Montand had probably formed a strong bond of affection, partly due to their extreme insecurity about acting, and that it was no one's business other than the group of four people concerned.

At the end of August, Marilyn was hospitalized for a week of rest at Westside Hospital. Peter Lawford, an actor and JFK's brother-in-law, was allegedly among the group of people who took her to the hospital.[119] Some say that Huston had racked up such huge gambling debts that he had to find a way to raise funds for weekly salaries and that he needed a week's official break in shooting the film to do so. He had supposedly made a deal with Marilyn's doctors and set it up with them. Others say that Marilyn was exhausted, suffering from overuse of barbiturates and in need of rehab. All of these factors resulted in her hospitalization, which Greenson arranged.

When she was released from the hospital, seemingly in fine form, she was acclaimed by a crowd in Reno there to greet her. She had not lost her knack for making an appearance; quite the contrary. In fact, several of these improvised "appearances" wound up in the film in the end. In a bar that the cast and crew often went to, Marilyn had started playing paddleball with the others and, by chance, someone filmed the scene just for fun.[120] This scene was included in the film and is a pivotal one. And the famous scene where Marilyn dances around the tree in the moonlight—so graceful, almost mystical—was also improvised. It was a moment of her own invention, caught in the course of the action when she is slipping away from Guido the traitor, who is trying to kiss her. There again, her performance was not cut, despite the Catholic censor's strong objection to the tree scene. They called it the "masturbation" scene and demanded it be left out.

Cartier-Bresson said of Marilyn, "The first time I saw her in person I was struck as by an apparition in a fairy tale... there is something extremely alert and vivid in her, an intelligence. It is her personality, it's a glance, something very tenuous, very vivid, that disappears, that appears again."[121] All agree that she had an amazing faculty to shine intensely even while receding from view. Huston wrote, "...She was

[119] Wolfe, *op. cit.*, 437.
[120] James Goode, photographer, wrote an account of the filming entitled *The Story of the Misfits*. This gives many photographic and written details.
[121] Quoted in Miller and Toubiana, *The Misfits: Story of a Shoot, op. cit.*, 71.

Chapter 13

taking pills to go to sleep and pills to wake up in the morning.... She seemed to be in a daze half the time. When she was herself, though, she could be marvelously effective. She wasn't acting. I mean she was not pretending to an emotion. It was the real thing."[122] In the end, she was forgiven for her frequent delays.

Miller had written this role as a gift to her, to help her get over her fear of inadequacy as an actress. He later acknowledged that it had had the opposite effect. Day after day, his gift became agonizing torment for her and, on the last day of filming, they separated. The funereal transformation that he had evoked for the story had materialized between the two of them. After the end of filming, Miller began a relationship with the photographer Inge Morath, whom he had met on the set.

Her psychoanalysts and her acting coach had not managed to help curb Marilyn's stage fright, her tardiness, or her drug use. When she had to play very emotional scenes, she had a slight trembling in her lips. This is reminiscent of another tic, a "breath from beyond," which can be seen in her following unfinished film, *Something's Got To Give*. At times, her face seemed to be at odds with the rest of her body, pale and mask-like, somewhat puffy. Undoubtedly, with the influence of the Strasbergs and the Actor's Studio combined with psychoanalysis, Marilyn was able to refine her transformative talents each time she appeared, but she paid a very high price.

The goal of the *Misfits* project was to strengthen their relationship and to bring the recognition for Marilyn that Miller had so hoped for. Instead, it brought about the final end to their marriage, leaving them both devastated, and yet none of the reasons cited above can completely explain their split.

This brilliant film shows how a man can come to desire a woman if she shows herself to be steadfast to her principles, even if the price she has to pay is the disdain of those around her. It deals with a quandary Miller had for himself, except that here, in this story, he took it to a gloomy conclusion. Whereas, for Marilyn, it was still just a role, even if her improvisation did draw on experiences from life—her own as well as that of the character. These Nevada misfits meet and find love, but the men connive together secretly, desperadoes, and their

[122] *Ibid.*, 80.

foolish actions isolate the woman they hold in such esteem. She becomes enraged because she had so hoped for something completely different. From their common bond as misfits and deserters, she had expected to find a new pureness, a mutual understanding between men and women, a new direction in life, without fear. She feels completely betrayed when she realizes this is not the case and the violence of her anger leads them to another level of understanding, even if they resist it. Something is now irrevocably concluded: they will have to begin living in a different way, perhaps conforming as working men; they will have to reinvent themselves. The role of Roslyn provided the trigger for truth. It was not a supporting role, contrary to what Marilyn thought; it was a difficult and compelling role with unmistakable impact. Marilyn's role in *The Misfits*, like her role as Nell in *Don't Bother to Knock*, was the only one where she wasn't ruefully required to play the sexy, flirtatious blonde. But the experience of making the film was so overwhelming that it radically brought to light the degree of misunderstanding between Marilyn and Arthur Miller. The finality of their breakup was probably exacerbated by the sordid third-party turmoil unfolding behind the scenes on set.

Was *The Misfits* responsible for the cold, bleak, silent breakup that ensued between Marilyn and Arthur Miller? If so, it was devastating for her... and dreadful for him.

14

ARTHUR MILLER, FORTY YEARS AFTER—STILL UNFINISHED

In his autobiography, Miller relates how Marilyn called him several weeks after the end of filming for *The Misfits*, surprised that he had not come home.[123] At the time of their painful breakup (end of 1960), he had already begun work on a play, the theme of which was a man's confession. The main character is Quentin, for whom acceptance of denial was the way into his own soul and for whom "innocence kills."[124] Miller wanted to create distance between Maggie, the character who is doomed to die, and Marilyn, who was struggling alone with her next film. Finally, it was when he was completing the writing of *After the Fall* (1962) that news of Marilyn's death broke. Without knowing it, yet all the time knowing, he had written his version of his relationship with Marilyn.

Maggie is already a revenant, dead for fourteen years, when she appears to her husband Quentin out of the ruins of a concentration camp. "She said some ridiculous things. But one thing struck me; she wasn't defending anything, upholding anything, or accusing—she was just there like a tree or a cat."[125] Quentin felt strangely "abstract" beside her.[126] "... [S]omewhere along the line—with Maggie, I think—for one split second, I saw my life.... And that vision sometimes hangs behind my head, blind now, bleached out.... Maybe that's why she sticks in my mind...." Maggie tells Quentin that, without him, she would never have seen an agent and would never have been as successful

[123] Miller, *Timebends, op. cit.*, 521.

[124] Miller was inspired by a visit he made with his new wife, Inge Morath, to the concentration camp, Mauthausen, as well as by his attendance at the trial of the guards from Auschwitz.

[125] Miller, *After the Fall, op. cit.*, 55.

[126] Miller would later admit, "Women are livelier than men and more interested in people. Men get abstract with their ideas." Quoted from an interview with Deborah Solomon, "Goodbye (Again), Norma Jean," *NYTimes Magazine*, September 19, 2004.

Chapter 14

as she was: "... [J]ust the way you looked at me... like... out of your *self*... it gave you a secret satisfaction?... I'm a joke to most people."

Quentin: "... [A] girl I'd laughed at like the others.... Why did I lie to her, play this cheap benefactor?... The first honor was that I hadn't tried to go to bed with her! She took it for a tribute to her 'value,' and I was only afraid! God, the hypocrisy!... [W]hy is betrayal the only truth that sticks?" Maggie offers to accompany Quentin to Washington, where he will have to appear before the HUAC; she would register in the hotel under an assumed name "... 'cause I can never remember a fake name, so I just have to think of nothing and that's me!" She would register as Miss None, which sounds surprisingly like "neon."

Quentin reflects on the fact that he "brought the lie that she had to be 'saved'! From what? Except my own contempt!" Maggie knows that he was ashamed of her. During their marriage, she had reproached him for being cold, for never holding her tightly enough. She insults him: the only thing that really interests him is money. She insinuates that he's a "fag," tries to swallow some pills, and treats him with disdain. He doesn't want to be the one who stops her from overdosing again. Quentin accuses Maggie of wanting too much from him and of trying to set him up as her "murderer." He'd rather turn her over to the doctors for help. Seeing that he is trying to slip away, Maggie screams and rages at him. Right then, she reminds him that the day she felt like she wanted to die was the day she discovered this sentence in his diary: "The only one I will ever love is my daughter." Marilyn had, in fact, discovered something hurtful in Arthur's diary when they were in London and, as a result, had taken a massive dose of barbiturates.

Quentin answers by saying that the greatest failure for him was "the worst thing I could imagine—that I could not love." He adds, "Always in your own blood-covered name you turn your back!" He shows he can relate to the feelings of guilt felt by the survivors of the concentration camps. The play ends with Maggie's death, left alone with her pills. Quentin then affirms his new love for a woman he has just met in Germany.

Maggie—ever inconsistent, high on drugs, lost in a world of predators and greedy users—incarnates the innocence that Quentin refutes, but which is so central to his very life. The play caused a scandal and was met with harsh criticism—the public and the critics saw it as a vicious attack on Marilyn so soon after her death.

Another great surprise: in 2003, at the age of 88, Arthur Miller completed a play entitled *Finishing the Picture*. Forty years after the fact, he once again returned to the subject of his separation from Marilyn at the time of *The Misfits*. The simple fact of writing this play seems logical to me. All these years, Miller seems to have been dogged by the unresolved, the unfinished.

Who would play Kitty forty years later?

In October 2004, I flew especially to Chicago to see a performance of *Finishing the Picture*.[127] Finishing? Finish, finish off, be done with. With what? *What Picture*? Finish the film *The Misfits*, which almost didn't get finished? One could go on and on: put an end to Marilyn, finish up the relationship with Marilyn, finalize the image and the portrait of the beautiful star, impossible to deplete the stock, still alive. For Miller, how to finish and come to the end of his life, in his own language—the theater—with Marilyn? These are the thoughts that came to me before I went to Chicago to see the play.

Miller starts their story where it left off, exactly at the moment when he put an end to it, when *The Misfits* almost didn't get finished. He produced his own version, "It's my truth. It's not your truth."[128]

Unlike *After the Fall*, this play is written with affection and subtlety.

The cast and crew are staying in a hotel in Reno. A businessman and producer, Philip Ochsner, is summoned to save a film from bankruptcy. The money problems are due to repeated lateness on the part of the lead actress, Kitty, who is in such a state that she can't get out of bed and go to work in the morning. Ochsner, in a patient and kind way, tries to clear up this sad situation. He finds the film thus far to be "cold" and "remote" and he finds that Kitty has "a spooky look." Early in the morning, he looks out his hotel window and worriedly remarks a flaming sky—a forest fire in the distance.

Let us remember that, in August 1960, a fire had destroyed the movie theater where Marilyn was to appear with Montand for the premiere of *Let's Make Love*. At that time, newspapers had printed degrading remarks about her, which Montand had allegedly made. She had greatly suffered from this and was unable to work, taking barbitu-

[127] Goodman Theater, Chicago, October 2004.
[128] Solomon, "Goodbye (Again)," *op. cit.*

Chapter 14

rates to allay her stage fright in the day and sleeping pills at night. She had been hospitalized for a week.

In Chicago, the play starred well-known movie actors (Matthew Modine, Stacy Keach, Frances Fisher). No mention is made of *The Misfits*; it is simply a random film which might be shut down. Everyone—the producer; the director; the director of photography; Edna, the assistant; Paul, the writer (husband of the main star)—is worried and hounded by the crew, who are chafing to get busy. Kitty, a worldwide star, refuses to get out of bed. No one really knows what's wrong with her—it's a mystery. Is it total exhaustion, or a complete fear of acting, or depression caused by repeated insults about her in the press? She is so moving, so marvelous, so adorable, so beautiful in all the rushes. Everyone is trying to understand this strange affliction that is making her act so strange and so torpid, sometimes vacant-eyed. They're going around in circles, trying to analyze the situation, completely frustrated by the money being lost and the exhaustion of it all. It is stifling hot. The husband is questioned and says that his wife is haunted by ghosts and that she is simply trying to survive. Ochsner takes pity on her and would do anything to remedy the situation. He voices his admiration for her: "she's a miracle...."

A week's hospitalization for Kitty is considered. Due to the fire and the occasional power cuts it causes, the insurance company will have to pay costs. Derek, the director (i.e., John Huston) is worried; he knows the actress well and thinks that the acting coach was wrong to come between him and the star. The assistant is devoted to the star; she knows that Kitty is a professional and a perfectionist who wants to work, but who is torn between her husband and her acting coach and is taking refuge in drugs. To make a film with this star, you've got to pay the price. The director of photography doesn't worry about all those details; he says she's splendid, that the camera loves her, that she has a living, animal-like quality to her skin. With her, as with animals (mustangs are brought to mind), you've got to use love and threats; even they don't know why they do the things they do. The assistant bristles at such base ideas because she believes Kitty has a soul. The director of photography answers that he's not filming soul, but rather skin and "ass," and Kitty has what it takes. On the other hand, he has noticed that she forgets her lines. Paul, the husband, says it's the fault of the acting coach, Flora (Paula Strasberg), who exhorts the star to use her

emotions so much that she forgets her lines. Besides, the coach only inflames the star's mistrust of everyone else.

Is Kitty the only one responsible for everything that's wrong? Or are the others using her as an excuse for all the flaws in the filming?

Meanwhile, the star has been seen wandering naked in the hotel, as if lost.

The highbrow acting coach has sent for her husband Jerome (Lee Strasberg), the famous New York acting professor, in whom Kitty has complete trust. Will the film be saved?

Will the actress be able to finish the picture or not? This is the burning question.

The assistant declares that Kitty thinks everything is fake.

The husband is assailed to find a way to urge his wife on. He affirms that in fact his wife understands only the language of love, real love. He explains to the others that even if they love and admire her, they will never get through to her because the financial side of their dealings with her is an obstacle to real love. In the movies, nothing is real and everyone is treated as just a commodity. They want her to be beautiful, healthy, magical, whereas she may be feeling like she wants to die. He is desperate; his relationship with her is at a breaking point. He has conscientiously written the script, but resentment is growing between them. Does she really exist? She has become "a phantom, a curl of smoke," and yet she really exists, he says. If she falls, everything will fall: her worldwide fame, the film, the bankers who curse her. Everything will crumble; she will be the one who'll be responsible for it and detested. So, she really must exist if only as "a figure to hate." Paul continues: she speaks to her analyst and even he is unable to help. But wasting his time and energy is exhausting for him. They are all afraid of her and don't know why.

Miller describes Jerome (Lee) as grotesque, pretentious, totally imbued with his superiority. He's had a brand new cowboy outfit delivered for himself, just like on the set of *The Misfits*. The audience bursts out laughing at the sight of the great professor clownishly struggling to pull on his brand new red cowboy boots. He's got to keep his wife (the coach Flora) quiet because he has understood that she went a little too far and was wrong to get between the great director and the star—something you simply mustn't do. Besides which, this is the greatest film director of the moment and the professor has come only out of professional friendship. He clarifies that he only speaks

Chapter 14

to his students, it's up to them what they do with his advice; he can't guarantee anything. The situation is totally out of hand; everyone is up in arms.

Obviously, the scope of the disdain put into this caricature shows that Miller blames Lee and Paula all the more as he cannot admit his own part of responsibility for all that went so wrong during the filming of *The Misfits*.

The third act takes place in the bedroom where Kitty is resting. She is either silent or she is screaming. Other characters answer her, but the public can't hear what she is saying. Derek, the director, understands that she wants to finish the film. She thinks that her lateness is because of her art; she compares herself to Michelangelo, who was also notoriously late. Ochsner explains to her that she should stop fighting it, that she is so exceptionally good that she should just go do it. No one wants to get mixed up in her anger and bitterness towards her husband. As time is compressed, they all affirm to her that they respect her completely, that she is wrong to doubt them. All the old, tired, clichéd descriptions of Marilyn are pushed to an extreme again and again.

The play is almost over, only 15 minutes left to see if the film will be made or not. Enter the long awaited Jerome. Right off the bat he orates to Kitty about the famous Eleonora Duse, for whose talent Marilyn had complete admiration. Paul comes into the room and interrupts the professor's long monologue—Kitty screams and her husband asks her if she agrees to be hospitalized for a week. Of course, she does not want to be and continues screaming. Paul castigates the professor and asks if he wants to assume responsibility for Kitty. Jerome refuses. Paul yells at Kitty that she will have to give up the idea that her professor has her own best interests at heart and that, if she excludes him, her husband, she will be alone in the world. She was completely wrong to have trusted in those people.

Jerome, again alone with Kitty and in a hurry to leave, suddenly declares that the week of hospitalization is a good idea. He goes on talking about Eleonora Duse and skirts around the idea that if she, the star, goes down, he does not want to be brought down too. And then he hears her tell him that she wants to start working right away. This shows that Miller understood that Marilyn had not given up on the film. Jerome, surprised by this change in heart, immediately claims responsibility for convincing her, announces it to the others, and leaves.

Everyone is happy and overcome with emotion, even if wary about the star's sudden change in heart and her decision to want to work. Edna doesn't want to place the blame on anyone and assures Kitty that her husband adores her.

Finally, the star gets out of bed and puts on her makeup. The others are all waiting anxiously on the couch, worried, ready to change their minds about Jerome. But Derek, the director, assumes his rightful place. He's going to deal directly with Kitty and keep her acting coach at bay. When Kitty is ready, he takes her in his arms, we hear her say yes. They take a few steps together and then she collapses in a heap.

As the others look on dumbfoundedly, Paul gently picks her up and carries her back to the bed. Kitty is docile and strokes him tenderly. She says that she nevertheless wants to start working right away in the afternoon.

Ochsner refuses. His mind is made up: she will be hospitalized to rest for one week and the filming will start up again afterwards.

The assistant tells Paul, "Kitty loves you," and he answers, "She doesn't *like* me."

Edna reminds him that Kitty didn't fight it this time when Paul took her in his arms. Paul is despondent and waves her away with a sign of despair and refusal. He says that what had been so "alive and crazy" between them has been reduced to ordinary dust. They had shared a fabulous hope that had not transpired: "I didn't save her, I didn't bring the miracle." She didn't save him either and nothing has changed; it's a sad story. She is life, springtime, the river of hope.... She'll be back in a week and will finish the film. Edna implores him to not give up. He says, "No more. Just... no more."

He gives up at the instant he understands his own cowardice and he also understands that Kitty, even through her anger, continues to love him. He backs down at the prospect of a future that terrifies him.

Outside, the sky is blue again. Edna and Ochsner have fallen in love, as if to signify that life goes on. There will be other love stories.

Here, on stage, we see the instant when Arthur gave up on his love for Marilyn, even though she had not left him. A *no more, no more* of elusion before the next step. He turned away without even saying goodbye, lost in the bitterness of his disappointment and despair. Miller gives no lines to Kitty; he supposes that because he cannot put words into Marilyn's mouth, none would have been right. Only the physical presence of the actress is there, carrying the mystery, a

Chapter 14

black hole, the origin of all misunderstanding, of all questions—his and those of others. The most significant aspect of this play is the wordless presence of the actress.

The Misfits was the script of this couple's history. Arthur Miller had not understood at the time that Marilyn was not simulating her dizzying moods, the source of all her incredible incapacity to appear and perform. Their love was a great source for her creativity, as long as Arthur could bear it.

As soon as Arthur backed out of their couple, something died for Marilyn. She had to keep up the struggle alone.

However, the unfinished business went on for Arthur for years. As life went on, he understood that Marilyn had held something essential within her. He says so in the subtle debate during the play when each is confronted with his own incomprehension and blames the other for it. Miller also shows that he had not been capable of meeting Marilyn's demands, that, at the time, he hadn't realized the scope of what she needed and, most of all, he had not stood by her.

Miller had started to write the play twenty years before, but he had put it aside in despair. After his wife Inge's death, it simply came back to him; he related that he did not know why, that he didn't understand the creative process. His son Robert, who loved Marilyn, said he felt that, if his father needed to write about their separation, it was because he wanted to be fair with himself and fair with Marilyn. It is clear that the tone of the writing is much more attentive, reflective, and loving compared to *After the Fall*.

No more, no more: a strange choice for the last words of his play. A week of rest in a hospital in no way cleared up the unfinished business of *The Misfits*. There was no real ending to their love story. From Nothingness to No More, Arthur's attachment to Marilyn remains decidedly *unfinished*. In spite of its title, the play *Finishing the Picture* in no way finishes the story.

It was, in fact, Marilyn's next film that remained unfinished. For *Something's Got to Give*, Marilyn struggled but did not prevail.

The facts are that the film, *The Misfits*, was completed. But can we say that Arthur Miller ever finished his attachment to it, or his attachment to Marilyn?

15
SOMETHING'S GOT TO GIVE

The day after filming on *The Misfits* wrapped, Clark Gable had a heart attack. Marilyn immediately blamed herself for having kept him waiting so much during the making of the film. On November 8, 1960, John Kennedy was declared president, but there was some uncertainty as to whether or not he had actually won the election. The mayor of Chicago, Sam Giancana's friend, had to hold a recount of the votes in Cook County (election fraud was well established in this county) so that Kennedy could be declared winner by a slight majority over Nixon, who had been in the lead up to the end. On November 10, despite his promise to do otherwise, Kennedy announced that he would keep Hoover at the head of the FBI. In order to make up for this necessary concession, he named his brother Bobby as Attorney General, a position where he could keep control over the hostile and furious Hoover.

On November 11, 1960, Marilyn returned to New York. On November 12, the New York tabloid *Daily News* caused a sensation with the headline "MILLER WALKS OUT ON MARILYN." She was assailed by a horde of reporters. On November 16, Clark Gable died. The devastating effects of *The Misfits* were in full swing.

Marilyn's days were spent either at the office of her psychoanalyst, Marianne Kris, or working with Lee Strasberg, who wanted to direct her in an adaptation of Somerset Maugham's *Rain*. Fox offered her the starring role in *Goodbye Charlie*, directed by George Cukor.

She had to wear a disguise when she left her home and she supposedly presented herself as a secretary when she secretly went to meet Kennedy at the Carlyle Hotel.

On January 14, 1961, Marilyn wrote a new will. She left money to her half-sister and to her friend and secretary May Reis. To her mother and to Mrs. Tchekov, she left a trust fund that would give them an annual income (in both cases she left money to friends as well as family). 25% of her remaining fortune would go to Marianne Kris, "to be used

Chapter 15

by her for the furtherance of the work of such psychiatric institutions or groups as she shall elect."[129] The 75% remaining was left to Lee Strasberg. The following year, Marilyn called in her attorney to rewrite her will, but she died before it could be signed. (As a result, her estate went to The Anna Freud National Center for Children and Families, a children's charity for child mental health services, and to Lee Strasberg's third wife, who had never met Marilyn.)

In order to escape the reporters' attention, Marilyn chose to file for divorce in Mexico on the same day that Kennedy moved in to the White House.[130] Miller publicly declared that he was so very saddened by the divorce. However, he would later suggest to an interviewer that, if he hadn't divorced, he "...might not be there talking about it." He seems to be suggesting that if he had stayed married to Marilyn, he would be dead. This surprising affirmation, made after their divorce, strongly resembles a justification of his despair and of the ordeal he was avoiding by divorcing.

Marilyn was completely shattered. On January 31, 1961, she was escorted by Montgomery Clift to the opening of *The Misfits*. Sad and disappointed, she left quickly without speaking to Miller. Yet again, she was dissatisfied with her work when she observed it being presented to the public.

She asked Miller to allow her to take her belongings from their house in Connecticut. He was not there the day she went and she took this as his clear wish to avoid seeing her.

Marilyn subsequently shut herself inside her Manhattan apartment and would neither eat nor speak to anyone. She was overusing barbiturates again and her psychoanalyst feared for her life. A house employee claimed to have found her preparing to jump out the window. Marianne Kris advised her to hospitalize herself voluntarily and drove her in her own car, where she was admitted to the Payne Whitney Psychiatric Clinic at Cornell University-New York Hospital, under the name of Faye Miller, on February 5, 1961. She was placed in a locked and padded room and she was completely unprepared for this. She sobbed and screamed and demanded to be released, but her pleas fell on the doctors' deaf ears. Two days later, a nurse brought her

[129] Spoto, *op. cit.*, 454.
[130] January 20, 1961.

some writing paper and she wrote out a cry for help to the Strasbergs: "....I'm locked up with these poor nutty people.... Please help me. This is the last place I should be...."[131]

There was no reply from the Strasbergs (friends and neighbors to Marianne Kris), so Marilyn was allowed to make one telephone call. Miller debated going to help her, but decided to stay out of it. She tried to reach her New York friends to no avail, but at last reached Joe DiMaggio. He arrived at the hospital that evening and threatened that he would "take the hospital apart brick by brick" if Marilyn were not discharged immediately.[132] Kris suggested that Marilyn should go to another hospital. Ralph Roberts, Marilyn's masseur and confidant, drove Marilyn home, with Kris in the car. Marilyn "... unleashed a storm of protest and criticism against her therapist."[133] Later, Kris, trembling with remorse, repeated, "I did a terrible thing, a terrible, terrible thing. Oh God, I didn't mean to, but I did."[134]

Kris left for Los Angeles to consult with Ralph Greenson about their mutual patient and Marilyn never saw her again.

DiMaggio visited Marilyn every day at the hospital (she had moved to the Neurological Institute of the Columbia University-Presbyterian Hospital Medical Center). When she got out three weeks later, she was glowing and had lost weight. She attended the funeral of Mrs. Miller, her former mother-in-law. She still cared very much for her former father-in-law, Isidore Miller. She then left for vacation in Florida with DiMaggio.

In April 1961, Marilyn decided to return to California to live. She settled in to an apartment owned by Sinatra, with whom she seemed to have started an affair. In May, she was operated on at the Cedars of Lebanon Hospital for her chronic endometriosis. She was also suffering from pains in her side. Greenson did not like the fact that Marilyn was seeing so much of Sinatra (his former patient), whom he found to be a bad influence on her. She was allegedly drinking heavily and leading a dissolute life. She was also seeing the president of the United States.

[131] Wolfe, *op. cit.*, 457.
[132] *Ibid.*, 458.
[133] *Ibid.*
[134] *Ibid.*, 458, 459.

Chapter 15

Marilyn owed Fox Studios one more film. She was reticent to accept the role in *Goodbye Charlie* and she convinced Skouras to agree not to sue her for refusing it. The date to begin shooting a new film again was postponed until November 1961.

Marilyn flew back to New York on June 14, 1961, to undergo another operation—the removal of her gallbladder, which had caused her so much pain. DiMaggio accompanied her to the hospital and her half-sister, Berniece, took care of her when she was released. During the year 1961, Marilyn was hospitalized five times in ten months.[135]

Marilyn wanted to show her house in Connecticut to her half-sister and Ralph Roberts drove them there. He recounted that, when Marilyn went upstairs to get her fur coat and smelled someone else's perfume on it, she threw it in the trash. It seems that Berniece had come to see Marilyn after fifteen years of absence to talk about their mother, but also to get some money for her children's education.[136]

Marilyn returned to Hollywood in August 1961. She was counting on Greenson to help her decide what to do next. She went to visit Sinatra at the Cal-Neva Lodge on Lake Tahoe. She was on friendly terms with Kennedy's brother-in-law, Peter Lawford, whom Sinatra referred to as "brother in lawford"!

On October 16, Fox notified her that she would be making her next film under the direction of George Cukor. It was to be a remake of *My Favorite Wife*: *Something's Got to Give*. Marilyn had no good memories of working with Cukor. She is said to have told Greenson that she would commit suicide, afraid that Cukor would want revenge because she had caused problems on the set of *Let's Make Love*.

Meanwhile, Fox was in trouble; they were in financial straits due to the filming of *Cleopatra* and Liz Taylor's caprices. Skouras was ill and the studio had been shaken by the rise of television, the decline of the Hollywood system, and internal struggles between studio heads in Los Angeles and New York.

In October, Ralph Greenson decided to provide Marilyn with round-the-clock company and to ask her to fire her devoted masseur, Ralph Roberts. She did so half-heartedly. Greenson suggested a new companion, Eunice Murray. Marilyn had no idea that Murray said she

[135] Spoto, *op. cit.*, 467.
[136] Wolfe, *op. cit.*, 462.

had been a psychiatric nurse. She was said to be a strange person who "was always whispering."[137]

At the time, Marilyn was welcomed by the Greensons as a member of the family. Apart from her daily or bi-weekly analysis sessions, she was often at their house for dinner, went to concerts with them, or spent evenings with them and their friends. She also spent time with Greenson's daughter.

Biographers relate that Greenson was a member of the Comintern, where he was in charge of the Arts, Sciences, and Professionals Council. His friend and colleague, Dr. Hyman Engelberg, prescribed medications for Marilyn and was said to be a clandestine member of the Communist Party.

Greenson was a technical consultant on certain films and quite influential at Fox. The contract Marilyn had signed in 1955 stipulated that she would earn $100,000 per film. But she still owed one more film to satisfy the terms of her contract. At the time, this was still a ridiculously low amount compared to what other actors were earning (about $700,000). Why was Marilyn, who was the most lucrative at the box office, always paid less than the others? Why didn't her lawyer, her psychoanalyst's brother, better represent her interests? The story of the making of *Something's Got to Give* seems extremely complicated, involving more than just the usual Hollywood turmoil.

Very soon after beginning the film, David Brown, studio director and producer, was replaced by Henry Weinstein for the production of the film. This was done without Cukor's consent and he was furious. Apparently, Greenson had privately orchestrated this change. He was connected to Weinstein by way of Weinstein's sister, who directed the Comintern from London. Greenson apparently guaranteed that Marilyn would cooperate on set if the studio agreed to make Weinstein the producer. Greenson himself was officially employed as technical consultant on the film. Studio documents show many late-night telephone conversations between Greenson and important studio heads along with their respective lawyers. In addition, Shulman, who was rewriting the script, was also replaced by Nunnally Johnson. Marilyn had met Johnson in order to ask him to take part in the rewrite.

[137] *Ibid.*, 471.

Chapter 15

Marilyn seemed to be undecided about her various lovers (including President Kennedy) and was greatly affected by her divorce from Miller. She depended entirely on Greenson's advice and met with him frequently. He cancelled many other appointments or meetings in order to see Marilyn at his home rather than at his office. He seemed to have arranged for Marilyn to be surrounded by people who had ties to him and he advised her to buy a house in Los Angeles. She was hesitant, claiming that she felt more at home in New York or Connecticut, but Greenson insisted and asked Mrs. Murray to be on the lookout for homes for sale in his neighborhood. In January 1962, the Greensons took Marilyn to visit a house they had found for her and she decided to purchase it with the royalties from her two previous films plus a small loan. This was all arranged with help from her lawyer, Milton Rudin. She had a moment of hesitation before signing the papers for the sale of the Spanish hacienda-style house in Brentwood, similar to Greenson's own house. On the ground at the entrance to the front door, a tile was engraved with the motto "*CURSUM PERFICIO*" ("I complete the course [or race]"). Installed long before Marilyn bought the house, the motto on the tile could be interpreted to mean several things: I have finally found a place to live; to stop; to settle down; to die.

When Marilyn returned to New York to discuss her next role with Lee Strasberg, she learned of Arthur Miller's upcoming wedding to Inge Morath. She immediately flew to see her former father-in-law, Isidore Miller, to find some consolation. It was she who informed him of his son's imminent marriage. From there, she flew to Mexico to purchase furniture and art objects for her new house. She gave several press conferences and spent time in the company of people linked to the Comintern, notably Fred Field, thought to be a communist agent. She was seen with a young Mexican writer, said to be a leftist, a friend of Luis Buñuel, and she was under FBI surveillance during her time in Mexico. Biographer Wolfe writes of a censored document from the Mexico office of the FBI dated March 6, 1962, which classifies Marilyn Monroe as Security Matter – C (Communist).[138] In Mexico, Marilyn needed no sleeping pills, but, the day she returned to California, she took a huge dose. She was back in Los Angeles to accept the Golden

[138] *Ibid.*, 488.

Globe award as "the world's favorite female star." She was again assailed by crippling stage fright and she arrived at the ceremony drunk and staggering, her voice slurred, accompanied by her Latin lover. She made a very bad impression, but was not about to let herself be defeated yet.

She turned up right on time for the meeting at Fox to confirm her agreement to star in *Something's Got to Give*.

Sinatra had built a small runway so that planes bringing Marilyn and John Kennedy could arrive discreetly. Bob Kennedy thought that it would be bad timing for them to meet then, as he had just launched an offensive against organized crime. Lawford was given the task of informing Sinatra that the president would not be coming after all. In a rage, Sinatra took a sledgehammer and completely destroyed his new runway.

Greenson had been planning to take a trip to Europe, but was reluctant to leave his patient alone with all the problems she was facing, as he thought she wouldn't be able to cope without him there. On April 10, 1962, Marilyn turned up as planned "in good humor and full of energy," ready to start work on the new film. She went through costume and makeup tests, but Cukor did not show up, a surprising and rather disdainful attitude for the beginning of a film. Marilyn may have interpreted his absence as an affront to her and the next morning she was unable to wake up. Whenever Marilyn experienced what she thought to be even the slightest offense, she would resort to drugs to calm her distress and would often end up in a terrible, befuddled state.

George Cukor had in fact postponed the beginning of filming in order to have the script rewritten yet again, this time by Walter Bernstein. Marilyn took advantage of the delay to go to New York to prepare her role with the help of Lee Strasberg and to attend an event where President Kennedy would be. When she returned to Hollywood, she found that the new script was nowhere near as good as Johnson's version.

In the new script, Ellen Arden (Marilyn) is married with two children and is being pursued by her husband's boss. Dean Martin plays her husband, Nick. She is afraid she has ruined her husband's career by accepting the boss's advances. She is humiliated and leaves to fly to the Far East by way of Hawaii. However, Ellen misses her connection in Honolulu—a stroke of luck as the plane crashes into the Pacific. She

Chapter 15

stays in Hawaii, probably living with a man, and, after five years, suddenly has the urge to see her children. She returns to her home, but her husband, believing her deceased, has just declared her officially dead and has remarried.

A thirty-minute piece of footage from the film was edited in 2001, long after the original filming.[139] In this piece of the film, we can see the announcement of Ellen's death and Nick's subsequent remarriage. Ellen, who has come back to their house, is recognized by the dog but not by her children. She passes herself off as the nanny, but of course her husband has recognized her immediately and is terribly embarrassed. The imbroglio includes ongoing issues of yet-to-be-paid life insurance money as well as jealousy on the part of her husband. He is trying to find out details about the man she met on the 'desert island' where she claims to have been stranded all this time. She comes up with a bespectacled shoe salesman to act as the improbable 'pal' she found on the 'desert island'! She takes a noisy midnight swim in order to force her weak-willed husband to tell his new wife that his first wife has well and truly returned home and that the 'nanny' is in fact the wife!

Marilyn may not have wanted to do the film, or at least this seems plausible in view of the fact that her lawyer, Greenson's brother-in-law, took action and declared that Marilyn's contract had already been completed. On the first day of shooting, Marilyn stayed home with a cold. Cukor and the studio heads were sure she was faking illness and sent doctors to examine her. They all confirmed that she was genuinely ill and Mrs. Murray attested that Marilyn had, in good faith, ordered a limousine to come pick her up for work in the morning, but that her condition had grown steadily worse and she could not leave the house after all.

Marilyn did finally show up on set, but broke down after an hour and a half of shooting. Cukor had to begin filming scenes without her. The studio heads put pressure on Greenson, reminding him that he had promised to keep her able and working. On May 10, Greenson left on his trip to Europe and was highly criticized for doing so.

[139] *Marilyn Monroe: The Final Days*, dir. Patty Ivins Specht (Los Angeles: Twentieth Century Fox, 2005), DVD. A documentary including the making of the film and a presentation on the last days of Marilyn according to the official version, as well as 35 minutes of the film, presented by James Coburn.

On May 14, Marilyn was back at work. That day, she had to shoot scenes with the misbehaving dog. The dog would not cooperate and the scene had to be shot again and again, but Marilyn was very patient and pleasant. As Henry Weinstein stated in a documentary, they certainly should have had better things to do than to make their biggest star, who was sick besides, waste her time on filming with a dog. It was clearly a strategy to humiliate her. The following days, with the help of Paula Strasberg, Marilyn continued working, but it was common knowledge that she would not be there on May 19, 1962, because she was scheduled to sing for President Kennedy's birthday party in New York. This day off had already been stipulated in her contract and Henry Weinstein had given his okay. He suddenly changed his mind and she received an official letter informing her that, if she didn't show up on set that day, she would be out of a job. Everyone knew good and well that she would go to New York anyway. Many people involved in politics, mostly Democrats who frowned on Kennedy's relationship with Marilyn, advised Marilyn not to go to the party. Bob Kennedy was probably among this group. However, during break time on set, a helicopter arrived to pick her up for her flight to New York. Along with her press agent and her acting coach, she flew off to go sing at Madison Square Garden.

She came on stage, several hours late, dressed in a sequined sheath so tight she could barely walk. Lawford had announced her several times in vain and, when she finally did appear, he was unprepared, giving a comical character to her appearance. He made the unfortunate introduction, "Here is the *late* Marilyn Monroe"! Was this a reference to her lack of punctuality or an omen of her upcoming death?

Before a breathless crowd, Marilyn began by shielding her eyes from the glare of the projectors so she could see the person to whom she was dedicating her performance. She started in a low, sweet, sensual voice to draw out an erotic, breathy, and fragile "Happy Birthday To You, Mr. President." It was entirely Marilyn, an unbelievably intimate creative moment. The footage of her performance was shown around the world and has become legendary. Then, as the cake was wheeled out, she began to jump up and down happily like a little girl and exhorted everybody to sing along. Kennedy thanked her and added, "I can now retire from politics after having had Happy Birthday sung to me in such a sweet, wholesome way." It is certain that Kennedy was

Chapter 15

determined for her to sing for him. He was the one who had unreasonably insisted on this controversial performance.

During the reception that followed the event, pictures were taken of Marilyn in heated conversation with the two Kennedy brothers. All of those pictures except one were destroyed by the Secret Service. Marilyn is said to have spent the night with the president at the Carlyle Hotel, arriving via a secret passageway. She never saw him again after that night.

The birthday gala was widely reported. Marilyn had made such an inspired performance—which malicious gossip columns labeled as 'cheap' or 'torrid'—that the rumors of her liaison with JFK started up again with a vengeance.

On Monday morning, Marilyn was ready for filming at 6 a.m. She asked that filters be used on the camera to help hide her visible signs of fatigue. The morning after, she shot the famous pool scene where Ellen takes a midnight swim to get the attention of her husband (Dean Martin) and force him out of bed, where he is sleeping with his new wife (Cyd Charisse). She was to wear a flesh-colored bathing suit, but she decided to take it off and asked that everyone leave the set—everyone except the photographers and cameramen who continued shooting for about four hours. In this scene, once again, she improvises: swimming, turning around to face the camera, bursting into laughter. She is cheerful, happy, lively, mischievous as she invents the situation. The wonderful photos of the shoot were seen round the world, gracing the covers of seventy-two magazines in thirty-two different countries. This time, Marilyn was sure she would outdo Liz Taylor, who had bankrupted Fox with *Cleopatra*. The studio executives were enchanted with Marilyn and the mood at Fox turned optimistic.

On May 24, J. Edgar Hoover, the director of the FBI, demanded to meet President Kennedy. On the same day, the White House switchboard was given strict orders not to put through any calls from Marilyn Monroe. It is easy to imagine that Hoover was using Marilyn's presence at the birthday party and her status as SM (Security Matter) as leverage to get information from the Kennedys regarding Marilyn's supposed 'political' affiliations. Greenson, reputed to be actively left-wing, was also under suspicion, along with his network of friends and family.

Marilyn worked all week in a euphoric mood, but the following Monday she did not report for work. No one knew how she had spent the weekend. According to Don Wolfe's version, her press agent, Pat

Newcomb, had kept Marilyn sedated at home, where she did not leave her room. However, she did come to work on Tuesday. She was supposedly frantically trying to reach Frank Sinatra. On June 1, Marilyn's thirty-sixth birthday, the cast and crew had prepared a cake and champagne to celebrate. When the cake was brought out before 6 p.m., it had to be rolled back in again in order to wait for the officially allowed exact minute when work could stop and celebrating could begin, even if this particular celebration was quite modest and simple. Once again, the studio heads showed themselves to be outrageously petty and humiliating towards their star, who was making so much money for them and doing such high-caliber work. The following Monday, Marilyn was unable to work because of sinusitis. Cukor, officially peeved, demanded that Marilyn be replaced. He informed the mocking Hedda Hopper that Marilyn "was finished." Gossip had it that John Kennedy had broken off relations with her and that Peter Lawford and then Robert Kennedy had been chosen to deal with the sticky problem of Marilyn Monroe, which now openly irritated the president. Greenson was hurriedly brought back from Europe to go to Fox, where he met with the studio heads to re-negotiate Marilyn's return to work. His brother-in-law, Marilyn's lawyer Rudin, was also present. He guaranteed she would comply with the agreement, and yet, despite this, she was officially fired by Fox on June 8. The New York office studio execs had already made their decision and had gone over the heads of those in Los Angeles. Greenson's efforts were all in vain; he had cut short his vacation all for nothing.

 The attitude of Fox seems incomprehensible in view of the media sensation Marilyn had caused several days prior with the pool-scene photos. It is surprising that she should be fired and treated with such little regard. The excuse given was that she was always so late, but it is clear that other imperatives were behind the order to fire her. She was obviously a high risk with regard to the political powers-that-be as well as with the studio executives. Her excellent performances did not work in her favor.

 Degrading comments were reported in the press. It was said she had finally lost her head and she was the reason why the film crew was idle, unpaid without work. Forces were set in motion to destroy her image and her career. Telephone records show that calls were made between the Attorney General and Rosenman, the president of Fox Studios, which would corroborate the idea that Robert Kennedy had

plotted to have her fired and to disgrace her so she would remain silent. This theory was later debunked.

Of course, Marilyn reacted and called on her old enemy Zanuck for help. (Zanuck was the former head of Fox and had produced *The Longest Day* in France.) Zanuck was furious at the directors at Fox and shocked that they would treat the young star so badly. He promised to finish the filming of *Something's Got to Give*, with Marilyn in the lead role, as soon as he could regain control of his position as head of Fox.

Marilyn launched a counter-attack, according to interviews and photos from the top journalists of the day. She dictated over one-hundred telegrams to the actors and technicians on *Something's Got to Give*, explaining that she was completely opposed to the halt in filming: "An actor is supposed to be a sensitive instrument. Isaac Stern takes good care of his violin. What if everybody jumped on his violin?"[140] Marilyn compared herself to a trampled violin.

She posed for photographs with George Barris for *Cosmopolitan* and with Bert Stern for *Vogue*. She was interviewed by Richard Meryman, associate editor of *Life* magazine. The studio was swamped with letters of protest. And, when Dean Martin learned that Cukor had decided to replace Marilyn, he said he would drop out of the film if Marilyn would no longer be his co-star. Dean Martin was part of Sinatra's rat pack and, although the studio put pressure on Martin, he would not give in. His refusal to do the film without Marilyn made the headlines. Meanwhile, Zanuck was buying up stock in Fox so he could once again take control of the studio.

On June 23, Marilyn saw Bob Kennedy again at the Lawfords' home. The next day, he visited her at her home, where they went into the garden to speak privately. The day after that, Bob Kennedy made a phone call to Samuel Rosenman, the president of Fox. Peter Levathes then received the order to re-negotiate Marilyn's contract so filming could start back up. What was the deal that was made? Would it be that Bob Kennedy gave in under the pressure of public opinion and particularly that of Sinatra's group of friends in exchange for Marilyn's disappearance from the political arena? Had Marilyn convinced Bob that she was harmless and that Hoover was blackmailing the Kennedys? Levathes went to Marilyn's home to re-negotiate the conditions

[140] Wolfe, *op. cit.*, 531.

to start filming again. Marilyn was the consummate businesswoman—punctual, sober, precise, and demanding. Levathes was impressed to find himself dealing with someone completely the opposite of the degrading image her own studio's PR department had given of her. He accepted a rewrite of the script, including Marilyn's demands for changes. She would receive one million dollars upon completion of *Something's Got to Give*, and she would do another musical comedy, *What a Way to Go*. The studio agreed to go back to using Johnson's script and to replace Cukor with another director approved by Marilyn.

On the Fourth of July, Bob Kennedy and Marilyn Monroe saw each other again at a barbeque at the Lawfords', a conciliatory meeting. Their conversation that day later became a matter of "national security."[141] Fox was in a hurry to sign the contract and proceed with filming again, but Marilyn's attorney began delaying tactics. Marilyn knew that Zanuck was working to overthrow the power at Fox and take over again, but no one suspected this would happen. If Zanuck took over at Fox again, Marilyn would escape the clutches of the Kennedy clan.

In July 1962, the Cuban Missile Crisis led the world to the brink of disaster. The FBI and the CIA were still interested in Marilyn; her house was under electronic surveillance. What was of particular interest to them was her relationship, when she had been in Mexico, to Fred Field, who was suspected of being a Communist agent. Hoover told Robert Kennedy about his concerns, but Kennedy refused to speak to Marilyn about the matter.

Marilyn was seeing Greenson on a daily basis and was getting injections of tranquilizers. At the time, the doctors, as well as the Kennedys, wanted only one thing: to keep Marilyn quiet.

Marilyn suspected that her phone was being tapped. She was also aware that she knew too much about the Kennedy brothers—she knew about their connection to Sam Giancana. And, to top it all off, she had been present when Bob Kennedy had spoken about sensitive political matters. President Kennedy is also said to have spoken to her about classified information. After listening to tapes, one commentator remarked, "This deals with a phenomenal issue which could have

[141] Document censored by the FBI, as quoted by Wolfe, *op. cit.*, 538.

Chapter 15

changed world history: the hypothesis that anonymous bombers were sent to China to destroy nuclear sites."[142]

In the month of July 1962, Marilyn knew she was at a dangerous junction of political intrigue. Did she feel she had enough strength to withstand a probable reversal of power at Fox studios? She was terribly worried, knowing that the Kennedys were stonewalling her with something she couldn't comprehend. She hinted that she could make startling disclosures if she were pushed too hard. Making private revelations public was not at all her style; she was known for never speaking ill of anyone.[143]

On July 25, 1962, Zanuck was elected president of Fox Studios after a sordid power struggle among the executives, several of whom resigned. Skouros replaced Rosenman on the administrative council. Marilyn signed her contract. Was she out from under the control of those at Fox who were in the Kennedy camp?

[142] Testimony by Rothmeiler in the documentary *Marilyn: Contre-enquête sur une mort suspecte*, directed by Jean Durieux, Arnaud Hamelin, and Fabienne Verger (Paris: France 2, 1999).

[143] We know from the cassette she gave to Greenson that she upheld her admiration and esteem for John F. Kennedy. See Matthew Smith, *Victim: The Secret Tapes of Marilyn Monroe* (London: Arrow, 2003), 207. Revelations from these tapes will be evoked later.

16
KEEP MARILYN HUSHED UP—SHE'S DEAD

On the weekend following the signing of the new (and, at long last, advantageous) contract, Marilyn was invited by Frank Sinatra to come celebrate the event with him at the Cal-Neva Lodge. She was flown out on his jet and given a room in the very private area of the Lodge. Her name was not included on the hotel register. Marilyn became frightened and Peter Lawford and his wife were summoned. This was unusual because, since the incident with the Kennedys, Sinatra had refused to see Lawford. There must have been some more important reason to justify the presence of Lawford and his wife. Sam Giancana was also present. Many testimonies and hypotheses have been recorded about this terrible weekend. What comes out of all of them is that everyone concerned seemed to fear that Marilyn would divulge information and had an interest in keeping her quiet. It was said that she was drugged and raped by the men present. During the sordid orgy, she was allegedly photographed in a very compromising position.[144]

Sinatra had forbidden Joe DiMaggio's presence. Marilyn had probably called him to ask him to come help her.

In the early hours of the morning, Lawford accompanied Marilyn back home—she was in a terrible state. The limo driver reported that he had to stop the car so Lawford could make a call from a phone booth. It was later discovered that he had called the White House.

What is incredible is that Marilyn did not breathe a word about this nightmare. She bounced back and planned a number of new projects, organizing her work and her travels. She asked a private detective, Fred Otash, to set up wiretapping in her home. In fact, he was already in the process of doing this, an order made by someone else whose identity is still not known. Don Wolfe believes it was count-

[144] A reported nine photographs in which Marilyn can be seen on all fours, straddled by Giancana—as yet unpublished.

Chapter 16

er-espionage forces who were trying to get evidence against Kennedy. Sinatra was provided with the compromising photographs, which undoubtedly had been taken in the aim of blackmailing Marilyn to keep her silent. The events of that horrible weekend were corroborated by the FBI, which had Giancana under surveillance. The nightmare had really happened! It is mind-boggling to think that her friend and protector, Sinatra, along with her friend, Lawford, had drawn Marilyn into such a trap. Whether the reasons for it were real or imagined, they must have been considerable! Marilyn kept quiet.

She began to want to distance herself from the people who had previously been so indispensable for her. She sent Paula Strasberg back home to New York on a one-way ticket, perhaps signaling an end to their work together. She allegedly planned to fire both Pat Newcomb, her publicist and a friend to the Kennedys, as well as Eunice Murray, her companion and friend to Greenson—perhaps even to dismiss Greenson himself. She must have believed she was strong enough to do without all these people whose behavior had been ambiguous and deceitful. They were all there as her supporters, but also as self-serving spies. Did she believe she had the inordinate power to vanquish all those who threatened her?

On Friday, August 3, she and Pat Newcomb dined at the Lawfords' home. Marilyn drank too much and the evening ended with a fight between Marilyn and Pat. Marilyn knew that Bob Kennedy was probably in the vicinity, but she could not get in touch with him; he would not take her calls. She was suffering from acute insomnia and, on Saturday, the fight between Marilyn and Pat intensified. No one is sure of the reason for the dispute; Marilyn allegedly begrudged Pat's having slept soundly the night before. What is likely is that their argument concerned the Kennedys. The result was that Pat was fired, but she did not leave immediately. Eunice was also fired and she called Greenson to ask him to come over right away. She did, however, pack her bags.[145]

[145] It is known that Marilyn wanted to get rid of Mrs. Murray, but feared that Murray would furnish the press with sordid details. She wanted Greenson to help her with a strategy to make Mrs. Murray leave. Perhaps this strategy was already in place, since, on the day Marilyn died, Mrs. Murray's bags were already packed. She was to leave that day or the next. See Wolfe, *op. cit.*, 565.

According to Don Wolfe's investigations, on Saturday, August 4, in the beginning of the afternoon, a helicopter delivered Bob Kennedy to Fox Studios, where Peter Lawford was waiting for him. Testimonies to this fact came out long after Marilyn's death.

Norman Jefferies, Marilyn's handyman (and Eunice Murray's son-in-law), stated that Bob Kennedy and Peter Lawford arrived at Marilyn's house sometime between 3 and 4 p.m. Pat Newcomb was still there. Jefferies affirmed that Lawford asked him to go do some errands with Mrs. Murray. When they returned to Marilyn's house, Kennedy and Lawford were gone and Marilyn was furious and seemed very afraid. Surveillance audiotapes indicated that Bob Kennedy and Marilyn had made love and then had a heated argument. On tape, Marilyn can be heard saying that she felt used and passed around, like a piece of meat! And Bob was yelling, "Where is it? Where is it?" He must have been talking about the famous red notebook in which she had recorded all her conversations with him. The tapes of that afternoon were seized by the police in 1966, during a raid ordered by New York District Attorney Frank Hogan, a close associate of Bob Kennedy.[146] The tapes are still unattainable today.

Eunice reached Greenson on the phone, who then came and stayed with Marilyn for about two hours. He later said that his patient told him she had envisioned terminating her 'therapy' with him because he was beginning to 'annoy' her!

Pat Newcomb went to dine at the Lawfords, announcing that Marilyn would not come because she didn't feel well. Marilyn herself called Lawford, but what she said is unknown.

Don Wolfe has another legitimate hypothesis, based on the testimony of the handyman Jefferies, among others, who affirmed that three men came to Marilyn's house shortly after 9:30 p.m.; one of the men was Bob Kennedy. He asked Jefferies to leave with Eunice and they did leave, but they remained in the neighborhood. At 9:30, Marilyn's Mexican lover, José Bolaños, called by chance from a bar near Marilyn's house. She told him about "...something shocking... something that will one day shock the whole world."[147] There was a commotion at the door and Marilyn put down the phone to go see what

[146] Fred Otash made the tapes for Bernie Spindel, who was unable to get them back through litigation after they had been seized.

[147] Wolfe, *op. cit.*, 572.

it was; she didn't hang up, but she never came back to the phone. On audio tapes, Bob Kennedy can be heard saying, "We have to know, we have to find it, it's important for the whole family..." (sounds of rifling through cupboards... books being opened and closed). A voice says, "...Calm down," and Marilyn yells, "Get out!," followed by a banging sound and voices trying to calm her and put her to bed.[148]

At about 10:30 p.m., Marilyn made a frantic call to Lawford in which she allegedly said, "Say goodbye to the president." When Lawford tried to call her back, her phone lines were consistently busy. He immediately called friends, the Naars, and asked Joe Naar to go see what was happening at Marilyn's house. But just after that call, Lawford made another call to Naar and told him that everything was okay and that it wasn't necessary for Naar to go to Marilyn's. It seems obvious that, in the time between the two calls, Lawford was contacted (by whom? Mrs. Murray? Pat Newcomb?) and told that it was best not to inform anyone about the situation. Fearing that it would be found out that the Attorney General was present at Marilyn's, Lawford decided it was better not to tell anyone about the situation and to go there himself.

In the last part of the audiotapes, there is talk of "...organizing a call from Marilyn's as soon as Bob Kennedy has left. Marilyn is in a coma."[149]

When Jefferies and Eunice got back, Marilyn was "...unclothed and lying across the daybed" in the guest cottage: "...She was facedown, her hand awkwardly holding the phone. It didn't look to me like she was breathing and her color was awful—like she was dead."[150] According to this version, she would allegedly have been poisoned by Bob Kennedy and his men. Eunice called an ambulance and Jefferies went to the front gates to wait for it to come when he saw Peter Lawford and Pat Newcomb, who were already there. "Pat started screaming," Jefferies said.

Twenty years later (November 1982), the *Globe* published the interview with the ambulance driver, James Hall. He stated he had found Marilyn naked and comatose (her heartbeat and breathing were barely detectable, her pulse rapid and weak). They placed her on the floor

[148] *Marilyn: Contre-enquête, op. cit.*
[149] Testimonies seen in *ibid*.
[150] Wolfe, *op. cit.*, 573.

to intubate her to attempt resuscitation. Pat Newcomb was screaming and hindering their efforts. Marilyn quickly started breathing correctly again, her color returned, and they felt that she was stable enough to be taken to the hospital. But at that moment, a man with a doctor's bag came in and, saying he was her doctor, ordered them to give her mouth-to-mouth resuscitation. Surprised by this order, since Marilyn seemed to be responding, Hall nevertheless did what he was told, removing the tube while the doctor massaged her heart. There was no trace of her having vomited. Hall stated that the doctor tried to inject adrenaline directly into her heart, but the needle hit a rib. Hall recounted that Marilyn died moments later. The doctor, who was none other than Greenson, the psychoanalyst, asked the ambulance drivers to leave the room and said he would declare the death. Peter Lawford was there along with a police officer. The neighbors had indeed seen the ambulance and the police car in spite of the many denials and counter-declarations surrounding the testimony of the ambulance driver. It was revealed, more than thirty years later (1995), that the ambulance company was in fact the same transport company used by the Kennedys when they needed to get to their clandestine appointments. This seems to confirm yet another element explaining the cloak of silence and lies concerning statements made by witnesses to the actual death of Marilyn Monroe. Some versions recount that she was taken by ambulance to the hospital, but that she died en route and was brought back to her house immediately.

Greenson must have wanted to save Marilyn, and yet it was he who stopped the others from successfully resuscitating her. He either killed her or finished what had already been started.

Neighbors reported they could hear a woman screaming, "Murderers, murderers!" It must have been Pat Newcomb, who, at 10:45 p.m., called her boss, Arthur Jacobs, to announce Marilyn's death. Attending a concert at the Hollywood Bowl with his wife, Jacobs left immediately to go to Marilyn's house to deal with the press.

It is now known that Marilyn did in fact die at 10:40 p.m. on the floor of the guest cottage and not at midnight in her bedroom.

In a short time, there was a steady stream of police cars coming and going from Marilyn's house. Numerous people appeared on the scene and the house was searched from top to bottom—drawers were emptied, documents seized. According to the neighbors and to Jefferies, many people went in and out in a flurry of activity and then, in the

Chapter 16

early hours of the morning, silence reigned again. Marilyn was taken to her room and placed on her bed in the same position in which she had been found before she died—stretched across the bed on her stomach, her hand placed on the dial of the telephone, off the hook. An empty bottle of Nembutal and other pill bottles were in view on the night table.

Shortly before midnight, a car was stopped for speeding. A policeman recognized the passengers to be Peter Lawford, Bob Kennedy, and, he would later admit, the third man was indeed the psychoanalyst, Ralph Greenson. What were these three men doing together just after Marilyn's death? We can suppose they were escorting Bob Kennedy, who had to get far away from Marilyn's house as quickly as possible. They must certainly have decided on what their official story would be. The fact that their speeding car was stopped has never been called into question by investigations, but it is very telling, as it places Greenson as an accomplice to the Kennedys. As a doctor trusted with professional confidentiality, he could confirm the diagnosis of death by suicide. He also had to protect himself from different accusations: he was a member of the Comintern and he had not managed to help or to save Marilyn.

But back to circumstances surrounding her death. The official announcement could be made by about 4:25 a.m. because, by then, Bob Kennedy was safely back with his family, far from the "scene of the crime." Dr. Engleberg called the police to announce, "Marilyn Monroe has died. She's committed suicide."[151] Mrs. Murray opened the door for Sergeant Jack Clemmons, acting watch commander. Marilyn was in her room, stretched across her bed with a sheet over her body, the telephone in her hand. Greenson and Engleberg were there and both spoke at the same time: "She committed suicide." She was so stiff and unnatural that the policeman immediately felt she had been moved there from somewhere else.

The policeman heard the "official" version of what happened; Eunice and Greenson both told the same story. According to them, shortly after midnight, Eunice had seen a ray of light under Marilyn's bedroom door, knocked, and got no answer. She tried to go into the room, but could not, as it was locked from the inside. She was worried

[151] Wolfe, *op. cit.*, 575.

Keep Marilyn Hushed Up—She's Dead

and called Dr. Greenson, who arrived quickly. Also getting no answer from Marilyn, he had to break a windowpane to get into the room. Finding her dead, the doctor turned and said, "We've lost her." When the sergeant inquired as to why it had taken them so long to inform the police, Greenson answered that they had waited for authorization from the Fox PR department before they let anyone know. The washer and dryer were both running, which surprised the policeman. He also noted that there was no drinking glass in the bedroom and that the water in the adjoining bathroom had been cut off as work was being done there. The doctors later confirmed that Marilyn had been given no prescriptions other than for drugs to be taken by mouth. All these early enigmas, plus the fact that he felt he was being lied to, made a strong impression on the policeman, who felt that the "official" version was completely false.[152]

It is impossible to give all the details of the meticulous investigations that were held and that continue to this day because all the legal attempts to appeal and all the exhaustive documents concerning this affair have been covered up, including the most recent ones. At each stage, and systematically today, there have been outside forces preventing the revelation of proof or traces of what happened that night: the disappearance of organs taken during the autopsy, the disappearance of wiretapping records, the disappearance of the famous red notebook (after it had been read by various people), the destruction of papers found in Marilyn's home, the censoring of official documents, the disappearance of telephone records from the day of Marilyn's death and the following night (after they had been studied by various people). According to witnesses, the telephone was constantly in use by Marilyn while she was still alive and by other people once she had died. Other items that have disappeared include private tapes that had been heard by various people.

At the Library of Congress in Washington, we attempted to obtain access to letters sent from Marilyn's psychoanalyst Marianne Kris to her childhood friend, Anna Freud. This correspondence has been purged of all letters mentioning Marilyn Monroe, with no explanation as to why. Access to any letters concerning Marilyn is denied. In addition, contact was made with the library at UCLA, which conserves

[152] Clemmons was fired from the police department shortly after these events.

Ralph Greenson's papers. There again, the correspondence between the psychoanalysts Greenson and Kris has been edited; any letters concerning Marilyn cannot be seen. It is not clear if access is denied due to the Secret Service or due to the heirs of Greenson or Kris. No explanation is given. The shroud of this political interdiction on the traces of Marilyn's life weighs heavily and renders her death even more occult. This veil of silence continues to serve as an obstacle to the truth about Marilyn, as if muffling her again and again.

The most important fact is that, despite the numerous attempts to hide the truth of the investigation, the autopsy revealed high doses of Nembutal (phenobarbital) and chloral hydrate in Marilyn's blood and liver. There was no trace of capsules in her stomach or intestines. Marilyn must have received these fatal poisons intravenously, "overdose by injection," or by enema (her colon was discolored and congested). The washer and dryer were running late into the night, which favors the hypothesis of an enema. This would mean poisoning by overdose of a product introduced other than by mouth or injection, which is sometimes done. If it was murder, the murder was first mistaken to be a prescription medicine accident or an accidental suicide. In the panic of the moment, it was quickly disguised as voluntary suicide in order to clear the Kennedys, who would have been directly implicated.[153]

Jefferies' testimony came very late (1993) and he is the only one (along with his mother-in-law, Eunice Murray, in 1983) to have affirmed that Bob Kennedy had been at Marilyn's house at about 9:30 p.m. accompanied by two men, after which Marilyn was found dying. It seems very bold that the Attorney General would come in person to settle his business with Marilyn. If he came in person, it was certainly so that he could get something from her. Even if Jefferies' delayed testimony is untrue, one could easily imagine a scenario in which Marilyn, completely upset and angry, could have asked Mrs. Murray to give her an injection of sedatives or an enema and that the dosage may have been augmented to contain more than what the doctors usually prescribed. (It is known that, on the occasion of one particular weekend, Pat Newcomb gave Marilyn drugs, which she had brought herself). A non-fatal dose planned *by* Marilyn or *for* Marilyn might have been

[153] Wolfe, *op. cit.*, 92.

increased by the desire to make sure she would be out cold or even dead. (Pat Newcomb lied repeatedly about her comings and goings on the night of Marilyn's death.) Jefferies, Dr. Greenson and Dr. Engelberg, and the ambulance driver, Hall, might have first believed it was either suicide or accidental death. Dr. Engelberg later affirmed that if Marilyn had called Lawford after 10:30 p.m., that would mean that she did not want to die; of that he is certain.[154] Seven days after Marilyn's death, Pat Newcomb was photographed on a yacht, smiling and wearing President Kennedy's pea coat. He is in the photo and is smiling too. If it was not Bob Kennedy himself who 'suicided' Marilyn, it could also have been Pat Newcomb (according to Don Wolfe), or the CIA working along with the Mafia to incriminate the Kennedys (according to Smith), or the doctors who did it by mistake (according to Durieux), or Mrs. Murray under the orders of one of the above.

Obviously, the most shocking thing about the whole affair is the role of the psychiatrist-psychoanalyst who served to validate the completely arranged staging of the voluntary suicide theory. When Greenson got to Marilyn's house, he probably thought it was accidental overdose, an experience he had already been through with her and which he attributed to a sort of involuntary self-destruction, and thus concluded it was accidental suicide. He covered up the exact circumstances of his patient's death in order to hide any implication of political powers in the affair and also to protect himself. Protect himself from what? From his failure to save her? From the fact that he could be regarded as being politically subversive? It would only have been a few days after the fact that he would have understood his mistake, as he secretly and categorically affirmed to the Assistant District Attorney, John Miner, that he firmly believed Marilyn Monroe had not committed suicide. Miner arrived at an opinion that he felt free to state as long as he did not reveal the exact contents of his interview with Greenson: "Dr. Greenson was very strongly of the opinion that Miss Monroe did not commit suicide..., he firmly felt that she did not commit suicide—very much so, very much so. That I can state. He did not bar me from saying that."[155] John Miner wrote a memorandum to the district attorney as well as to the coroner's office. When he was

[154] *Marilyn Monroe: The Final Days, op. cit.*
[155] Wolfe, *op. cit.*, 48.

questioned in 1983, he repeated his affirmations. And when asked if he thought Marilyn had possibly been murdered, Miner stated that he could not respond. John Miner's memorandum has also disappeared from the files. To justify his opinion, Greenson played tapes for Miner containing the last recording Marilyn had made and sent to Greenson (discussed below).

However, the coroner made the official announcement that Marilyn "...had suffered from psychiatric disturbances for a long time. She experienced severe fears and frequent depressions; mood changes were abrupt and unpredictable.... On more than one occasion in the past... when depressed... she had made a suicide attempt... had called for help and had been rescued... the same pattern was repeated, except for the rescue."[156] Curphey, the coroner, gave the official conclusion: "probable suicide." Given the denials and disclaimers that surround this whole affair, should we not read this conclusion as the affirmation of a "probable homicide"? Proof shows today that Marilyn did not voluntarily commit suicide.

Many people had an interest in keeping Marilyn quiet and it seems that these same people had an interest in concealing the circumstances of her death and in making it look to the public like she had voluntarily committed suicide. What is dispiriting is to realize that even those who had totally divergent interests, who were in fact enemies of each other, came together to make Marilyn appear to be sick, crazy, depressed, and drugged and thus give credit to the theory that she had committed suicide because she was in too much distress.

In this way, no one had to fully bear the burden of responsibility for this stupefying death. Each one came out unscathed to start anew and completely erase Marilyn from the sordid and complex web of power. Her death seemed all the more upsetting because the idea of the "most popular star in the world" committing suicide because she suffered too much becomes the responsibility of everyone—all are guilty for her unhappiness and death. And, at the same time as everyone wants to glorify her, we endow her with this lonely act of self-liberation: suicide allows her to pass into the other world fully intact.

We love her because we want to see her as sacrificed.

[156] *Ibid.*, 50.

III
THE ACTOR'S STUDIO, PSYCHOANALYSTS, AND PHOTOGRAPHERS: THE PITFALLS OF STARDOM

17
SHE WAS THE LIGHT, THE WIND

Marilyn's death—so strange, so impossible to grasp, so contradictory—will forever remain an enigma, and not only because the "objective" proof has been irremediably lost. In the legends and accounts of her death, the theories of murder and suicide continue to be contaminated each by the other. It is as if Marilyn's death is marked by her style: a never-ending performance with its characteristic indefinable quality—marked, on the one the hand, by brilliance and, on the other, by danger.

Marilyn loved playing with the caricatured image of the sexy, saucy, absolute woman, which she did so well. All those who came into her orbit fell for her when they saw her in motion, even though she was not the epitome of classical beauty. She conveyed something else—open, infinite feeling. The myriad emotions that she was able to express came across as perfectly natural. She softened the sharpness of each image and carried viewers away to another realm. The rawness of her presence, her vulnerability, her gestures called forth the viewers' imagination.

For example, in *Gentlemen Prefer Blondes*, Jane Russell is not only a great beauty, but also an excellent actress. And yet, the viewers are eager for Marilyn to appear on screen, even though she may not be as beautiful as Jane. Although Jane Russell is an excellent actress, her screen presence is more polished and the limits, the nuances, the technique is apparent. Her style of acting is well defined, predictable. It is immediately recognizable; this is her appeal. When she mimics her friend Lorelei (Marilyn), she excels at it because, even with her "polished" performance, she manages to convey the "rawness" of Marilyn's presence. It becomes a superb parody.

Marilyn, in contrast, was never that polished and this was held against her. While other performers keep a tight rein on their image, or as best they can, going to great pains to hide their frailty as well as all the ploys they resort to, to hide their vulnerability, Marilyn is different.

Chapter 17

She reveals her hidden frailty—a mix of both extreme self-discipline and fear of failure—her unwavering belief in her own resilience masking great self-doubt.

The glamour or restraint that characterized her acting, her clothes, her poses, her make-up, her facial expressions still had to allow her true self to shine through. She was hard to pin down; her appeal was impalpable. The way she opened herself up, displaying her feminine frailty, conveyed a plea to be loved, adored, helped, protected, on the one hand, but, on the other hand, it left her open to exploitation and humiliation. In what Marilyn revealed of her inner self, each viewer could identify with her alienation and let their mask fall. Marilyn brought to light what had been left in darkness. We all tend to think of our own alienation as a weakness, something to be ashamed of, because we know others may take advantage of it. Marilyn, however, took risks—she laid bare her own differences, not as alienation, but as something for all to see—a light, an enveloping wind, as it were. Hence her enigmatic success, which did not stem from the sexy, flirty Marilyn, as all the machos believed. Beyond appearances, her attraction resided in her openly expressed difference and in her vulnerable erotic charm—the mainspring of unconditional love. Something of the self is exposed and given to everyone, contaminating all those she touched. It is laid bare, and yet remains indefinable; it must become myth. Marilyn drew strength from this contradiction within her.

From 1955, once she had become a star, Marilyn strove to control her appeal and understand who she was so as to use her indefinable, even underrated, talent to enhance her work as an actress. Hitherto, she had been loved for her presence, her voice, or her performances—whether at gala events, on podiums, or in photos, more than in films. From the moment she set out to be—and to be recognized as—a true artist, Marilyn did her best to understand herself and suffered all the more. The more help she got from experts, the more disabling her symptoms became. She inevitably lapsed into drug abuse and too much champagne to try to stave off insomnia and fear of failure, and this led to her constantly being late. What was behind this reaction? Was she completely wrong in wanting, at whatever cost, to become a true artist in order to be treated as a lady? Was there a contradiction between her innate talent for performing and the mastery of her craft?

Was she misadvised or misunderstood by those she paid to help her? This conclusion would be too simple; it is more likely that psychoanalysis and the Actor's Studio exacerbated the suffering she endured in creating Marilyn Monroe the star.

18
METHOD ACTING—THE ACTOR'S STUDIO

Right from the start of her involvement with the Actor's Studio, Marilyn was taken under Lee Strasberg's wing. He made her his most important student, to the point that many felt that his strong personal investment in her was excessive and destructive. Arthur Miller wrote at length about the quasi-hypnotic power that the Strasbergs held, particularly Lee, over Marilyn. Susan Strasberg, their daughter, an actress herself and younger than Marilyn, wrote about how her parents, and particularly her father, was interested only in Marilyn, to the point of neglecting his own children. Susan envied Marilyn for her beauty and charisma, while Marilyn envied Susan for the respect she commanded.[157] John Strasberg, their son, felt even more bitter towards his parents than his sister did. He was convinced that they had betrayed Marilyn and that they had "devoured her energy." He felt unloved, neglected, abandoned by them, forgotten in the midst of all their famous students. Marilyn was very caring toward the Strasberg children.

Every one of Marilyn's film directors, without exception, complained about Paula Strasberg's presence on their film sets and felt that her interference was disastrous. All felt that, by wanting to make herself indispensable, Paula only aggravated Marilyn's fears and inability to work. Inevitably, the horrible psychodramas that erupted during filming involved the meddlesome Paula, her husband's emissary. Marilyn always ended up standing up for her acting coach against everyone else.

Lee Strasberg had developed, in the US, the method Stanislavski had perfected to direct Chekhov's plays for the Moscow Art Theatre. According to Stanislavski, "You must find a physical form of the character which corresponds to an interior image you have found, without which it will be impossible to transmit the very life of this interior image. You must become this person rather than relive it." The actor

[157] Susan had played Anne Frank on Broadway at the age of seventeen to resounding success.

Chapter 18

must use all kinds of techniques—relaxation, concentration, etc.—in order to help the creative process bring about the "natural birth" of the character. The actor thus becomes fully himself. The Stanislavski system aims to grasp the creative process as closely as possible.[158]

According to Sarah Eigerman, a professor of dramatic arts, disciple of Stanislavski, and critic of Strasberg, the Stanislavski system is based on the idea that:

> [M]emory and the imaginary function in the same way. Sensory memory exercises are like practicing scales. The actor has to work on them to develop his reflexes, just like a sportsman does, in order to be available for his imaginary linked to the text. He has to use the text to find his way back to an experience he has had; he must live it authentically and intensely. The experience of acknowledging senses is real even if it is not true. Sensory memory is second nature; one recognizes sensations automatically. As a child does, one recognizes the sensual aspects of an object, one deciphers them even in the absence of the object. One must work on letting go, on getting in contact with oneself, on the discovery of one's theatricality. This aims to help the actor understand his own creative process.[159]

Many debates have transpired concerning Strasberg's transformation of the Stanislavski system. The Russian master had warned his American students as early as 1934 against relying exclusively on "affective memory" and against "sense memory" exercises. Strasberg employed a departure from the Stanislavski system with the elaboration of his Method.

Sarah Eigerman recounts:

> He was looking for an emotional result, he didn't contextualize, he wasn't interested in factual circumstances, he made things more personal. He developed *affective memory*: the actor chooses a key moment of his life, a turning point. He should not describe or narrate it but should explain what he sees, what he feels from a tactile point of view. In that way, the actor gradually arrives at a moment of intense emotion, like a revival. The exercise is meant to test the actor's capacity to trigger a real experience, and, in that way, to arrive at a kind of reflex where he is able to

[158] Constantin Stanislavski, *Building a Character* (New York: Routledge, 1977).
[159] Interviewed in Paris in November 2003.

rapidly call up an intense and real experience. Strasberg worked on these exercises without any rapport with the imaginary scene to be performed. To work on a role, he delved into the personal life of the actor. Strasberg maintained that the script was the enemy of the actor, he was opposed to the "presentational" method of French theater. He created an alternative world, always based on the return to personal experiences.

Stanislavski's system prepared actors to get in touch with their creative process through exercises and to approach the role in a state of availability, whereas the Strasberg method used exercises to bring up real emotional and affective experiences from the actor's personal life in order to play a role that had nothing to do with the relived events.

What does Strasberg himself say in his book, *A Dream of Passion: The Development of the Method*? He claims to have been inspired by Japanese theater, which includes a ritualistic preparation the actor must accomplish. Strasberg asks the following questions: How can the actor feel and master what he must accomplish on stage? How can the actor master his own feelings once on stage? His work also uses aspects from Yiddish theater. One must find "natural" gestures, that is to say, "psychological" gestures, the most expressive. The gesture must be imbued with inner life; it must transmit that vibration, be "inspired." How can you give the illusion of "the first time"? The terms "truth" and "reality" are constantly used. The creative mood must be summoned; one must feel a truth that has been long present deep inside. Creating a truthful, authentic emotion while in a made-up situation is what he has called the "creative if": if the situation were real, how would I act? To develop sensory memory, one must practice with imaginary objects or situations like those the actor encounters every day (a coffee cup, the feeling of the sun on skin, intense pain, a private reflective moment, global feelings, etc.). The actor must learn to recreate these things without their presence and note the physical actions he uses in order to do that, his behavior. To stimulate inspiration, one must use the five senses to call forth sense memory. The actor must understand the emotion of his character and then find within himself the same emotion and substitute it, even if this emotion stems from an entirely different circumstance. The actor prompts himself with details from his own life in order to reach the moment of intense emotional reaction. He must master his sensory concentration or else he may get

too carried away by the emotional experience. He must not learn his lines by heart, but rather call them forth at a specific moment in order to make the moment appear spontaneous and vivid. The actor must master his instincts and use his affective memory to create his reality on stage. Many of the greatest American actors have made use of the Actor's Studio in one way or another. However, it has also been said that American film acting is limited by this fake 'naturalism' developed by the Method.

It seems immediately obvious that such a Method could only bring out and reinforce Marilyn's weaknesses. The impact she had goes beyond the many techniques of fabrication and overacting that she used to create her effect. Now she is asked to learn exercises that will encourage what she had already been doing, what Strasberg called "inspiration." She is pushed to remember extremely emotional moments and find within them the appropriate feelings and actions required for a role. Finding and writing about her own creative process must have been troubling for Marilyn because clarifying what she already knew how to do and intensifying it forced her to attach words to it before doing it. That must have aggravated her apprehension of acting by the simple fact that it became an educational process—too much talk paralyzes action.

I put forth the hypothesis that her experience of total immersion in the Method, including her intense relationship with Strasberg (and his family), should not have come at the same time as her experience with psychoanalysis and therefore created an impossible situation for her. These two practices do not aim for the same type of catharsis. The first one involves a believable reenactment of raw feelings while the second involves triggering the release and retelling of buried memories. With the Method, Marilyn was already pushed, by the use of powerful suggestion, to find within herself intense, remote emotions in order to develop and perfect her performance in front of the camera. With psychoanalysis, one would have expected that a distinctly different approach would have been employed—anti-suggestion. In fact, what happened was the exact opposite. As will be shown, Marilyn's psychoanalysts focused on a return to her dreadful past. They all adhered to an American approach to psychoanalysis, Ego Psychology, which uses suggestion to bring out repressed, "traumatic" childhood experiences. At the same time, it gives a seemingly step-by-step guide to follow for a reasonable and normal life according to the standards

of the proclaimed conventional "American dream"—the good life. The analyst is expected to eliminate fear and anxiety supposedly linked to any deviation from that norm. Marilyn went along with the crazy contemporary illusion of believing that she could get recognition, respect, happiness, serenity, and kinship only from other people, preferably noteworthy ones. It was as if self-understanding could alleviate symptoms. Marilyn let herself be swept up in the infernal cycle of opposing forces: "coaching" and self-awareness.

19
PSYCHOANALYSIS—THE MISUNDERSTANDING

From 1955, Marilyn began the experience of psychoanalysis while she was already involved with the Actor's Studio. She eventually consulted three different psychoanalysts, all connected with Anna Freud. The link to Sigmund Freud's daughter was very important to Marilyn as she had great respect for him, not only as the inventor of psychoanalysis, but also as the man she imagined him to be.[160] Marilyn read many books on psychoanalysis. Her American analysts were European Jews, exiled in the United States. In February 1955, she consulted Margaret Hohenberg in New York.[161]

After the first year of analysis, Marilyn was satisfied with her progress; she had begun to understand herself and better accept herself. In February 1956, Marilyn included Hohenberg in her will.[162] Hohenberg was asked to travel to the set of *Bus Stop* to give Marilyn support. It seems that Hohenberg approved of Marilyn's marriage with Arthur Miller, who maintained that Marilyn was "...discovering that in so many situations in her life she was not the one who was wrong. She feels psychiatry has made a big difference to her."[163]

Irving Stein, a lawyer for the company Marilyn had created, MMP, kept a diary. In it, he wrote misgivings about the enormous influence the analyst held over Marilyn's life. Margaret Hohenberg herself participated in financial negotiations regarding the production of the film *The Prince and the Showgirl*.

Back in New York, relations between Marilyn and her business partner Milton Greene had irrevocably soured. Arthur Miller accused Greene of betraying Marilyn and possibly even stealing from her. Miller

[160] Spoto, *op. cit.*, 460.
[161] Hohenberg had studied medicine in Vienna and Prague and had emigrated to the US in 1939.
[162] $20,000. Spoto, *op. cit.*, 346.
[163] Summers, *op. cit.*, 199.

Chapter 19

advised Marilyn to cut ties with Greene. It may be that Miller's analyst, Loewenstein, had a hand in this move. In any case, Marilyn felt betrayed by Hohenberg, who, she felt, had played Greene and Marilyn against each other. She decided to change analysts and, on the advice of Anna Freud, she began to consult with Marianne Kris in March 1957. Kris was a childhood friend of Anna Freud and her representative in the United States. Kris' husband, Ernst Kris, had died two weeks before Marilyn began consultation.

Each day, Marilyn went to see her analyst at her home in the same building where the Strasbergs resided. According to accounts, Marilyn hoped analysis with Kris would bring her stability and help her live a more stable, conventional lifestyle. Marianne Kris asked many questions and Marilyn didn't always know how to answer. Marilyn sometimes became weary of the process and complained that it "went around in circles."

In July 1957, Marilyn became pregnant but had to undergo surgery for an ectopic pregnancy. In October 1958, during the filming of *Some Like It Hot*, she became pregnant again. Her analyst was called to the set. Marilyn was using barbiturates heavily and, in December, she lost the baby.

Little is known about Marilyn's analysis with Marianne Kris, who was the daughter of Oscar Rie, a Viennese pediatrician and good friend of Sigmund Freud. Marianne had emigrated to London at the same time as the Freuds. Later, she settled in New York with her husband, the art historian Ernst Kris, who would also become an analyst.

The considerable correspondence between Marianne Kris and Anna Freud is mostly in German with many passages in English. The Library of Congress inherited the papers of Anna Freud, yet possesses only the letters from Marianne Kris and a few rare carbon copies of typed letters from Anna Freud. As stated earlier, upon close examination of their correspondence, I observed that all letters making any reference to Marilyn Monroe's analysis have been removed. This reflects heavy censorship, as Marianne Kris wrote to Anna Freud frequently and discussed her patients, her work, and her personal and family life, as well as their scientific and institutional projects. It is also known that Anna Freud had assessed Marilyn's condition, based on information from Marianne Kris. Witnesses spoke of Kris' worries concerning Marilyn's overdose episodes and the infamous psychiatric hospitalization, which went so wrong. Certainly, in one way or another, Marianne

spoke to Anna about Marilyn, and yet many letters are missing from their correspondence. For example, there is nothing from October 1958 to October 1959, the year when Marilyn was in New York and allegedly made incessant visits to her psychoanalyst. Other missing dates indicate the same censorship. It is very likely that the Secret Service has made access to these letters impossible, all the more so as Jackie Kennedy Onassis consulted the same psychoanalyst at the end of the 60s and made a donation to the Anna Freud Center in London. Another hypothesis is that Marianne Kris' beneficiaries have forbidden access to their mother's letters concerning Marilyn because they do not wish to allow biographers to tarnish the memory of their mother. The curator of the Freud anthology gave no reason for the absence of letters concerning Marilyn Monroe.

One can suppose that Marianne Kris practiced psychoanalysis according to Ego Psychology, the leading proponent of which was Heinz Hartmann. On the theme of the autonomous Ego, analysts of this American school of thought departed from the teachings of Freud, who had never imagined the Ego as an independent entity. It is an adaptation of Freudian analysis oriented to the standards of what was considered to be a successful life according to the criteria of 1950s America: a stable marriage and family life with its income-based norms. The individual must manage to master his autonomy within a social context. Authors of this school of psychoanalysis explain: "The Ego organizes our relation to reality. It is designed as an organ for adaptation, it controls motility and perception. It examines present reality and anticipates aspects of future situations...." Under the pretext of autonomy of the Ego, the question of desire is hidden behind all the different types of demands required for adaption to American norms.

Marianne Kris sent her friend, Doctor Ralph Greenson, also a friend of Anna Freud, to consult and give support to Marilyn when she was in California. At that time (January 1960), she was dealing with rumors of an affair with Yves Montand, as well as criticism from George Cukor about her notorious delays. Greenson thus became the California representative for Marilyn's analysis in New York.

Greenson later claimed that he wanted to cure Marilyn of her dependence on drugs and her chronic insomnia. Marilyn had allegedly confided in him that she felt painfully bitter towards Arthur Miller, whom she reproached for having been "cold and indifferent" about her problems. Greenson evoked "paranoia" and traces of "schizophre-

nia." In Marilyn, he recognized an orphan, an abandoned child, who "masochistically provokes people so that they will treat her badly and take advantage of her." He attempted to treat her as he would an adolescent whose development had not allowed the Ego to become autonomous. In this case, in his opinion, classic psychoanalysis was out of the question. Another form of direct action was required of him before beginning psychoanalysis *per se*. Although he wished to help cure Marilyn of her dependence on drugs, he prescribed medication for her or had his friend and correspondent, Dr. Engelberg, do so.

Marilyn was delighted with Greenson at first; she claimed to have found "[m]y Jesus—My savior." He helped her enormously, listening to her and giving her confidence. She said that he made her feel smart and that she wasn't afraid anymore.[164]

During the filming of *The Misfits*, she nearly overdosed on barbiturates and it was Greenson and Engelberg who oversaw her hospitalization. Greenson believed that "[a]lthough Marilyn resembled a hard-core addict, she was not the usual addict. She could stop cold with no physical symptoms of withdrawal."[165]

Back in New York, on January 31, 1961, Marilyn viewed *The Misfits*. Extremely upset, she retreated into her apartment and refused to eat or speak. Fearing Marilyn might attempt suicide, Marianne Kris suggested a hospital stay, which, as we know, turned out to be disastrous. Marilyn was absolutely irate to find herself inadvertently locked in with "real nuts," where the doctors would not listen to her. Marianne Kris had made a grave mistake by giving in to panic and putting her patient in the hospital.

Inside the psychiatric unit, Marilyn wrote a long letter to Greenson (found later in 1992) concerning her catastrophic internment. She had been confronted with the ineptitude of the staff there, who were convinced that one could not be an artist or creative as long as one was depressed. These ridiculous opinions were imparted to Marilyn with great disdain and even cruelty. She was denied any contact with the outside world and told to complete ridiculous tasks under the guise of occupational therapy. It was an absurd and revolting episode for Marilyn, who was visibly shaken by the gratuitous mistreatment to which

[164] Wolfe, *op. cit.*, 409.
[165] *Ibid.*, 437.

she was subjected. At a loss for what to do, she remembered her role in *Don't Bother to Knock* and decided that if they were going to treat her like a crazy person, she would act like one. She managed to use a chair to smash a glass-paned door and sat holding a piece of glass threatening that if they didn't let her out, she would harm herself.

She ended her treatment with Marianne Kris and left New York at the same time. Just as for her former analyst, Marilyn had bequeathed a sum of money to Kris to be used for the institution of her choice. Apparently, it had been Marilyn's intention to change her will, but she died before her attorney, Greenson's brother-in-law, was able to carry out her wishes.[166] Marilyn spent hours on the telephone with Greenson and when she was in Los Angeles she consulted him almost every day, sometimes for several hours at a time. He rearranged schedules and made himself available for her, inviting her into his home and family. Taking pity on this "eternal orphan," he tried to instill in her his own values so that she could use them to help herself cope. Greenson's presence in Los Angeles was one of the reasons why Marilyn had returned to California, but, for her, this return represented failure.

Greenson wrote to Anna Freud on December 4, 1961:

> I took over the treatment of a patient that Marianne Kris had been treating for several years, and she has turned out to be a very sick borderline paranoid addict, as well as an actress. You can imagine how terribly difficult it is to treat someone with such severe problems and who is also a great celebrity and completely alone in the world. Psychoanalysis is out of the question and I improvise, often wondering where I am going, and yet have nowhere else to turn. If I succeed, I will have learned something, but it takes a tremendous amount of time and also emotion.[167]

Anna Freud answered:

> I know about Marianne Kris' patient and her own struggles with her. She seemed a worthwhile person from Marianne's description. The question is whether one can supply for her the impetus to get well, which she ought to have herself. I treated a male patient of this type once, not paranoid, but a self-destructive homosexual addict, not a celebrity, but an un-

[166] Elisabeth Young-Bruehl, *Anna Freud: A Biography* (Norton: New York, 1988), 412.
[167] Letter from Ralph Greenson to Anna Freud, Dec. 4, 1961.

usually favored status in life which almost comes up to the same. He was a success, but, in spite of everything, he had a deep-seated determination to get well (I used to say some ancestor had forgotten it in him), which had not served him before, but of which analysis could make use.[168]

Anna Freud had understood Greenson's approach. She believed that if the patient does not possess the underlying will to get better, it is impossible to impart it to the patient. And yet Greenson tried to do this by intervening more and more in Marilyn's everyday life. He surely could have seen that the multiplication of his attempts was not the way to proceed. Those who practiced Ego Psychology must have been blinded by a stubborn devotion to their method.

Greenson had spoken to Marilyn about Arthur Miller in a surprising way:

> As a great intellect and playwright, he was too big a challenge for her. In trying to win his [Miller's] respect, she had become obsessed with the "serious dramatic actress" goal. This was false, it wasn't her. She should continue her acting lessons, and gradually improve her skills, but the movies she should concentrate on now were those that came most naturally to her—comedies, musicals, "fun" movies, nothing too serious. Above all she had to be herself.[169]

These remarks go against everything that Marilyn was expressing publicly. What did the analyst mean by "be herself," concerning someone who had clearly stated for all to hear that what she wanted was *not* to be anything other than herself? What she desired was precisely to be herself and yet to be respected. It is strange that Greenson would discredit Marilyn's plea to be taken seriously as an actress and to play roles other than just comic ones. Greenson made Miller take the blame for these desires and thought that Marilyn was simply trying to gain her husband's esteem by bending to his will. Of course, Marilyn was proud to be the wife of the great playwright. The love affair between them coincided with her desire to be a great actress and a wife. Their union was not without strategy on both their parts—Marilyn was drawn to intellectual and famous men. After being married to the great

[168] Letter from Anna Freud to Ralph Greenson, December 29, 1961.
[169] Wolfe, *op. cit.*, 452, 453.

sports star, Marilyn would become the wife of a great intellectual and Miller would become the husband of a great movie star.

It seems unjustified to agree with Greenson that Marilyn should have had to give up all her ambitions in order to cure her related symptoms. He must have tried to sway her to follow a path divergent from that of her aspirations. I feel he should rather have approached the conflicts that seemed most important to her as she presented them to him by opening a discussion about these conflicts. He should have let his patient lead instead of fearing to broach the issue of her childhood trauma, her experiences in foster families, all more or less unstable. It seems Greenson did not know how to allow room for what must have been terrifying and recurring in Marilyn's life. He approached her problems from his own psychiatric and conventional bourgeois criteria. He guided her towards something he thought was attainable even if it meant suggesting to Marilyn that she should give up her own aspirations. He tried to make her adopt his own values. It was Greenson's protective, positive, pedagogical technique that seems to have prevented Marilyn from completing analysis of herself, in the strict sense of Freudian analysis. On several occasions, Marilyn tried to show Greenson the way to allow her to enter into her own "mental meanderings."[170]

In May 1961, Greenson wrote to Marianne Kris concerning his plan to help heal Marilyn:

> Above all I try to help her not to be lonely, and therefore to escape into the drugs or get involved with very destructive people, who will engage in some sort of sado-masochistic relationship with her.... This is the kind of planning you do with an adolescent girl who needs guidance, friendliness, firmness and she seems to take it very well.... She said, for the first time, she looked forward to coming to Los Angeles, because she could speak to me. Of course, this does not prevent her from cancelling several hours to go to Palm Springs with Mr. F.S. [Frank Sinatra]. She is unfaithful to me as one is to a parent.....[171]

[170] As she so appropriately used the term in reference to Molly Bloom. See below tape recordings published in Smith, *op. cit.*, 184.

[171] Wolfe, *op. cit.*, 459, 460.

The followers of Ego Psychology refused to accept the Freudian concept of the "death drive." They claimed that aggression was always reactional, necessary for survival, firstly, and, secondly, a manifestation of rivalry. They did not believe cruelty was a fundamental element of human interaction with others—be it verbal interaction or loving or desiring each other. It was also expected that the patient should refuse to recognize these aspects of Freudian thought because "horrible, human cruelty" was considered unsuitable, indecent. With such an idealized American vision of life as it should be lived, the analyst had introduced a growing refusal to see and acknowledge the destructive dimension inherent in desire. Marilyn seemed to be caught in a position where she was forced to conform. Her resistance to this resulted in physical symptoms and a reliance on drugs. Deep down, Greenson disapproved of Marilyn's affairs with the Kennedy brothers, but he could not stop her. When Greenson arranged for Marilyn to hire his friend, Mrs. Murray, as a kind of assistant nurse, he requested that Marilyn fire her dear friend and companion, the masseur Ralph Roberts. With a heavy heart, Marilyn did so, saying that Greenson felt "that two Ralphs in my life are one too many."[172] Marilyn must have felt quite torn about obeying her analyst, but had no one else on whom she could rely. She must have resented having to go back to Los Angeles to continue analysis with him, but was unable to tell him so (he speaks of an "extreme paranoid phase"). Greenson became even more present in Marilyn's life and more manipulative.

As we know, with Greenson's advice and Mrs. Murray's assistance, Marilyn had bought a house very similar to Greenson's in January 1962. Preparing for a party at Peter Lawford's home, where she would see the Attorney General Bob Kennedy, Marilyn worried about what she would say and wanted advice about how to impress Kennedy. Greenson's son helped compile a list of questions for her to ask. Marilyn was seen at the party either reading from or writing in a little red notebook that she kept clutched in her hand!

Norman Rosten recalled that he was in Los Angeles on Sunday, May 25, 1962, and called Marilyn to ask her to go out with him. When he picked her up to go visit some art galleries, she appeared bloated and drugged with sleep. In a gallery that featured modern paint-

[172] Wolfe, *op. cit.*, 468.

ings, Marilyn bought a red, abstract oil painting by Poucette and then a bronze copy of a Rodin sculpture—a man and woman locked in a passionate embrace: "The man's posture was fierce, predatory, almost brutal; the woman, innocent, responding, human."[173] Marilyn hesitated a bit and then, despite the rather high price, bought the statue. She held it on her lap in the car, staring at it, and said, "Look at them both. How beautiful. He's hurting her, but he wants to love her too."[174]

Rosten recounted that Marilyn's mood suddenly and inexplicably shifted from cheerful to sullen and that, in a strident voice, she announced, "We'll stop off at my analyst. I want to show him the statue." "Now?," asked Rosten. This sudden turn of events worried him. "Sure," she mumbled, "Why not now?" At Greenson's home, he greeted them courteously and Marilyn proudly placed the statue on the sideboard next to the bar:

> "What do you think?," she asked, stridently turning toward him. He replied quietly that it was a striking piece of art. Marilyn seemed unusually restless and kept touching the bronze figures. A belligerence crept into her speech. "What about it? What does it mean? Is he just screwing her, or is it a fake? I'd like to know. What's this? It looks like a penis." Marilyn kept repeating, her voice shrill, "What do you think, Doctor? What does it mean?"[175]

It would seem that the act of buying the statue represented a clear link to all that she was puzzling over in analysis with Greenson. Marilyn knew that Greenson wanted her to distance herself from dangerous lovers, and yet there she was, statue in hand, demanding that he explain to her what such an erotic posture meant, in which the man seemed to be "hurting her but wants to love her too." Her tone was agitated, harsh, demanding, probably a sequel to discussions she and Greenson had had concerning destructive people in her life, the lovers against whom she was unable to defend herself—her "sado-masochistic" inclination, according to Greenson. And now there she was, demanding clarification from him, with Rodin's statue as validation.

[173] Norman Rosten, *Marilyn: An Untold Story* (New York: Signet, 1967), 113.
[174] *Ibid.*, 114.
[175] *Ibid.*, 115.

Chapter 19

On April 29, 1962, Greenson wrote to Anna Freud to recount that his patient was walking a fine line between two outcomes: Marilyn was teetering between establishing her independence or, on the other hand, regressing, which would prevent him from going on a trip to Europe he had planned. He wrote, "I think she will succeed in living without me, but I'm not sure I will survive this."[176] This is an ambiguous statement: What is it that he is not sure to survive? He seems to be shaken by his inability to help Marilyn.

Greenson nevertheless left for Europe in May 1962, just as Marilyn was having a very difficult time on the filming of *Something's Got to Give*. In his textbook, *Explorations in Psychoanalysis*, in the chapter "On Transitional Objects and Transference," Greenson wrote about an emotionally immature patient who had developed a very dependent case of transference on him. When he announced to her that he would be going to a conference in Europe, she later reacted by telling him she had found something to help her get over his absence. It was a chess piece from a carved ivory set she had received as a gift:

> As she looked at the set through the sparkling light of a glass of champagne, it suddenly struck her that I looked like the white knight of her chess set. The realization evoked in her a feeling of comfort.... The white knight was a protector, it belonged to her, she could carry it wherever she went, it would look after her, and I could go on my merry way to Europe without having to worry about her.[177]

Greenson wrote that his patient had been very apprehensive about his departure because she would be making an important public appearance. She now felt she would be protected by the talisman—protected against anxiety, nerves, or bad luck. Greenson went on to explain that he was later very relieved and delighted to hear that the public appearance had been a resounding success for her.

It seems obvious that the patient in question was definitely Marilyn—champagne was her signature drink and the public appearance in question was her performance at John F. Kennedy's birthday party. Here Greenson tinkers with the theory of transference to give a positive illustration of the transitional object and show his colleagues how

[176] Letter from Ralph Greenson to Anna Freud, April 29, 1962.
[177] Wolfe, *op. cit.*, 503.

he and Marilyn comforted each other. Symbols of protection seemed to be very important to Marilyn, as we saw before with her insistence on using Jean Harlow's hair colorist.

As it turns out, Greenson had to cut short his trip to Europe and come back to Los Angeles when Fox abruptly fired Marilyn. He had been heavily involved in negotiations for the filming and had assured Fox that Marilyn would behave. On July 2, Anna Freud wrote him to say that she had been following the events closely in the papers and had seen that his patient had been "acting up." Damaging stories had been sent out by Fox about Marilyn's tardiness and irresponsibility towards the studio. What Anna Freud probably didn't realize was that Greenson's vacation had been interrupted. Freud wrote, "...I did not realize that this would interrupt your holiday and I do feel sorry for this. I wonder what will happen to her and with her. There must be something very nice about her from what I understood from Marianne Kris. And still, she is evidently far from being an ideal analytic patient."[178] Evidently, Anna Freud did not understand the situation.

Greenson wrote to Marianne Kris of Marilyn's decision to "'terminate her therapy' and stated, 'I was aware that she was somewhat annoyed with me. She often became annoyed when I did not absolutely and wholeheartedly agree [with her].... She was angry with me. I told her we would talk more, that she should call me Sunday morning."[179] But on that Sunday, Marilyn was dead.

Immediately following Marilyn's death, Anna Freud wrote to Greenson on August 6, 1962. She wrote:

> I am terribly sorry about Marilyn Monroe. I know exactly how you feel because I had exactly the same thing happen with a patient of mine who took cyanide two days before I came back from America a few years ago. One goes over and over in one's head to find out where one could have done better and it leaves one with a terrible feeling of being defeated. But, you know, I think in these cases we are really defeated by something which is stronger than we are and for which analysis, with all its powers, is too weak a weapon. When I read in the papers of her 12 foster families in childhood, it reminds me of the concentration camp children with similar

[178] Letter from Anna Freud to Ralph Greenson, July 2, 1962.
[179] Quoted in Wolfe, *op cit.*, 569, 570. (Donald Wolfe cites this letter dated August 20, 1962. However, we were refused access to this correspondence.)

Chapter 19

fates whom we treated, or tried to treat, in our Clinic. The trouble was that none of them made the kind of transference that can be used for analysis, in spite of making attachments to the analyst. Do write soon and do not be too unhappy.[180]

On August 12, Greenson had already secretly, yet formally, declared that Marilyn had certainly not voluntarily committed suicide. But, on August 20, he wrote to Anna Freud suggesting that he nevertheless still validated the theory of suicide. He wrote:

> It was so nice of you to write me with such understanding. This has been a terrible blow in many ways. I cared about her and she was my patient. She was so pathetic and had such a terrible life. I had hoped for her and I thought we were making progress. And now she died and I realize that all my knowledge and my desire and my strength was [sic] not enough. God knows I tried and mightily so, but I could not defeat all the destructive forces that had been stirred up in her by the terrible experiences of her past life, and even of her present life. Sometimes I feel the world wanted her to die, or at least many people in the world, particularly those who after her death so conspicuously grieved and mourned. It makes me angry. But above all I feel sad and also disappointed. It is not just a blow to my pride, although I am sure that is present, but also a blow to my science, of which I consider myself a good representative. But it will take me time to get over this and I know that eventually this will only become a scar. Some good friends have written to me some very kind letters and this helps me, but it hurts to remember; and yet it is only by remembering that I shall some day be able to forget.[181]

Greenson was devastated after Marilyn's death. He stopped working for a period and left Los Angeles. He must have been the target of all nature of accusations. In December, he wrote to Anna Freud that he had to "...reassure my friends and enemies that I am still functioning."[182]

Anna Freud answered, "Marianne Kris told me quite a lot about Marilyn Monroe in the summer and about her own experiences with

[180] Letter from Anna Freud to Ralph Greenson, August 6, 1962.
[181] Letter from Ralph Greenson to Anna Freud, August 20, 1962.
[182] Letter from Ralph Greenson to Anna Freud, December 8, 1962.

her. I think no one could have held her in this life."[183] She must have meant her remark to be reassuring, but she does underline the fact that Greenson had tried to "hold her in this life." If one tries with all one's will to prevent a looming threat, often one only hastens its arrival.

In the spring of 1963, Greenson wrote to Anna Freud, "I have overcome my grief and depression about the M.M. affair...." To justify himself against criticism, he wrote in a medical journal that he had tried a particular type of treatment on this patient as all other types had failed.[184] He justified having welcomed her into his family fold, of having negotiated with Fox Studios on her behalf, of having actively participated in helping her to make various decisions in her life. He acknowledged that he had failed because his patient was now dead! He never once used the word suicide.

It is clear that his remarks are very misleading. To Anna Freud, he leaves out certain details and complains to her of having to treat a patient who is bent on self-destruction. He might use psychoanalytical doctrine to justify his having intervened in his patient's life because she was immature and a borderline personality, but that does not answer the question: If he hadn't intervened so much, would she still be alive?

It seems more fitting to hear from Marilyn herself. In a recording intended for her analyst, she sheds light on their misunderstanding. In 2003, Matthew Smith published four-fifths of the transcriptions and notes taken by John Miner.[185] Greenson had played the tapes for Miner to prove to him that Marilyn had not committed suicide. Marilyn must have made these recordings a day or two before her death because she makes reference to a strategy she was developing to get rid of Mrs. Murray, whom she could no longer tolerate.

In the tapes, Marilyn suggests that Greenson could patent this new method of speaking to one's analyst by means of a tape recorder—in that way, the patient could be alone and "free associate" without restraint. After listening to the tape, the doctor would consult with the patient and then propose a treatment.

[183] Letter from Anna Freud to Ralph Greenson, January 20, 1963.
[184] *Medical Tribune*, October 24, 1973.
[185] Smith, *op. cit.*

Chapter 19

It is regrettable that Matthew Smith thought best to censor this precious document, as it goes against what Marilyn tried to do—that is, to finally break free from the generous yet heavily binding moralistic demands of her analyst. Smith writes in his preface:

> I must here record that discretion has been exercised in relation to publication of certain of the tapes' content that were deemed extremely intimate and entirely personal. Some references have been omitted to preserve decorum. Had I published those portions of the tapes in question, Marilyn would have been embarrassed and, no doubt, my readers would have been embarrassed for her.[186]

Marilyn strongly asserted quite the contrary in these recordings.

Lying on her bed, half dressed, she boldly speaks into the microphone to the one person who thinks he has all the answers. She, on the contrary, felt he was not really listening to her despite all the good he hoped to do for her. Alone in her room, she begins:

> Dear Doctor,
> You have given me everything. Because of you I can now feel what I never felt before. She comes by herself and with somebody else [in the third person]. So now I am a whole woman [voluntary play on words—just like Shakespeare]. Now I have control—control of myself—control of my life.... What can I give you?... Not money.... Not my body.... What I am going to give you is my idea that will revolutionize psychoanalysis.
> Isn't it true that the key to analysis is free association? Marilyn Monroe associates. You, my doctor, by understanding and interpretation of what goes on in my mind, get to my unconscious, which makes it possible for you to treat my neuroses and for me to overcome them. But when you tell me to relax and tell you what I am thinking, I blank out and have nothing to say; that's what you and Dr. Freud call resistance. So we talk about other things and I answer your questions as best I can. You are the only person in the world I have never told a lie to and never will.[187]

As for free association about her dreams, Marilyn says she has the same problem of blanking out: "more resistance." She acknowledges that Greenson has the right to complain about this and to ask

[186] *Ibid.*, xvi.
[187] *Ibid.*, 183.

her questions instead of letting her speak. He had been trying to help Marilyn overcome this problem:

> You told me to read Molly Bloom's mental meanderings (I can use words, can't I) to get a feeling of free association. It was when I did that I got my great idea.... Here Joyce is writing about what a woman thinks to herself. Can he, does he really know her innermost thoughts? But after I read the whole book, I could better understand that Joyce is an artist who could penetrate the souls of people, male or female. It really doesn't matter that Joyce doesn't have breasts or other female attributes.... Wait a minute. As you must have guessed I am free associating and you are going to hear a lot of bad language. Because of my respect for you, I've never been able to say the words I'm really thinking about when we are in session. But now I am going to say whatever I think, no matter what it is.[188]

[Regrettably, Smith decided to censor Marilyn's use of language, which he deemed to be too foul. This is unfortunate, given the context. Truman Capote recounted that Marilyn liked to use coarse language.]

> To start with, there is the doctor and the patient. I don't like the word analysand. It makes it seem like treating a sick mind is different from treating a sick body. However, you and Dr. Freud say that the mind is part of the body.... I'll bet Gertrude Stein would say a patient is a patient, is a patient. See, free association can be fun.... [T]he doctor says I want you to say whatever you are thinking.... And you can't think of a damn thing. How many times after a session I would go home and cry because I thought it was my fault. While reading Molly's blathering, the IDEA came to me. Get a tape recorder. Put a tape in. Turn it on. Say whatever you are thinking like I am doing now.... Patient free associates *sans* difficulty. Patient sends tape to Doctor. After he listens to it, Patient comes in for a session. He asks her questions about it, interprets it. Patient gets treated.[189]

Next, Marilyn flatters her analyst as being the "greatest psychiatrist in the world." She suggests that he take her new idea and pretend it was his own without paying her any rights. He could introduce it to his colleagues and the world and then publish it in a paper for a scientific journal. He would be the first to "let his profession know how to

[188] *Ibid.*, 184.
[189] *Ibid.*, 186, 187.

Chapter 19

lick resistance. Maybe you could patent the idea. And license it to your colleagues."[190]

[Was Marilyn being sincere? Though she does make fun of him somewhat, she also compliments him and quietly slips him a foolproof solution to the problem they had encountered. He had not managed to find a way to let her speak freely by herself. She was caught up in the proper way of thinking: the duality between lying/telling the truth, using coarse language/speaking properly. Moreover, she seems to hint that neither he nor Dr. Freud had tackled the question of body-related identity, the duality of mind/body. With the help of Joyce, she gets into sophisticated word games and attempts something else: to overthrow all this rigidity and make herself heard!]

> You are the only person who will ever know the most private, the most secret thoughts of Marilyn Monroe. I have absolute confidence and trust in you. What I told you is true when I first became your patient. I had never had an orgasm. I well remember you said an orgasm happens in the mind, not the genitals.
> I don't think the problem is words themselves, it is the way people use them. It doesn't bother me but this damn free association could drive somebody crazy. Oh, oh, crazy makes me think about my mother.[191]

Marilyn goes on to speak about orgasm:

> You said a person in a coma or a paraplegic doesn't have an orgasm because the genital stimulation doesn't reach the brain, but that an orgasm can happen in the brain without any stimulation of the genitals. You said there was an obstacle in my mind that prevented me from having an orgasm; that it was something that happened early in my life about which I felt so guilty that I did not deserve to have the greatest pleasure there is; that it had to do with something sexual that was very wrong, but my getting pleasure from it caused me guilt.[192]

[It is not known exactly what this incident was. What was this "something sexual that was very wrong"? And why not something that

[190] *Ibid.*, 187.
[191] *Ibid.*
[192] *Ibid.*, 188, 189.

was sexual THEREFORE it was wrong? Marilyn gives Greenson a real lesson in psychoanalysis. She's beating him at his own game.]

She continues:

> What you say is gospel to me. What wasted years. How can I describe to you, a man, what an orgasm feels like to a woman. I'll try. Think of a light fixture with a rheostat control. As you slowly turn it on, the bulb begins to get bright, then brighter and brighter and finally, in a blinding flash, is full lit. As you turn it off, it gradually becomes dimmer and at last goes out.[193]

[This passage is amusing. Is she saying that she had managed to solve the orgasm problem without his help because he, as a man, and unlike Joyce, wouldn't know anything about it? And she uses the metaphor of the rheostat to explain to him how she feels it now.]

Next, she speaks at length about how important Clark Gable was to her little girl's imagination. She tells about how, on the set of *The Misfits*, he had been both protective and teasing with her and how she would have loved to be his cherished little girl. "Of course that's fantasy." She continues:

> Ever since you let me be in your home and meet your family, I've thought about how it would be if I were your daughter instead of your patient. I know you couldn't do it while I'm your patient, but after you cure me, maybe you could adopt me. Then I'd have the father I've always wanted and your wife, whom I adore, could be my mother.... No, Doctor, I won't push it. But it's beautiful to think about it. I guess you can tell I'm crying....[194]

[There lies one of the limits to Greenson's technique of total patient immersion in his family life and in his own life values. But for Marilyn, it is "beautiful to think about," beautiful to think about actually being a part of his family. And it would have been too "pushy" to expect him to prolong this shared life of theirs by means of legal adoption! With psychoanalysis, Marilyn was no longer on a movie set in the

[193] *Ibid.*, 189.
[194] *Ibid.*, 192.

Chapter 19

context of the creative "if" (acting as if it were real). She was trying to establish a real life, not just one that was imagined.]

She goes on to speak about Clark Gable's death, which left her devastated. Next follows a long tirade about Johnny Hyde, her rich lover and protector at the time when she was twenty years old. She says, "...he died suddenly before he could keep his promise to put me in his will. *C'est la vie.*"

She then evokes the "so-called Crawford-Monroe feud" sustained by the press. Citing Shakespeare, she says, "He that takes from me my good name robs me of that which not enriches him and makes me poor indeed." She goes on to alternate between criticism and praise of Laurence Olivier, "...supercilious, arrogant, a snob, conceited... a great, great actor," especially when he delivers Shakespeare. She recalls a party when Olivier recited Shakespeare for two hours, "...Life's but a walking shadow, a poor player that struts and frets his hour upon the stage and then is heard no more...." Olivier had remarked, "That says it all"!

She says she wants to study Shakespeare night and day, to pay Strasberg to help her do it and to pay Greenson so he will be completely available for her. She wants to produce and act in "The Marilyn Monroe Shakespeare Film Festival."

> But let's get to something serious. Doctor, I want you to help me get rid of Murray. While she was giving me an enema last night I was thinking to myself, lady, even though you're very good at this, you've got to go.[195]

Marilyn asks her analyst to come up with a ruse to send the housekeeper away to take care of someone else, someone who urgently needs her help, a suicidal patient, for example. Marilyn then suggests that, with Greenson's help, and with a "substantial severance bonus," Mrs. Murray could be made to sign a contract not to write or give interviews about Marilyn, "*Secrets of Marilyn Monroe by Her Housekeeper.*" "She'd make a fortune spilling what she knows and she knows too damn much."

[195] *Ibid.*, 198.

Doctor, the fact is we just plain don't like each other. I can't put up with her insolence and disregard for anything I ask her to do.[196]

Greenson must have been quite embarrassed about this situation because he was the one who had found Mrs. Murray and hired her to help Marilyn—to keep her company, but also to spy on her. This was the height of the paradox of Greenson's situation and explains why Marilyn had to resort to using a tape recorder. She couldn't possibly explain this to Greenson face to face as she knew instinctively that his hiring Murray represented a betrayal of her own trust. She is constantly on the razor's edge of teaching him a lesson yet continuing to genuinely admire him.

The pertinence of Marilyn's sharp wit is clearly shown here. The remark about the enema that Mrs. Murray had performed carefully, yet certainly with a malicious attitude, corroborates one idea about Marilyn's death—that it may have been caused by an enema, "carefully performed" by the housekeeper, but this time with a little too much "medicine" mixed in with the liquid.

And Marilyn continues with a story about Joan Crawford having trouble giving an enema to her own daughter. Marilyn had to finish the job:

> I gave it to the sweet angel so gently she giggled. Joan gave me a sour look and said, "I don't believe in spoiling children." I felt she had a cruel streak towards the child.... I told her straight out I didn't much enjoy doing it [making love] with a woman. After I turned her down she became spiteful. An English poet best described it: "Heaven hath no rage like love to hatred turned; and hell hath no fury like a woman scorned."
> ...I remember a little bit about the enemas I had as a child. They were what you and Dr. Freud called repressed memories. I'll work on it and give you another tape.[197]

Marilyn then speaks at length about the practice of giving enemas and how it was so widely practiced by actresses, just as it had been at the court of Louis XIV. She tells how enemas were used to give a good complexion and to fight against diarrhea and intestinal toxins,

[196] *Ibid.*, 199.
[197] *Ibid.*, 201, 202.

Chapter 19

which give pimples. "Yes, I enjoy enemas, so what!... We have had fun with those piston syringes at beachhouse [*sic*] parties [at Peter Lawford's beach house]."

[The tape is then censored, which is unfortunate because Marilyn speaks about someone who had done her wrong and we do not hear the name of the person.] She explains that she asked Frank Sinatra about it, that he is a great help and a great friend, but not the marrying kind. She is aware that marriage destroyed her relationships with "two wonderful men."

> Joe DiMaggio loves Marilyn Monroe and always will. I love him and always will... There is no way I could stop being Marilyn Monroe....[198]

Marilyn explains that it would be impossible for her to become a faithful wife, to do what her husband tells her to do and devote herself to him.

> It's different with Arthur [Miller]. Marrying him was my mistake, not his. He couldn't give me the attention, warmth, and affection I need. It's not in his nature. Arthur never credited me with much intelligence. He couldn't share his intellectual life with me. As bed partners we were so-so. He was not that much interested; me faking with exceptional performances to get him more interested. You know I think his little Jewish father had more genuine affection for me than Arthur did.... But the Jewish religion never got to me and I think Arthur didn't care about it. Maybe he is a fine creative writer. I suppose so. Arthur didn't know film and how to write for it. *Misfits* was not a great film because it wasn't a great script. Gable, Monroe, Clift, Wallach, Huston. What more could you ask. I'll tell you. There has to be a story as good as the talent who play it. You know why those religious theme pictures like *Ben Hur* and *The Ten Commandments* are so successful? Because the Bible is a good script.[199]

[There is nothing to add to this; Marilyn has made her diagnosis: Arthur didn't really love her all that much. He recognized neither her intelligence nor her talent and she knows it. She is still trying to grasp the terrible effect of *The Misfits*, which ruined her marriage and

[198] *Ibid.*, 205.
[199] *Ibid.*, 206.

left her devastated. It seems that neither Greenson nor Marianne Kris had understood this. Moreover, just at the time when she was recording this tape, it was a pivotal moment for her: she was trying to fight Fox Studios, who had treated her shamefully in the previous weeks; she was trying to get her life back on track; and she had learned that Miller's new wife, Inge Morath, was expecting a child. She does not speak about the pregnancy, but she apparently knew about it. In the portions that Matthew Smith censored, Marilyn allegedly spoke about her intention to remarry DiMaggio.] She continues by speaking about the Kennedys:

> Marilyn Monroe is a soldier. Her Commander-in-Chief is the greatest and most powerful man in the world. The first duty of a soldier is to obey her Commander-in-Chief.... [T]his man is going to change our country. No child will go hungry. No person will sleep in the street....
> No, I'm not talking about Utopia—that's an illusion, but he will transform America today....
> You don't think you're hearing me, do you?...
> I'll never embarrass him. As long as I have memory I have John Fitzgerald Kennedy.[200]

Marilyn points out that Bobby has more hair on his body than does his older brother, John.

> But Bobby, Doctor, what should I do about Bobby? As you see there is no room in my life for him.... I want someone else to tell him it's over..., because I know how much he'll be hurt; I don't have the strength to hurt him. His Catholic morality has to find a way to justify cheating on his wife, so love becomes his excuse. And if you love enough, you can't help it and you can't be blamed. All right, Doctor, that's Marilyn Monroe's analysis of Bobby's love for me. And now I understand it for what it is, I'm not going to have any problem handling it myself. What is amazing is I solved my problem just through the free associating I did for you.
> Well, there's something for you to sleep on, Doctor.
> Goodnight.[201]

[200] *Ibid.*, 207, 208.
[201] *Ibid.*, 209.

Chapter 19

With the tape recorder, Marilyn Monroe has become the psychoanalyst of the "I" who is speaking and so she has discovered how to let Bobby know that their affair was over. This passage is interesting because it contradicts the theory that (because she had become too problematic) Marilyn had been jilted by John and then by Bobby. She explains things to Greenson in a completely different way. President John Fitzgerald Kennedy will be forever etched in her memory (he is no longer a friend nor a lover), and for his brother Bobby, she finds a personal way to explain things: he loves so deeply he cannot help himself and so he can't be blamed. With this argument, she can refute Catholic morality on its own terms: the power of love. Thus, she has found the way to stop seeing Bobby without hurting him.

By using the tape recorder, probably used only once for this session, Marilyn can say whatever comes into her head, just as Molly Bloom does in Joyce's *Ulysses*. As Marilyn had remarked, Joyce is an artist who can penetrate even the soul of a woman. Marilyn Monroe is an artist; she can use a tape recorder to say things the way she wants to, to communicate in straightforward language. In any case, she has not been "heard" by Greenson, the great psychiatrist, so she uses this method to explain herself to him in no uncertain terms.

It should be remembered that, in the United States, the titles of psychiatrist and psychoanalyst often denote the same profession. One must be trained as a medical doctor to become a psychoanalyst. Psychoanalysis is situated entirely within the realm of medicine and the goal is to find "the cure."

At the same time, Marilyn lifts the dialogue out from under doctor-patient confidentiality, since the recording leaves a trace of something that can be read today. Otherwise, this "conversation" would never have been made public. This extra component indicates that Marilyn was changing the way she dealt with her life.

If we proceed by remembering what had been said before, we can suppose that the recording was probably "interpreted" by the analyst and that would have "annoyed" Marilyn because he probably wouldn't have agreed with what she said on the tape. Perhaps that is why she may have decided to tell Greenson she wished to terminate their "therapy"—she had found another way.

None of Marilyn's psychoanalysts allowed him or her self to trust Marilyn, to really listen to her, to let her speak, in her own language, complete with "bad words." They were unable to stop fearing for her,

which would have been the only way to give her a chance. They wanted to "hold her in this life," thinking they were protecting her from destruction. They chose not to acknowledge that it is by recognizing what is impossible to change within the patient, wherever it may be, that the destruction inherently linked to desire can be transformed into something creative. Few analysts know how to tackle this notion.

By choosing the wording she used on the tape, Marilyn seemed to want her analyst to hear something more subtle than the moralizing affirmations or statements he had employed about her, such as: "immature, abandoned adolescent," "borderline personality," "depression," "paranoid phase." She wanted him to open up to what she had to say. By trying to pin on Marilyn a specific model by which to identify her, he had locked her into the stultifying position of being constantly with him and being spied upon by him, inside *his* Ego. Marilyn's analysis seems to be an example of the serious and dangerous limitations of Ego Psychology. If this school of thought implies that there is a strict interpretation and a universality of concepts, then the *Greensonian* values that Marilyn needed to adopt (she the abandoned child, the eternal adolescent) are treated as if they, too, are universal. Despite what Greenson thought he understood, he did not recognize the singularity of his patient. He explained her case to himself on his own terms and did not understand her unique style of expression. He generalized and annihilated that which was exceptional about her. Marilyn finally decided to take matters in her own hands and speak to him in her own language and answer him, whether she chose to use words or works of art: Rodin, Joyce, Shakespeare. Here is where their relationship began to unravel.

What is disturbing is that she died just as she was beginning to clearly show a change in her reasoning. After the fact, this tape-recorded material resounds as a spoken testament of her resolve.

20
MARILYN'S EVANESCENCE—MADE FOR PHOTOGRAPHY

Let's go back to photography—an art form that was more perfectly suited for Marilyn. There was a sort of coincidence between Marilyn and the phenomenon of photography; let's just say she was absolutely in her element.

Two great professionals, Billy Wilder and Constance Collier, said that Marilyn possessed within her a fleeting presence that evoked danger.

For Constance Collier, she was "like a hummingbird in flight: only a camera can freeze the poetry of it... lovely talent that's wandering through her, like a jailed spirit."[202]

Wilder said, "she looks... as if you could reach out and touch her, she's kind of a real image, beyond mere photography."[203] He also remarked, "...she was like a tightrope walker who doesn't know there's a pit below she can fall into."[204] The movie camera, like the still camera, was sensitive to this flickering, ethereal quality, on the brink of fading away. Many noted that Marilyn's talent as an actress was not necessarily obvious on a movie set, but that her image as captured on film was always sublime! There was a certain vibration between light and movement, the pulse of her being. "She pierced through the screen": the expression of a recurring leitmotif, something about her was only visible after the fact, whether in print or on film. In photographs, she had a certain brilliance that pierced, jolted, engaged, moved whomever beheld the image. Roland Barthes gave a name to this photographic phenomenon—he called it the *punctum*. In Latin, the word means wound or prick. It is metonymic, an element of a given photograph that causes a "lacerating" encounter and moves or rouses the viewer, "... a kind of subtle *beyond*—as if the image launched desire beyond

[202] Wolfe, *op. cit.*, 312.
[203] Spoto, *op. cit.*, 287.
[204] Leaming, *op. cit.*, 313.

what it permits us to see."[205] The *punctum* has a virtual force of expansion, a disturbance of the photographic surface; it is a "vivid immobility" that shows itself to the viewer. For the viewer, it is difficult to pinpoint exactly what it is and trying to explain it means the viewer will reveal much about his or her own self.

Marilyn's gift for still photography was even more outstanding than for motion pictures because her great talent was that she would "shine" for one unique moment, her one chance, and then disappear. These instances could be more faithfully captured in the theatrical setting of a photographic pose than they could on a film set. Playing to the movie camera, Marilyn was forced to fit into an arrangement that included other people and she had to perform as per the filmmaker's directions. In addition, with photography, it was Marilyn who controlled the final selection: she could approve or reject photographs. This she could not do with movie film since the final editing depended, once again, on the director's decisions. Even though she would often immediately ask to do another take and to review the rushes and editing, she could nevertheless not control the final cut. She could not reduce cinema to still photography. Moving film requires action within a set, playing a role within a certain lapse of time. The framework of a movie set brought out in her the terror of not being good enough, the notorious lack of punctuality and drug use, whereas, with a still photographer or when she appeared live in public, she alone was the director of these fortuitous moments. Here, she was not directed but rather borne along by the promise of what she would give the photographer or the public. In this context, she would come alive, improvise, create the exciting moment or the event; she would feel unafraid and blossom. A photograph is captured in an instant, one fleeting spin of the roulette wheel, and gone forever in the next second. In a different vein, it shows the element of "that-has-been"—time interrupted. Barthes says photography is not about what is being photographed, but rather about time. In that way it becomes subversive and assaults the viewer.

Photographers loved Marilyn; they strove to capture those moments given to them alone and recorded on the film where grains

[205] Roland Barthes, *Camera Lucida*, trans. Richard Howard (London: Random House, 2000), 59.

of silver fixed her attitude forever. For photographers, Marilyn moved easily, generously. She was inventive, quick—like a bird let out of its cage. On the other hand, with her odd selection of psychoanalysts who wanted to know her, explain her, identify her, she was like a bird trapped in its cage.

Marilyn was first discovered through still photography. As more and more photos of her were produced, they graced the covers of ever more prestigious magazines.

We have the marvelous testimony of the photographer André de Dienes. His published diary explores the friendship and love he felt for the lovely, fresh-faced nineteen-year-old Norma Jeane who would become Marilyn. De Dienes confirmed just how much Marilyn liked being photographed, how at ease she felt. It was often her idea to pose for him; she absolutely wanted him to photograph her and would send for him, even at night. In the winter of 1945, they embarked on a two-week photographic shoot—travelling through California, Nevada, and Oregon—choosing open-road, desert, mountain, and Pacific Ocean settings. Again, in 1946, they chose the Pacific coast and produced photos of Marilyn, thoughtful and absorbed. They did a new series of photos in 1949 on the Atlantic coast. In 1952, they shot photographs in California at the Beverly Hills Hotel and, in 1953, at the Bel Air. A night session in 1953 produced photos of Marilyn as insomniac, lit up by headlights. These different episodes provided the two of them with moments of happy and erotic creativity. She was never tired and always ready to get started. She was inventive, fun-loving, and mischievous and offered easy, evocative, feminine, flirtatious, charming, suggestive, happy, lively, natural poses. De Dienes bitterly regretted that he had declined to do a photo session with her in 1960 and, when he realized he should have said yes immediately, she was no longer available. The sessions that de Dienes describes were always cut short by outside events, which would immediately put an end to the session—the magic would be snuffed out in an instant. The creative bubble was so fragile that it could burst at the slightest interference.

Among other photographers with whom Marilyn was close, Milton Greene stands out as an extremely intelligent man, convinced of Marilyn's great talent. He allegedly had a "brief and passionate affair" with her in 1947 and again became her lover in 1953. Marilyn purportedly became pregnant with his child at the same time that his wife, Amy Greene, was pregnant. Milton apparently could not make up his

mind to get a divorce, so it was Marilyn's decision to get an abortion. Amy later said that there was some sort of secret between Marilyn and her husband and she did not know what it was. It must be remembered that Milton had Marilyn come to New York to help her get out from under the grips of the Hollywood studios. He took a number of erotic photographs of her, beautiful and moving, dark with dark backgrounds: "the black sessions." Marilyn is wearing fishnet hose and a top hat or is partly dressed lying on a bed, in many poses, taking off her hose and more. Milton was photographing a woman, not an image. The negatives were recently found in Poland and have not all been published. Greene kept these photos secret, as well as a number of other documents Marilyn had given him. Details about their intimate relationship have remained private.

Sam Shaw, a film-set still photographer and great friend of John Cassavettes, met Marilyn in California in 1951–52 when he was working on the set of *Viva Zapata*. He recounted that at that time Marilyn was adorable, warm, and cheerful. She was way before her time as far as her simple style, her free and open morals, and her way of wearing surplus-store blue jeans that she made skin-tight by wearing them into the ocean for a swim. She was very witty and therefore was great friends of the reporters who reveled in her off-the-wall quips. Sam Shaw became close friends with Marilyn and it is rumored that his "pornographic" novel is based on his love affair with her.[206] It was his idea for her to stand over the subway grate for the famous photos taken during the filming of *The Seven Year Itch*. He also took the photos at the reception in Marilyn's honor at Romanoff's in Hollywood, where everyone who was anyone turned out to fete her. Sam Shaw liked to capture moments backstage—relaxed, playful, affectionate moments when Marilyn was happy to go along with it. He showed the fun side of Marilyn even in the context of the studio world. He made her out to be the quintessential Hollywood story thanks to the irony he included in his photos: the beautiful, hot girl from nowhere who has got what it takes and makes it to the top.

In Manhattan, Sam asked Marilyn to pose for him using the Actor's Studio method of employing sense memory: in the middle of Central Park, she is wearing white gloves and reading the newspaper;

[206] Published by Maurice Gordias.

the couple sitting next to her don't realize who she is. Sam Shaw liked to capture Marilyn's ease with the public, shooting her in the middle of a cheering crowd. He had a fondness for scenes from everyday life and shot pictures of her walking in the street or the countryside, splashing at the beach, playing with a dog, enjoying a coffee in a café, dining in a restaurant, getting off a plane, riding in a convertible, reading, getting ready in the bathroom, putting on her make-up, browsing in a bookshop, tasting an ice-cream cone, telephoning endlessly, doing exercises at home, giving loving glances. The photos are in light tones with bright backgrounds.

Sam Shaw's photographs stood out from the myriad of other shots showing Marilyn as the vamp, the star, the *femme fatale*. In those images, Marilyn is beautiful but frozen, always carefully made-up with her eyes half-closed in an infinitely suggestive expression. Photographers who shot this type of portrait include Phillip Halsman, Richard Avedon, Henri Cartier-Bresson, Eve Arnold, Frank Powolny, Cecil Beaton, Henri Dauman, and many others. Some of these photographers are well known and some less so, as they were working under the auspices of photo agencies. All of them relate how much Marilyn loved being photographed. She was a perfectionist about her appearance and never left anything to chance. Everything was always carefully prepared for the event she would create. It was a bubble out of time that opened up the arena for her spontaneous performance, always something new for the surprised beholder. She herself was surprised by the click that would capture that one fixed moment. Once the session was over and the event had concluded, the magic would vanish—her brilliance would only become visible on the surface of the glossy prints.

The last two photographers to shoot pictures of Marilyn, in July 1962, were Bert Stern and George Barris. They were both so affected by her death that they continued to speak of her for a long time after. We find their photos so moving because, like all photographs, they record a moment in time, but also because they capture the last images ever taken of her. The "that-has-been" dimension of these photographs stands out as even more irrevocable.

The young photographer Bert Stern had gone to shoot pictures of Elizabeth Taylor in Rome and began to dream of shooting Marilyn Monroe for *Vogue* magazine. He wanted to take the definitive portrait, just as Steichen had done with Garbo. He came up with the idea of a

Chapter 20

first session and yearned to capture her in print, naked. He was immediately fascinated by her "extreme beauty" and by her directness and good humor.

He had prepared the studio with a brilliant white paper backdrop and diaphanous scarves as props. He quickly coaxed her to bare her torso and to pose spontaneously with the scarves. He wanted her without make-up to show her "pure" side, the velvety texture of her skin. The recent scar on her right side (from the operation to remove her gallbladder) would not be inappropriate in the context. Courageous and bold, Marilyn had nothing to hide. She was aware that the other version of her as groomed and composed—made-up, sophisticated, glamorous—might actually reveal the true fault line of her image, like an actual trace on her skin of the torture she felt inside. In these photos, she exposes the most contrived along with the most raw, even cruel, portrayal of herself.

Stern was completely taken with Marilyn and moved by this essential fleeting quality she gave off, which gave each image the whiff of danger: "I had nothing to fear from her... except that she might vanish before my eyes now that I'd found her. I had a camera to make sure that wouldn't happen."[207] Contrary to what he feared, Marilyn had "all the time that we want." They drank glass after glass of champagne. "It was hard, it really was hard, because she was *happening*. She was alive, a wild spirit, as fleeting as thought itself and as intense as the light that played on her. I couldn't freeze Marilyn and expect to get a picture from her. She was totally the opposite of Elizabeth Taylor."[208] "She'd move into an idea, I'd see it, quick lock it in, click it, and my strobes would go off like a lightning flash—pkcheww!!—and get it with a zillionth of a second."[209] "Her innocence amazed me. Here was a girl you'd think would be super aware of guys coming on to her, and she just went right *past* that, into another space that was far more childlike and interesting.... We're out in space. We're out of this world. I'm out here in the absolute, taking photographs."[210]

Vogue loved the first photos and asked Stern for other fashion shots, this time with Marilyn fully clothed. She went along with their

[207] Bert Stern, *The Last Sitting* (London: Little, Brown, and Company, 1982), 40.
[208] *Ibid.*, 47.
[209] *Ibid.*, 54.
[210] *Ibid.*, 54, 60.

demands and tried on all the jewelry and elegant dresses, one after the other, until she was exhausted. After several glasses of champagne, the photo shoot got into swing. At one point, she'd had enough and struck a pose in a "tacky" negligée, definitely not *Vogue* style, and the fashion editor protested. Bert Stern had everyone leave the studio so Marilyn could feel free to find her own inspiration for the photos:

> That *energy of observing* is marvelous. When you desire someone so much, and she's right there in front of you, there's something very special about *not* touching, and just letting *the light* caress her. And the camera plays a very powerful role in all this. Because you've got love coming through the lens. You just let it in and click! Close the box, and you've recorded impressions of that love, that energy, in photographs you can print and preserve.[211]

Marilyn quickly found her desire to play with the camera again; this time, she was naked on a bed with white sheets. Stern was completely excited and, after taking numerous photos, tried to give Marilyn a kiss, which she discreetly refused. He approached her sleeping and, sensing that she might let him, he hesitated to touch her, but decided to let her sleep: "I could hear her breathing. At least she's alive, I thought. I looked at her. She was just lying there beside me, peacefully, her eyes closed."[212]

Stern finished the series of photos and felt determined to do the ultimate black-and-white iconic photo of Marilyn Monroe. He positioned her lying on a bed, made-up and dressed in a sophisticated style. He shot her from an overhead angle, as if from a lover's viewpoint. Marilyn demanded to see the finished proofs and, to Stern's chagrin, vetoed more than half of them by marking through them with a felt pen or slashing them with a hairpin. Vogue wanted ten pages of black-and-white shots with Marilyn clothed while Bert Stern much preferred the color shots of her in the nude. He was stunned when Marilyn's death was announced the day before the magazine came out—she had been so alive and inventive, so touching, happy, and sensuous.

[211] *Ibid.*, 136.
[212] *Ibid.*, 140.

Chapter 20

After her death, Stern wrote: "...[Marilyn] *was* trouble. And trouble begets trouble."[213]

Bert Stern's testimony is authentic and rare because he also speaks of his own place in the dynamic of the photo shoots with Marilyn. He conveys well the erotic interval that can open up for the duration of a shoot, like a dance that reaches a certain climax, a sort of love scene between the photographer and the model. Marilyn loved this short-lived transformation—an important creative moment between two people.

At the same time, on June 1, 1962, on the day of her thirty-sixth birthday, Marilyn embarked on a project to write a book with George Barris. It would be her personal and autobiographical rebuttal to the negative publicity that Fox had been spreading about her. She said she wanted to "review the situation" and "set things straight." She had been officially attacked concerning the delays she caused, which the studio had insidiously linked to her "mental instability," pathological "weakness," and "depression."

With Barris, she talked and he took pictures. In what she said, it is clear to see how her background had determined her style. She said that she had been very badly paid—scandalously less than other stars—and that she had been treated poorly without quite understanding why. It was probably for the same reason that she was so successful: her provocative, unpretentious manner—sexy and *possessable*.

Barris, a friend of Marilyn's since 1954, took the last photos ever done of her. After one work session for the book project, they left to go walk on the beach, where Barris snapped pictures. These photos are very natural looking: Marilyn is wearing very little make-up and her hair is wet and windblown. She is wearing a bulky, patterned sweater over her bathing suit and seems happy and carefree in the photographs. Barris hardly ever spoke of her after her sudden death.

She said to a reporter:

> ...[O]ne of my problems happens to show: I'm late. I guess people think that why I'm late is some kind of arrogance and I think it is the opposite of arrogance. I also feel that I'm not in this big American rush, you know, you got to go and you got to go fast but for no good reason. The main thing is, I want to be prepared when I get there to give a good

[213] *Ibid.*, 187.

performance or whatever to the best of my ability. A lot of people can be there on time and do nothing, which I have seen them do, and you know, all sit around sort of chit chatting and talking trivia about their social life. Gable said about me, "When she's there, she's there. All of her is there! She's there to work."[214]

Within the private confines of a photo shoot, Marilyn was sure of herself. She was entirely focused for her event, for the metamorphosis that would take place within that moment, and she was completely committed to conjuring that special presence that would make of her mere image veritable performance art.

In photographs of Marilyn, the symbiotic interplay of her radiance and the camera lens restores her—a constant resurrection for the viewer. But death must be found somewhere in society, reasoned Barthes, even if removed from the context of religion. And if the rise of photography was contemporaneous with the decline of the practice of religion, it corresponds to the intrusion of death without ritual, a "literal" or "flat Death," according to Barthes. A photographic image produces death as a consequence of aiming to conserve life. The shutter clicks open/shut—life/death.

The living, breathing Marilyn comes into my thoughts as I contemplate these photos and she brings with her the incredible confusion between the "that-has-been" and the "there-she-is!"

[214] Quoted in Richard Meryman, "Last Talk with a Lonely Girl: Marilyn Monroe," *Life Magazine*, August 17, 1962.

CONCLUSION

In works concerning Marilyn, even if the author seems determined to treat her with fairness, there almost always comes a moment when he or she fails. In his play, Arthur Miller has made her mute: he concludes with the words "no more, no more." Matthew Smith redacted the transcripts of her taped conversation; he has omitted the "bad words" in order to preserve the decency of her memory.

At a decisive time in their relationship, a critical point when love is either nourished or left to wither and die, Arthur Miller had tried to confront the issue by writing *The Misfits*. His attempts, however, were in vain and so he fled.

Marilyn's way of always pushing the conventional boundaries provoked a defensive reaction from many people. Even if generosity was the intention—whether they tried to advise her or moralize to her, to help her, to understand her, or to seduce her—their approaches eventually proved to be fatal.

Marilyn overplayed the many sensibilities she might project during her performances until they all faded out and dissolved, giving rise to a visible metamorphosis. When viewed, it is like a parody that suddenly takes on a wider meaning, a joyful and light-hearted transformational moment. For every situation, Marilyn reinvented the way to show herself. She was said to be like a silent film character as she was so expressive. If we take a closer look, when she is on screen, we can always see a contradiction in her attitudes and then we hear her voice: it surprises us and derails what the image is meant to convey. Godard said that real cinema is silent cinema because it is up to the public to invent the text.

It is not enough just to see Marilyn in films or photographs. In other footage of the times, we can see her walking, answering reporters' questions, descending from a plane, putting on make-up, throwing a ball, appearing for her own weddings or divorces. Her visual performance subverts the context that the moving image conveys to

Conclusion

us. In other words, when we see her move, it is overplayed, extreme, multiple, and it interferes with what we think we know or have understood about the scene. We think it is easy to understand Marilyn and yet, at the same time, we are not sure to have done so. It is so enjoyable and liberating to watch her, but, if we might suspect she's playing it up or putting us on, we reject her for fear of being duped.

Marilyn believed she had specific needs, unique to her alone. She was constantly looking for the right way to live her life.

Although it is little known, Marilyn wrote poetry, which she sent to Norman Rosten, himself a poet. He seems to be the only person who was a true friend to her, and who wanted nothing more than friendship.

Here are a few of her lines:

(To the Weeping Willow)
I stood beneath your limbs
and you flowered and finally clung to me
and when the wind struck with ... the earth
and sand—you clung to me

Here is another fragment:

... life—of which at singular times
I am both of your directions—
somehow I remain hanging downward the most
as both of your directions pull me

And:

Night of the Nite—soothing—
Darkness—refreshes—Air
Seems different—Night has
No eyes nor no one—silence—
except to the Night itself[215]

With Marilyn, there is always something forceful and brilliant that becomes convincing and leaves us yet again with unanswered

[215] Rosten, *op. cit.*, 58–59.

questions about her. News of Marilyn Monroe still seems pertinent. She is survival itself.

In 1962, when Marilyn died, her name (her body, her image, her work) became the crystallization of all that the twentieth century engendered in terms of the deconstruction of traditional identities (sexual, political, economic, cultural, artistic, and communicational). "I" is no longer attached to one individual, nor to the ego; it is movement as an action, performance art.

The way Marilyn moved, danced, and spoke has made her creations forever contemporary. Her natural, positive, and joyous "performances" were what Guy Debord later denounced with the rise of the "society of the spectacle." Marilyn took the "real" out of what was being represented—images of her were everywhere, a confusion between real and fake, reproduced *ad infinitum*, a ubiquitous commodity. She had no private life to hide, nothing to proclaim, nothing to reveal—she produced for all to see her own non-negotiable space of existence. The viewer need only register the emotions she provoked without necessarily understanding why. The effect of her appearance was like a virus for which there was no defense. She is at the same time the artwork AND the artist; she distilled within herself this dichotomy. An artist without a piece of art, without a frame: an intangible and limitless work of art.

In my view, Andy Warhol immediately understood the Marilyn phenomenon. His art conducted her image like a lightning rod, immortalizing her as a contemporary icon.

At the time of Marilyn's death, Warhol was discontent with his work. He desperately wanted to create something new, but had no specific idea about what that might be. At one point, he paid a friend a derisory sum for an idea about what he should paint. Her answer? Paint what you love the most: money. He subsequently did a series of paintings of one-dollar bills and then had the idea to paint another everyday object—a can of Campbell's soup.

Warhol said:

> What's great about this country is that America started the tradition where the richest consumers buy essentially the same things as the poorest. You can be watching TV and see Coca-Cola, and you know that the President drinks Coke, Liz Taylor drinks Coke, and just think, you can drink Coke, too. A Coke is a Coke and no amount of money can get you

a better Coke than the one the bum on the corner is drinking. All the Cokes are the same and all the Cokes are good. Liz Taylor knows it, the President knows it, the bum knows it, and you know it.... The idea of America is so wonderful because the more equal something is, the more American it is.... Everybody looks alike and acts alike, and we're getting more and more that way. [No need to be a Communist for that, he said.] I think everybody should be a machine. I think everybody should like everybody.... [Pop Art is] liking things.[216]

Keller says that Warhol created "A reality from which all notion of identity has been excluded."[217]

Andy Warhol was in a period of flux when Marilyn's death inspired him to start a new technique:

In August 62 I started doing silkscreens. I wanted something stronger that gave more of an assembly-line effect. With silkscreening, you pick a photograph, blow it up, transfer it in glue onto silk, and then roll ink across it so the ink goes through the silk but not through the glue. That way you get the same image, slightly different each time. It was all so simple—quick and chancy. I was thrilled with it. When Marilyn Monroe happened to die that month, I got the idea to make screens of her beautiful face, the first Marilyns.[218]

Michel Nurisdany wrote that the repetitive and grid-like aspects of the work reflect the commercial production of art as a commodity. That is what made Warhol's style so successful: "There is no hierarchy in the information presented. The figure, the person doesn't matter—what is important here is the parceled dimension, multiplication or division, the series."[219] As involves death, he says, "The multiplication of death makes it less tragic; it becomes banal and we become somewhat de-sensitized to it. Repetition makes everything equal—whether it is an accident, Marilyn's face, the electric chair, or a can of Campbell's soup. Everything has the same value and none of it is important."[220] Warhol clearly claims that the spectacle is "the opposite of dialog." It is

[216] Quoted in Michel Nurisdany, *Warhol* (Paris: Flammarion, 2001), 149.
[217] Jean-Pierre Keller, *La nostalgie des avant-gardes* (Paris: Éditions de l'Aube, 1998).
[218] Quoted in Nurisdany, *op. cit.*, 190.
[219] *Ibid.*, 191.
[220] *Ibid.*, 194.

what Fellini denounced as "the image reduced to the state of confetti," yet not done in a haphazard way. At the same time as the silkscreen process cancels out the uniqueness of the central figure, each work is singular—in its color, its irregularities, its variations in ink, its accidental distortions. Each image of the same motif ends up altered. Marilyn is reproduced indefinitely, and yet she is so very present in each one of these varying images, a fleetingness that suits her so well. "The ink runs carrying with it the contours of Marilyn's lips, and repetition degrades the face which can no longer die because it is already devoid of life," wrote Otto Hahn.[221]

Debord said, "Truth is a moment of falsehood." Warhol took this to the extreme: he sent someone else to do his interviews and recounted that he actually had his assistants do the silkscreens. In that way, "everyone can usurp someone else's identity, all identity is suspended."[222] The uniqueness of the work does not depend on what is represented in it, but rather on the variations or "mistakes" within it.

With her luminous presence, Marilyn created an event each time she appeared and subverted the traditional image of femininity—she, the quintessential woman. The very essence of her performance is transformation: woman as woman, woman as man, transgender, the label is not important. Each appearance was re-invented as an ephemeral performance, fitting perfectly to the circumstance and vividly, exquisitely executed—neither man nor woman, nor couple, all those at the same time and yet something else—lost in translation.

[221] *Ibid.*, 226.
[222] *Ibid.*, 202. In November 1963, Warhol's works were shown in New York: *Campbell's Soup Cans*; *3 Coke Bottles*; *Elvis I & II*; *Gold Marilyn Monroe*; *Marilyn Diptych*. The show was a great success—the critics hated it, but the public loved it.

www.ingramcontent.com/pod-product-compliance
Lightning Source LLC
Chambersburg PA
CBHW030112100526
44591CB00009B/372